Alan Krell
is one of the younger generation of scholars
who are looking afresh at the received ideas of art history.
A graduate of the University of Cape Town, he went on to
obtain his PhD in 1978 from the University of Bristol. He
has published in learned journals on French painting of
the late 19th century, especially on Manet, Realism and
contemporary social and sexual attitudes. After a teaching
career that has included South Africa and Britain, he is
currently Senior Lecturer in Art History and Theory at the
University of New South Wales College of Fine Arts,
Sydney, Australia.

WORLD OF ART

This famous series
provides the widest available
range of illustrated books on art in all its aspects.
If you would like to receive a complete list
of titles in print please write to:
THAMES AND HUDSON
30 Bloomsbury Street, London WC1B 3QP
In the United States please write to:
THAMES AND HUDSON INC.
500 Fifth Avenue, New York, New York 10110

Printed in Italy

Manet

and the Painters of Contemporary Life

ALAN KRELL

185 illustrations, 30 in color

THAMES AND HUDSON

ACKNOWLEDGMENTS

I wish to thank my friends and colleagues who have provided all manner of
support; the staff of libraries and museums, particularly The Pierpont Morgan
Library, New York; and my family for their encouragement. I must also thank
Graham Forsyth and Martin Sims for their incisive criticisms of the manuscript.
To students who have indulged my interests and made me think twice about my
material, I am most grateful. Finally, a special thanks is due to my research assistant,
Eric Riddler.

First published in the United States of America in 1996 by Thames and Hudson
Inc., 500 Fifth Avenue, New York, New York 10110

Library of Congress Catalog Card Number 95-60470
ISBN 0-500-20289-3

Printed and bound in Italy

Contents

PREFACE 7

CHAPTER ONE
'But What a Scourge to Society Is a Realist Painter' 9

CHAPTER TWO
'Bathers, Bodies and Put-ons' 23

CHAPTER THREE
'A Parcel of Nude Flesh or a Bundle of Laundry' 47

CHAPTER FOUR
Manet, Zola and 'Le Jugement Public' 67

CHAPTER FIVE
'That Subtle Feeling for Modern Life' 83

CHAPTER SIX
Manet and the Impressionists in 1874 113

CHAPTER SEVEN
Modern Paris, Modern Pleasures 129

CHAPTER EIGHT
'Dandy of Realism' 159

Select Bibliography 201

List of Illustrations 202

Index 206

Edouard Manet (1832–83) has not received the myth-making impri-
matur of celluloid: there is no Vincente Minnelli's *Lust for Life*, the 1956
film of Vincent van Gogh, or an *Agony and the Ecstasy*, Carol Reed's 1965
epic about the life and times of Michelangelo. Nonetheless, Manet is
ubiquitous in the popular imagination as the painter of *that* work: *Le
Déjeuner sur l'herbe* (Luncheon on the Grass), painted in 1863 and exhib-
ited in the notorious Salon des Refusés of the same year. For a seemingly
endless army of cartoonists and marketing gurus, the *Déjeuner*, it would
seem, has a claim on their attention far outweighing any 'Old Master',
from the cover of Gilbert Shelton's comic, *The Fabulous Furry Freak 22
Brothers*, no. 3, 1976, to the RCA Ltd sleeve, 'Go Wild in the Country' (by 23
the eighties' Punk group, Bow Wow Wow). Cartoons in the daily press
frequently parody the *Déjeuner;* and, more recently, *The Simpsons* saluted
Manet's provocative grouping of men and women in the American tele-
vision serial of the same name. [1]
 If popular culture has taken to one particular work by Manet, then
more recent scholarship has cast its net much further. A major exhibition
in Paris and New York in 1983, commemorating the centennial of his
death, brought together a substantial number of paintings, drawings and
prints; the catalogue by Françoise Cachin, Charles S. Moffett and Juliet
Wilson-Bareau is rich in information and insights. Also held at this time
was the exhibition *Manet and Modern Paris* at the National Gallery of Art,
Washington; it had a catalogue written by Theodore Reff. Since then,
the literature on Manet and the Impressionist circle has burgeoned.
Important studies by Kathleen Adler, Juliet Wilson-Bareau, T.J. Clark,
Hollis Clayson, Tamar Garb, Robert L. Herbert, John House, John
Hutton, Eunice Lipton, Charles S. Moffett, Linda Nochlin, Paul Tucker,
and Kirk Varnedoe, among others, have greatly increased our understand-
ing of the 'New Painting' and its complex relationship to modern life.
 This issue is central to my book: how and in what ways does Manet's
art, in particular, and that of his Impressionist friends negotiate questions
of modernity?

1 Manet, aged about 33, photographed by Nadar

LE PUBLIC AU SALON

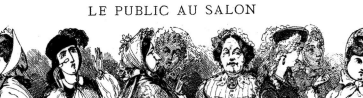

On reconnaît la bonne peinture au toucher, c'est quand elle est bien lisse.

AUX REFUSÉS. — Quelle horreur !que ces artistes ! m'avoir écrit que mon portrait était reçu !

— On vous a fait dans votre salon : eh bien, à vous dire franchement, il ne me plaît pas trop, il sent trop l'artiste.

L'ÉPOUSE DE MON ENGAGEUR. — Mon mari a deux cadres à l'Exposition !

La petite comtesse... c'est frappant de ressemblance; elle est affreuse.

— J'ai vu tout de suite qu'il y avait un défaut dans ce tableau-là, le cadre est abîmé.

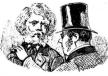

— Avez-vous vu l'horreur de robe de Mme ***?
— Et la petite M*** avec son chapeau sans bavolet ; à force de vouloir faire de l'originalité, elle finit par en être ridicule.

— MM. les artistes y s'a pas bien comporté à l'endroit du militaire, cette fois-ci ; t'as pas vu un certain Messonnier qu'a eu peur d'user de la toile. A la bonne heure, M. Yvon.

— Tenez, jeune homme, je vais vous dire en deux mots comment on voit s'y prendre pour juger un tableau d'après les règles de l'art.

— C'est superbe, c'est magnifique Regardez-donc, ma chère, vous ne trouvez-pas ? Enfin, voilà, ça me paraît assez... gentil.

— J'aimerais assez les statues, si a z'étaient écoulorées et qu'à z'aient pas des toiles d'araignées tout plein comme ça !

LE MARCHAND. — Nous ferons affaire ensemble, je ne demande pas mieux, seulement ne soyez pas trop exigeant ; elle ne plaît pas au public votre peinture. Qu'est-ce que vous vouliez ?

LE ZOUAVE EN PLATRE.
Qui s'y frotte, s'y pique !

— Ce monsieur qui vient de me saluer, c'est un grand artiste : nous avons causé Peinture ensemble, c'est étonnant comme il est toujours de mon avis.

Le chroniqueur d'un journal de modes, qui n'a le sujet du tableau de la peinture des dames !... Pauvre homme.

Un envieux qui trouve Fontin trop... prétentieux.

— Ce que tu as fait là c'est rempli de défauts, mais c'est très - bien tout de même.

— Qu'est-ce qui m'avait donc dit que M. Signol, encouragé par le succès que m'a « Vestale » m'avait obtenu au Salon dernier, la renvoyait cette année avec ce nouveau titre : J'veux pas y aller, c'est trop froid.

Le collégien qui en ferait bien autant.

Un rageur qui se trouve mal placé.

M. Chose s'extasiait devant la peinture de M. Machin pour que M. Macbin en fasse autant pour M. Chose.

<hr>

A MONSIEUR MARCELIN

Je suis campagnard forcément. Jeune, j'ai trop habité Paris, que tout Provincial ne quitte que plumé comme un pigeon. Cependant, je brame toujours après cette ville qui fut ma ruine.

De mes chers et cruels souvenirs résulte la préférence toute particulière que j'accorde à la *Vie parisienne*. Grâce à son arrivée, le dimanche est un double jour férié... *(Passons les compliments d'usage.)*

Ma partialité pour votre revue bien établie, je me sens le droit de lui faire quelques légères critiques. D'ailleurs vos rédacteurs sont de bons enfants, témoin M. Christophe, qui bafoué p r un de vos amis, dans un dessin où il fait marcher de pair une notaresse parisienne et une tabellionne départementale, a loyalement reconnu son erreur. Et de même, je l'espère, le spirituel illustrateur de l'*Angleterre au temps de Shakespeare*, me permettra quelques observations à propos du dessin que je viens de citer.

Il a *poché*, on ne peut mieux, Ossian, Shakespeare, Walter-Scott. On reconnaît leurs traits, on voit ce qu'ils firent. Mais pourquoi transformer Milton, en une vieille femme jouant à cache-cache ?

Et surtout, pourquoi Byron est-il si peu lui-même ?

Et quel *pied* ! — Il n'y en a qu'un. — Un pied de danseur de mazourke ! Lui, qu'un bal faisait fuir, comme le diable un goupillon. Couleur locale, diront les jeunes gens ; mais l'âge mûr de Byron n'a jamais chaussé la botte collante, et plus incontestablement encore, jamais le pauvre Noël ne mit en évidence l'une ou l'autre de ses jambes. La bonne faisait penser à la mauvaise : l'amertume de sa vie

Tout jeune et timide, il les dissimulait ces jambes fâcheuses sous sa chaise ; plus tard, en ne se laissant voir, qu'en buste, derrière un fauteuil, ou bien en s'appuyant contre une muraille, ou encore en prenant dans un entre-deux de porte, une pose byronienne.

Beau comme l'antique, le plus grand talent de son époque, envié des hommes, aimé des femmes, jusqu'au suicide, il se désespérait des quelques lignes qui manquaient à sa jambe pied-bot !

Grands hommes que vous êtes petits !

4 mai, St-Clar (Gers).

'But What a Scourge to Society Is a Realist Painter'

For Edouard Manet the Paris Salon was always 'the real battleground'. Held in the Palais de l'Industrie, a massive exhibiting hall built for Napoleon III, this 'great event of the artistic world', as it was described by an English diplomat in 1865, drew many thousands of people from all walks of life. Even the early Salons of the eighteenth century, which took place in the Louvre, had attracted a cross-section of visitors. It was this public, or publics to be more precise, that artists had to contend with. Additionally, there were the all-important critics and caricaturists: in specialist art journals, daily newspapers, satirical publications, fashion magazines and a variety of written ephemera, the Salon was scrutinized.

Manet's first attempt to show there in 1859 with a painting called *The Absinthe Drinker* was unsuccessful. In 1861 (the Salon was held every two years until 1863, when institutional reforms turned it into an annual event) his fortunes changed, and a portrait of his parents, *Portrait of M. and Mme Auguste Manet*, and *The Spanish Singer* were both hung. Acceptance was one thing, however, critical comment another. While the picture of the guitar player drew an enthusiastic response from Théophile Gautier, critic for the government newspaper *Le Moniteur universel*, and in fact went on to win Manet an 'honourable mention', the *Portrait of M. and Mme Auguste Manet* was derided as a piece of vulgar Realism. A review by Léon Lagrange in the *Gazette des beaux-arts* put it thus: 'But what a scourge to society is a realist painter! To him nothing is sacred! Manet tramples under foot even the most sacred ties. The *Artist's Parents* must more than once have cursed the day when a brush was put in the hands of this merciless portraitist.'

Looking at the work today, it is difficult to understand these words. To be sure, the portrait is rather sombre – the unsmiling face of Mme Manet; the furrowed brow and clenched fist of her husband – but this would hardly justify Lagrange's invectives. But what *we* think is, of course, beside the point. It is wishful thinking to suppose that we all 'see art' in the same way; contexts change, and so do our perceptions. We need to reconstruct a time and a place and, inevitably, we must speak with two voices, the possible 'then' and the more emphatic 'now'.

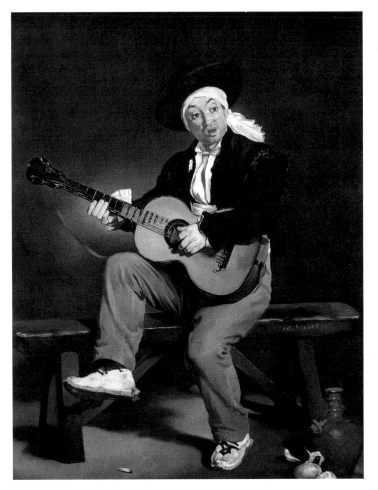

3 Manet
The Spanish Singer
1860

4 Manet
*Portrait of M. and
Mme Auguste Manet*
1860

Edouard Manet was born in Paris on 29 January 1832, four days after his father, Auguste Manet (1792–1862), was named a Chevalier of the Legion of Honour. A well-known and respected career magistrate and judge, Auguste had married Eugénie-Désirée Fournier, the daughter of Jean-Antoine Fournier and Adelaide de la Noue, in 1831. One year later they had a second son, Eugène, and in 1835, Gustave.

Auguste Manet came from an upper-middle-class family which had placed a premium on civic duty and social correctness. His wife, Eugénie (1811–35), was the goddaughter of Charles Bernadotte, the French Marshall who had become the Crown Prince of Sweden in 1810.

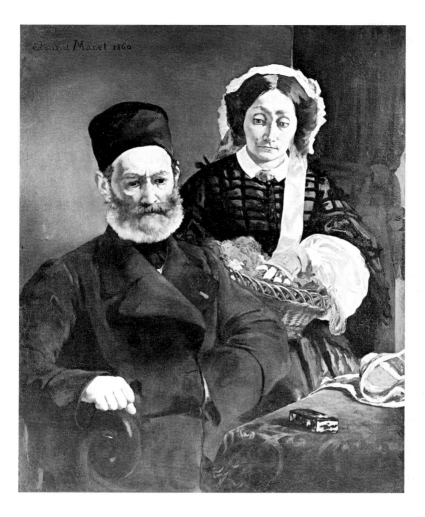

Eugénie's father had helped Bernadotte to the throne, and was later appointed French Vice-Consul in Sweden. As was befitting the wife of a well-to-do civil servant, Mme Manet 'received' twice weekly: her own women friends on Tuesdays and those of her sons at the renowned Thursday soirées.

When Edouard was six he was sent to Canon Poiloup's School at Vaugirard. He did not adapt well to this environment, much to the concern of his father, who decided that a boarding school was the next best thing. Little changed at the Collège Rolin, however, where Manet gained a reputation for being a 'backward boy' with a 'difficult character'. But he

did excel in gymnastics and showed an aptitude for drawing, initially introduced to him by his uncle Colonel Edmond Fournier, a military officer with a love for the arts.

Fournier was keen to encourage his nephew's latent talents and often took him and his childhood companion, Antonin Proust (1832–1905), on sketching trips and visits to the Louvre. It was Fournier, in fact, who persuaded M. Manet that Edouard should enrol in an extra drawing class at the Collège Rolin, but these lessons were thoroughly academic and failed to hold his attention: copying casts and reproductions of paintings was not where Manet's interest lay. A story, now legendary in the literature on the artist, has him furtively reading Diderot's art criticism during one of his classes and dismissing the writer's claim that serious art should have no truck with contemporary costume. Manet is reputed to have said: 'That's silly; one has to be of one's time and paint what one sees, regardless of fashion.'

Although it soon became clear to Auguste Manet that his son had no wish to follow in his footsteps and enter the legal profession, he would not accept his becoming an artist. In the end, however, he reluctantly agreed to allow Edouard to apply for entry to naval college. He failed the examinations, however, and went on to enlist in the Merchant Marine. In December 1848 the young Manet set sail for Brazil on board the training ship *Le Havre et Guadeloupe*.

The country he left behind was in the throes of political unrest. The Revolution of 23 January 1848 had led to the abdication of Louis-Philippe and the establishment of a provisional government. Popular dissatisfaction with this administration gave way to six days of bitter street fighting in Paris, the so-called 'June Days'. General Cavaignac put down the revolt and took over the reins of power, and then appointed a ministry to hold office while the National Assembly completed its constitutional proposals. On 10 December 1848 Louis Napoleon Bonaparte became the first President of the Second Republic.

Letters written by Manet while at sea reveal that he had little faith in Napoleon. He urged his father to 'try and keep a decent republic against our return, for I fear L[ouis] Napoleon is not a good republican.' Other correspondence gives additional insights into the young man's social and political beliefs. Soon after *Le Havre et Guadeloupe* dropped anchor in Rio de Janeiro in early February 1849, Manet went with his 'new friend', Jules Lacarrière, on a tour of the town. To his mother he wrote: 'In this country all the Negroes are slaves; they all look downtrodden; it's extraordinary what power the whites have over them; I saw a slave market, a rather revolting spectacle for people like us.' Elsewhere in this letter he

turns his attention to the more picturesque aspects of local life:

> The Negresses are generally naked to the waist, some with a scarf tied
> at the neck and falling over their breasts, they are usually ugly, though I
> have seen some rather pretty ones. ... Some wear turbans, others do
> their frizzy hair in elaborate styles and almost all wear petticoats
> adorned with monstrous flounces. ... Most Brazilian women are very
> pretty; they have superb dark eyes and hair to match ... they never go
> out alone but are always followed by their black maid or accompanied
> by their children.

While in Rio de Janeiro Manet's artistic talents were put to good use.
He had already acquired a reputation as a caricaturist during the voyage,
and the Captain now asked him to give drawing lessons to his shipmates.

Le Havre et Guadeloupe arrived back in France on 13 June 1849. Manet
was then seventeen years of age and more determined than ever to
become an artist. His father finally yielded and allowed him to enrol at
the studio of Thomas Couture in January 1850. Born in Senlis in 1815,
Couture had moved to Paris eleven years later. He had received his initial
training under Baron Gros before entering the atelier of Paul Laroche in
1838. Although better known as the painter of the monumental *Romans
of the Decadence*, a huge success at the Salon of 1847, there was another
side to Couture which predisposed him to smaller, less theatrical subjects

5 Thomas Couture *Romans of the Decadence* 1847

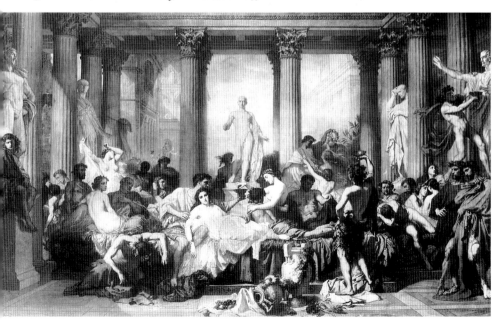

such as his *Little Gilles*, an informal study of a young boy carrying a tray with some glasses. It is interesting to note in *Little Gilles* and other similar works how Couture moves away from a linear treatment, the preferred option of the academic artist, towards a more painterly approach. This less traditional aspect of his make-up is further revealed in his *Conversations on Art Methods*, where he makes some pointed comments on the importance of modern subject matter: 'Have you remarked the faces of the workmen, who are no longer beasts of burden, but directors of the forces which mechanical genius has put at their disposal. ... These are new subjects. Our workmen have not been represented.'

The years Manet spent in Couture's studio (1850–56) were later to be recorded by another of his pupils, Proust, who became a lifelong friend of Manet. (It was Proust who would organize the artist's memorial exhibition at the Ecole des Beaux-Arts in 1884.) Proust's *Souvenirs*, first published serially in *La Revue blanche* in 1897, and then in book form with some additions by his secretary, A. Barthelemy, in 1913, are useful, but they are anecdotal and partisan. Thus we find Proust emphasizing the hostility between Couture and Manet to highlight the latter's innovative ideas, whereas there is little doubt that Manet benefited from time spent in his master's studio. Couture's penchant for telling amusing stories and a fondness for practical jokes may also have appealed to the young Manet who, as Renoir was later to recall, had a prankish side.

A small caricature self-portrait Manet did while probably still at Couture's sheds light on his more private self. He depicts himself with a large forehead and squinting eyes, and inscribes the work, 'Un ami!! Ed. Manet.' This modest picture testifies to one of Manet's important personal characteristics, a sense of irony and play which many of his contemporaries would later comment upon: the writer Jacques-Emile Blanche, Jacques de Biez (author of a book on Manet published shortly after his death in 1883), the journalist and art critic Théodore Duret, and many others. At times, however, Manet's irony could become acerbic, as Armand Silvestre found out. A habitué of the Café Guerbois in the late 1860s, a favourite meeting-place for artists and writers in the Batignolles district of Paris, Silvestre spoke about Manet's 'formidable wit, at once trenchant and crushing'.

7 There is an early picture by Manet called *Fishing* in which he shows himself and his wife-to-be, the young Dutch woman Suzanne Leenhoff (1834–1906), in historical costume: they are the couple on the bank at the bottom right. Their pose and dress actually mimic those of
8 Rubens and his own wife, Hélène Fourment, in that artist's *The Castle Park*, a work reproduced (in reverse) in Charles Blane's *Histoire des*

6 Manet *Self-portrait* 1850s

peintres de toutes les écoles. As we shall see in later chapters, Manet often 'borrowed' from the art of the past, especially during the early part of his career. *Fishing* is in a sense autobiographical statement, but characteristically one couched in play and disguise.

Manet removes this disguise in *Music in the Tuileries* (1862), a work done at about the same time as *Fishing*, and exhibited with thirteen others in his first one-person show at Louis Martinet's gallery in March 1863. This is a group portrait of Manet's family, friends and associates, including his parents, the painter Henri Fantin-Latour (1836–1904), the artist and poet Zacharie Astruc (1835–1907), the poet and critic Charles Baudelaire (1821–67), the composer Jacques Offenbach (1819–80), and Mme Lejosne, the woman without a veil in the foreground who looks steadfastly out at the viewer; she was the wife of Commandant Lejosne, at whose home Manet had met Baudelaire and Frédéric Bazille (1841–70). Twenty years later, critics still found the formal properties of *Music in*

9

7 Manet *Fishing* 1861–63

8 Rubens *The Castle Park*

9 Manet *Music in the Tuileries* 1862

the Tuileries problematic. When Huysmans saw it at the exhibition in honour of Manet in 1884, he wrote: 'His blobs of paint are unbalanced and jump out at you.' What for Huysmans were simply gratuitous accents – the pale cream of a face, red epaulettes, a white collar – are in fact integral parts of a carefully designed picture.

Music in the Tuileries presents not only Manet's close circle, but also the artist himself: he stands on the fringe of the gathering, half hidden by the man in front of him (the animal painter Albert de Balleroy with whom he had shared a studio), and cut by the edge of the canvas. Even in this emphatically 'modern' picture, however, Manet looks over his shoulder at earlier art – not at Rubens, who had provided him with a model for *Fishing*, but at a work then attributed to Velazquez, *The Little Cavaliers*, 10 which he had copied in the Louvre: that picture shows two figures, thought to have been Velazquez and Murillo, standing in similar positions to those occupied by Manet and De Balleroy. In *Music in the Tuileries*, Manet introduces himself as simply another fashionably dressed man in the crowd – a participant in the spectacle before him, but also distanced from it. He looks out at the viewer, almost diffidently.

10 Manet after Velazquez *The Little Cavaliers c.* 1858–59

It is instructive to compare this picture with the way the Realist artist Gustave Courbet (1819–77) portrays himself in his monumental canvas, *The Painter's Studio: A Real Allegory Summing up Seven Years of My Artistic Life*, painted in 1855 at the height of his notoriety. Here, Courbet places himself centre stage. He is seated in front of an easel, and flanked on the left by a motley collection of social types, including a huntsman, a rabbi, a grave digger, and a woman suckling her child. To Courbet's right are the 'art lovers' and intellectuals, among them the writer and critic Jules Husson Champfleury (1821–89), advocate of Realism and close friend of Courbet (he is shown seated in profile behind the nude model); the Socialist philosopher Proudhon (1809–65), friend and champion of Courbet; and Baudelaire (who also appears in Manet's *Music in the Tuileries*), seen reading on the extreme right. A naked woman looks over Courbet's shoulders, but he is oblivious to her as he is to all those around him.

Courbet presents himself as the artist-hero, but Manet in his caricature self-portrait, *Fishing*, and in *Music in the Tuileries*, comes across as a far more ambiguous figure. He appears in a rather different light in a group of paintings by Fantin-Latour. The *Homage to Delacroix*, inspired by

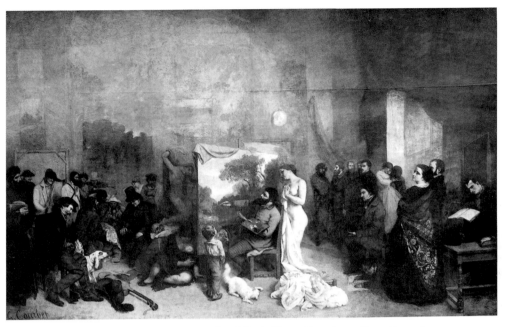

11 Gustave Courbet *The Painter's Studio: A Real Allegory Summing up Seven Years of My Artistic Life* 1855

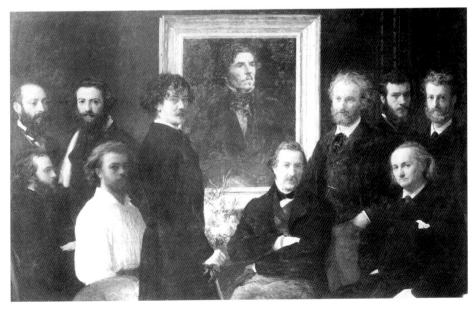

12 Henri Fantin-Latour *Homage to Delacroix* 1864

that artist's death in August 1863, depicts Fantin-Latour's friends and acquaintances standing around Eugène Delacroix's portrait. Manet is informally posed with jacket open and hands in pockets; to his left is a rather fatherly looking Champfleury, arms crossed; and on his right, Baudelaire, whose white pocket handkerchief adds a stylish note to his otherwise staid appearance. Fantin-Latour himself wears an open-necked shirt and holds a palette. Other figures include the artists Alphonse Legros (1837–1914) and Félix Bracquemond (1833–1914), and the novelist and critic, Edmond Duranty (1833–80). Most of this group, as it so happens, had been part of the deputation to Manet's studio in 1861 to express admiration for his painting *The Spanish Singer*.

The *Homage to Delacroix* would seem innocuous enough, but in 1864 critics were quick to point out that these men were all Realists who, true to form, were not even bothering to look at the ostensible subject of their homage, Delacroix. No doubt it was Champfleury's presence which had suggested the identification with Realism. He was an outspoken defender of Courbet, and had, as we have seen, appeared in Courbet's *The Painter's Studio*; indeed, some commentators even thought that Courbet himself was present in Fantin's painting. The critic Jean Rousseau summed up these sentiments when he said the work was devoted to 'the glory of realism', and 'shows us the principal figures gathered in touching unity around their lord and master Champfleury'.

Fantin-Latour's *The Studio in the Batignolles Quarter* (1870) depicts Manet at his easel painting a portrait of Astruc, seated on his left. Standing behind Manet, from left to right, are Otto Scholderer (1834–1902), Auguste Renoir (1841–1919), Emile Zola (1840–1902), Edmond Maître (1840–98), Bazille and Claude Monet (1840–1926). In this orderly gathering of male, middle-class artists and writers, Manet, like those around him, is the very picture of sobriety and seriousness.

These are the characteristics Fantin-Latour emphasized in an earlier portrait of the artist, where there is no brush or palette, but simply the signs of the boulevardier: top hat, gloves and cane in hand. This is Manet the 'homme du monde', the dandy, the immaculately groomed Parisian. As the critic Jules-Antoine Castagnary observed, Fantin-Latour's portrait showed 'only the exterior of the man', but it was an 'exterior' that took many by surprise. Reviewing the portrait in the Salon of 1867, an anonymous writer remarked: 'Monsieur Fantin la Tour [*sic*] is showing a highly distinguished portrait of *Monsieur M* ...; that is, Monsieur Manet ... the creator of *Olympia*. So there we have it! This correct, well-gloved, well-dressed young man, whom one would take to be a member of the racecourse set, is in fact the painter of the black cat, whose fame spread on a

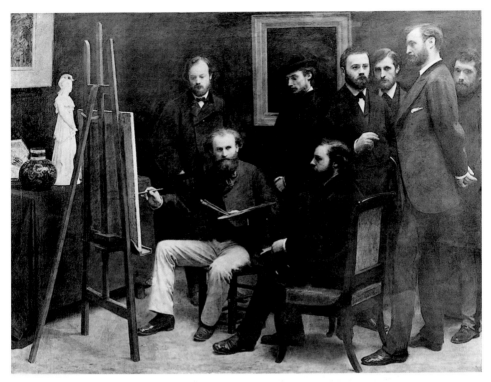

13 Henri Fantin-Latour *The Studio in the Batignolles Quarter* 1870

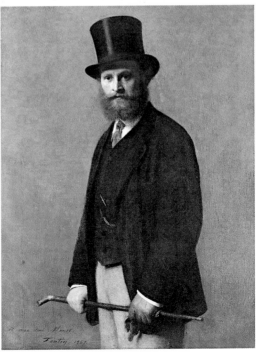

14 Henri Fantin-Latour *Portrait of Manet* 1867

wave of laughter, and whom one would have imagined looking like a long-haired student and wearing peak russet-coloured hats and smoking death's head pipes. His rehabilitation could not have been undertaken more ingeniously.'

The reference to *Olympia* and the black cat will be explained in Chapter Three. The point here is that, just as Manet's detractors described Realist art as coarse and commonplace, a promotion of the ugly, so they expected the artist to be coarse, commonplace and ugly too. In the case of Manet, however, this equation simply did not add up. He was anything but a dishevelled bohemian; he was a 'correct, well-gloved, well-dressed young man', and this clearly came as a shock.

'Bathers, Bodies and Put-ons'

If the adolescent Manet had rebelled against drawing from casts and copying reproductions, he by no means underestimated the value of studying Old Masters. Soon after entering the studio of Couture in 1850 he went and registered as a copyist at the Louvre. On his first trip to Holland in July 1852 he also took the opportunity of registering at the Rijksmuseum in Amsterdam. And again, when he visited Florence in October 1853 he went to the Uffizi and made copies of Titian's *Venus of Urbino* and Filippo Lippi's *Head of a Young Man*. These exchanges with the art of the past would soon have important repercussions for his own paintings of contemporary themes.

In 1862 Manet exhibited, at the Imperial Academy of Art, St Petersburg, a painting now known as *The Surprised Nymph* (1859–61). 17 The model was Suzanne Leenhoff, whom Manet would marry in October 1863, but the painting is laden with references to classical

15 Manet *Reclining Nude c.* 1858–60

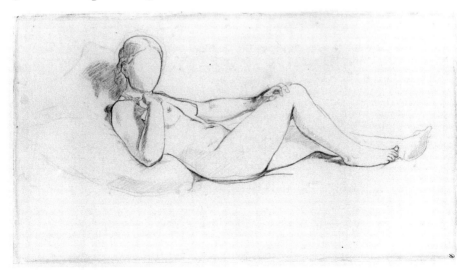

sources. These include Boucher's *Diana at the Bath*, which he had copied at the Louvre; an engraving by Raimondi of a *Nymph and Satyr*; and a lost Rubens, *Susanna and the Elders*, known in Manet's day through an engraving by Vosterman. *The Surprised Nymph* certainly has the air of an 'Old Master' about it, but the clearly delineated figure set against a loosely painted background anticipates his far more 'modern' treatment of the nude in *Le Déjeuner sur l'herbe*. It also begins to negotiate what is to be an important concern of that work, the relationship between the naked woman and the spectator.

In its original version *The Surprised Nymph* contained a satyr in the bushes, who would have made the spectator an accomplice in the act of spying on the woman – a concept analogous to the traditional 'Susanna and the Elders' theme: the unsuspecting Susanna, the voyeuristic Elders. Yet Manet's nymph is unusually self-contained. While her crossed legs and arms wrapped around her body imply an awareness of the 'other', they also signal a 'no go' zone. Manet's decision to change the title from *Nymph and Satyr* (in St Petersburg) to *The Surprised Nymph* (on the occasion of his one-person exhibition in 1867) carried with it a hint of irony: the woman's expression, no matter how it may be described, is surely not

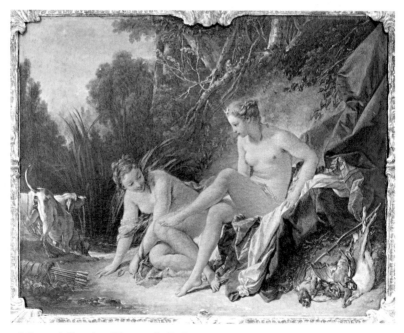

16 François Boucher *Diana at the Bath* 1742

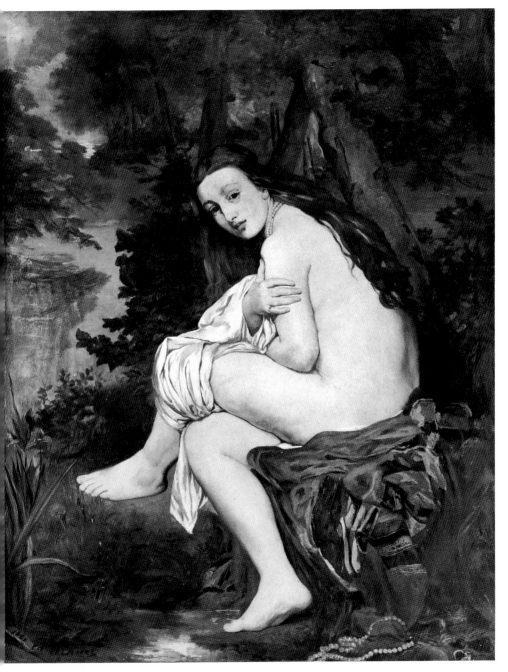

17 Manet *The Surprised Nymph* 1859–61

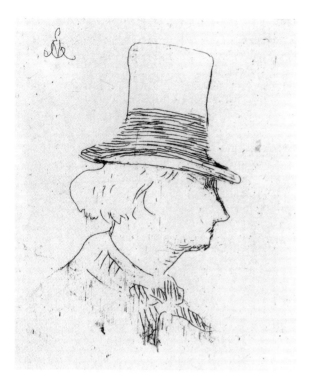

18 Manet *Baudelaire in Profile, Wearing a Hat c.* 1862–65

19 Manet
Le Déjeuner sur l'herbe 1863

one of surprise. That Manet once again changed the title in an inventory of his studio in 1871, this time to *Nymph*, suggests that by then he was quite happy to acknowledge her independent status.

This first serious attempt by Manet to paint the female nude was unfavourably reviewed, and not even shown in Paris until 1867. His decision to pursue the subject in the intervening years, first with *Le Déjeuner sur l'herbe* and then *Olympia*, showed his determination to master the genre. Now, however, he would locate his nude in a distinctly modern context, an approach probably influenced by Baudelaire with whom he had become close friends in the late 1850s. Poet, critic, dandy and *provocateur*, Baudelaire constantly stressed in his writings on art the importance of 'la vie moderne' as a rich source for artistic inspiration. A passage from his *Salon of 1846* dealing specifically with the subject of the nude could not have failed to impress Manet: 'The nude, this subject so dear to artists, this indispensable element of success, is as prevalent and necessary today as in the life of antiquity – in bed, the bath, in the medical theatre. The

technical means and the themes of painting are equally numerous and varied; but there is a new element, which is modern beauty.' In Manet's hands, as we shall see, 'modern beauty' was to be given a particularly provocative interpretation.

Proust has described the genesis of *Le Déjeuner sur l'herbe* in his *Souvenirs*. While sitting with Manet on the banks of the Seine at Argenteuil, some women bathers caught the artist's attention. Manet turned to Proust, and supposedly said: 'I'm told … that I must do a nude. All right, I will! I'll do them a nude. Back in our student days, I copied Giorgione's women, the women with the musicians. That's a dark picture. The background has retreated. I'm going to do it over, and do it in the transparency of the atmosphere, with figures like you see over there.'

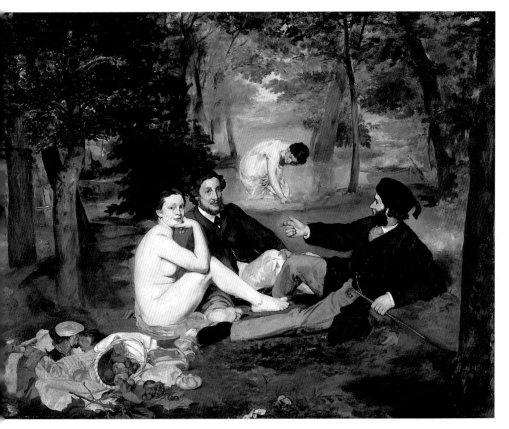

Although this explanation is simple and convincing, it is a recollection of a conversation that allegedly took place some 35 years earlier. Nonetheless, Proust's account does serve to show how the *Déjeuner* had its origins in a number of distinct yet interrelated concerns.

The painting, first of all, is a studio piece (each figure separately posed in the studio), and not, as Proust would have Manet imply, executed *en plein air*. The reference to the Giorgione, however, is another matter. The work in question is Titian's *Concert champêtre*, then attributed to Giorgione, and hung in the Louvre. That Manet had this image in mind is further corroborated by his close friend, Zacharie Astruc. Writing in the daily periodical he edited, *Le Salon*, on 20 May 1863, Astruc heaped praise on Manet, 'one of the greatest personalities of our time', and said that the Giorgione had 'inspired' him. To be sure, the picture's juxtaposition of nude women and clothed men is echoed in the *Déjeuner*, but in so many other respects, as we shall see, the two are very different.

Proust's account also fails to mention, although perhaps he was simply unaware, that Manet had looked beyond Giorgione to Raimondi, specifically to his engraving after Raphael's *Judgment of Paris*. Not one critic in 1863 commented publicly on this source, and it was left to an incredulous Ernest Chesneau to mention it first the following year, and then only in a footnote in his book, *L'Art et les artistes modernes en France et en Angleterre*.

The two men and a naked woman in the *Déjeuner* are based directly on the group of river gods and a nymph at the bottom right of the *Judgment of Paris*. Manet's models were the young Dutch sculptor Ferdinand Leenhoff (1841–1914) – his wife's brother – in the centre, and his own brother, Eugène (it is possible that Gustave Manet also posed, alternatively or successively). Victorine Meurent (1844–1928), a professional model and artist whom Manet had met in September 1862, sat for the nude; the identity of the other woman remains unknown.

Manet, who never made gratuitous 'borrowings' from older art, would have seen how Marcantonio Raimondi's three figures could readily be translated into a picture of Parisian picnickers. And perhaps just as important, he grasped the appropriateness of a Judgment of Paris – a beauty contest involving three naked goddesses – to his own wish to 'do a nude'. In addition, the pastoral setting of the Raimondi related to the *Concert champêtre*, while the shepherd Paris (he is the one on the left of the print awarding the golden apple to Venus), had his counterpart in the 'real' shepherd in the right middle-ground of the *Concert*.

The musicians in the Giorgione unite in a common endeavour, a feature disregarded by Manet who has emphasized the emotional distance

20 Marcantonio Raimondi after Raphael *Judgment of Paris c.* 1520

21 Titian *Concert champêtre c.* 1508

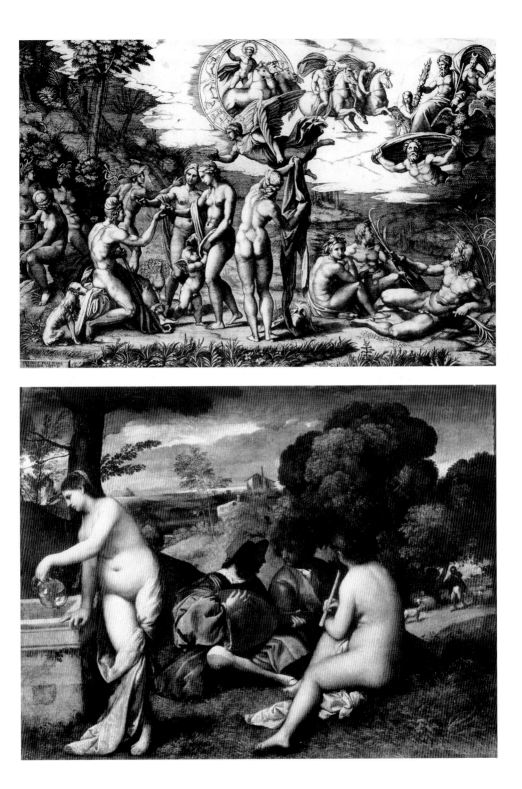

22 Gilbert Shelton *Déjeuner sur l'herbe* (1994); an earlier version was reproduced on the cover of his comic *The Fabulous Furry Freak Brothers* No. 3 1976

23 Cover of Bow Wow Wow's album
Go Wild in the Country 1981

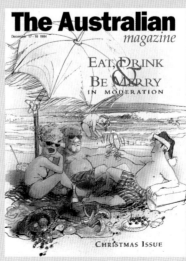

24 Cover of *The Australian Magazine*
17-18 December 1994

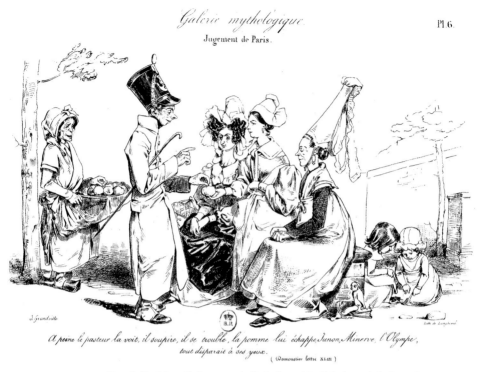

A peine le pasteur la voit, il soupire, il se trouble, la pomme lui échappe, Junon, Minerve, l'Olympe, tout disparait à ses yeux. (Pennonstier lettre XLIII)

25 Grandville *Nouvelle jugement de Paris*, from his *Galerie mythologique* 1830

26 James Tissot *Partie carrée* 1870

found among Raimondi's threesome. Victorine, oblivious to the pointing hand of her companion, looks confidently at the viewer, while the other picnicker stares vacantly out of the picture. Isolated from this group, and yet paradoxically painted too large for the position she occupies in the composition, is the woman wading in a stream.

Whereas Raimondi's river gods are naked, Manet's two Parisians wear casual dress. The female nude, after all, was his chief concern. Yet Victorine's rather large right foot, pointing directly at the groin of her companion, suggests a playful reference to the river-god who quite openly displays his genitals. The cane held by Eugène (the man wearing the tasselled cap) replaces the bulrush in the river-god's hand, but it could also be seen as a witty equivalent of Paris' crook. One precedent for this was the illustrator Grandville's earlier *Nouvelle jugement de Paris*, a parody of the classical story in which the naked goddesses give way to three ostentatiously dressed women and Paris is portrayed as a droll soldier with a cane tucked under his arm.

32

It is often overlooked that Manet first exhibited his painting as *Le Bain* (The Bath), a title which draws attention to the bather, but can hardly be said to describe the picture's more obvious subject accurately. Critics soon christened it the 'Déjeuner sur l'herbe', a name Manet himself used when he next showed the picture in his one-person show in 1867. The matter did not stop there, however: an inventory of his studio from 1871 has the *Déjeuner* listed as *La Partie carrée*, apparently the title known to a few close friends.

A *partie carrée* was the popular designation for a pleasurable gathering (*partie de plaisir*) of two men and two women. The *Dictionnaire erotique moderne* of 1864 was more emphatic, and defined a *partie carrée* as a 'four-way debauch, involving two men and two girls, who sleep together, go for walks together, eat together, and kiss'. For an artist intent on 'doing' a modern nude this was, of course, the perfect pretext. Yet Manet's picture had little to do with the more conventional treatments of this theme.

A comparison of the *Déjeuner* with James Tissot's *Partie carrée*, shown at the Salon of 1870, makes this point very clear. The Nantes-born Tissot

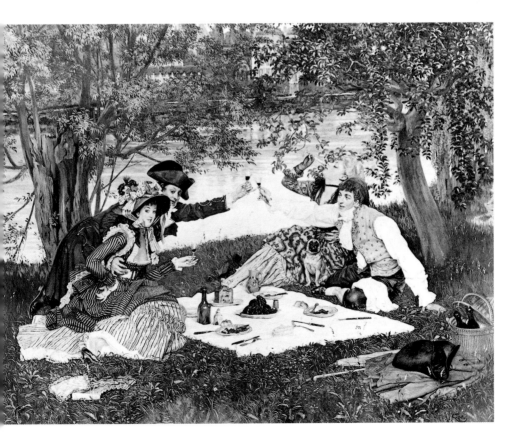

(1836–1902) has depicted a *partie de plaisir* in which the couples, dressed in period costume, openly enjoy themselves. The man on the left clasps his partner's waist and raises his hand in a boastful toast. She exudes a coquettish air and smiles in our direction. The other man responds to the toast while his companion lifts her glass contentedly to her lips. A smug-looking dog sits in front of her. Everything in this painting signifies flirtation, male bravado and female acquiescence.

Nothing could be more different from Manet's *partie carrée* where the couples eschew such 'delights'. He has taken the provocative step of undressing one of the women, but there is absolutely no suggestion of a *partie de plaisir*. The only hint of physical intimacy is Eugène's gesture towards the naked Victorine, but she pays no attention to his overtures.

There is a bird hovering above the central group in the *Déjeuner* and a frog at the bottom left. They may simply be realistic details in keeping with a scene out of doors, but familiarity with Manet's significant use of apparently trivial motifs, especially animals, suggests a more important reading (as we shall see later apropos *Olympia*, *A Young Lady*, *Nana*, and Manet's illustrations for 'The Raven'). The bird, frozen in mid-flight, could be a whimsical reference to the term *oiseau de passage* (bird of passage), the designation prostitutes gave their fly-by-night lovers. It also seems appropriate that the bird is a finch. In his witty *Zoologie parisienne* of 1869, Alfred Truqui described the finch as a 'live-wire', but cautioned against confusing it with a 'demonstrator' in a stud farm. Considered in these terms, Manet's creature comments ironically on the distinct lack of companionship among the people below, let alone any sexual misbehaviour. As for the frog (*grenouille*), this term was a popular epithet for prostitutes. Given Manet's fascination with 'la vie moderne', there is little doubt that he was familiar with these niceties of popular language.

Manet's distinctly modern 'Old Master' is a sophisticated mixture of ambiguity, tease, and homage, and these are the reasons why the painting continues to challenge and confound. It should come as no surprise, then, to discover another likely source for its provocative imagery in a commonplace item from popular culture.

Playing cards known as 'cartes à rire' and dating from *c.* 1820 were cards designed to elicit laughter. A 'carte à rire' called *La Partie carrée au clair de la lune* (The Foursome in the Light of the Moon) presents a tantalizing comparison with Manet's own *partie carrée*. (Another 'carte à rire', *Promenade de Longchamp*, shares much in common with Manet's *Music in the Tuileries*). The card, a seven of hearts, shows a group of people in a forest clearing. Their dress and postures incorporate the design of the 'heart' which has the effect of 'flattening' out the image, a feature no

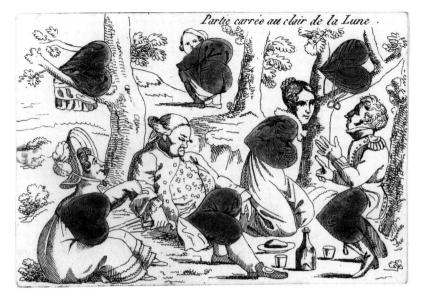

27 Carte à rire, *La Partie carrée au clair de la lune* c. 1815–30

28 Carte à rire, *Promenade de Longchamp* c. 1815–30

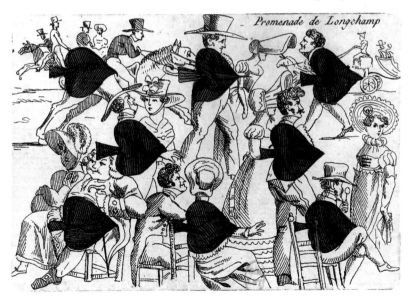

doubt appealing to Manet whose method of constructing a painting regularly called attention to its inherent two-dimensionality. For some of his contemporaries the result was 'an appalling flatness', works which had more in common with the simplified colour woodcuts from Epinal than with serious art.

The woman on the left of *La Partie carrée au claire de la lune* tries to awaken her dozing companion, while the other listens attentively to her gesticulating partner. This foursome, though, is not alone: in the distance, beyond a stream, is the crouched figure of a man.

The more obvious similarity between this image and *Le Déjeuner sur l'herbe* is that they both show Parisians in a woodland setting. A closer inspection, though, reveals more striking parallels. The space between the bather and the foreground group in the painting is ambivalent, but this solitary figure is part of an implied triangle which includes the trio and has as its apex the patch of sky above her head. She is also connected to this group by a diagonal movement beginning with the tree in the right foreground and continuing through the back of the reclining man and

29 Epinal woodcut *Battle of Waterloo* 1835

BATAILLE DE WATERLOO.

the two trees on either side of the water. The playing card has a comparable structure. The lone figure in the background corresponds to the bather in the *Déjeuner*, while the three trees on the right of the card (note especially the angle of the trunk in the immediate foreground) are remarkably like those in the painting.

Further intriguing links now suggest themselves. The basket containing fruit in the *Déjeuner* mimics the straw bonnet of the woman on the left of the card who strikes a pose similar to Victorine's (bent foot, right arm resting on her knee). Whereas Manet's nude turns away from her friend's outstretched hand, in the card the comparative roles are reversed and it is the woman who tries to awaken her sleeping companion. His reclining position is identical to, but the reverse of, Eugène's in the *Déjeuner*, whose tasselled cap echoes the gentleman's wig.

Finally, what are we to make of the fifth figure in *La Partie carrée au claire de la lune*? Given that it is a foursome, he must therefore assume the role of voyeur. But there's a twist. Shown revealing his buttocks, which presumably is the 'moon' of the card's title, he stares at the couples. In the process his gaze falls on us as we, in like manner, observe him. In Manet's *partie carrée*, however, we do not make contact with an unseen witness; rather, it is one of the four dramatis personae, the naked woman, who looks out and acknowledges our presence.

Irreverence abounds in *Le Déjeuner sur l'herbe*, to be sure, but as I have tried to show, it is not simply irreverent. The picture raises questions to do with making art, tradition, popular culture, and sexuality. Yet, as the art historian Linda Nochlin has pointed out, it is inconceivable that such a work could have emerged were it not for the prevailing vogue for *la blague*, what the Goncourt brothers described in their novel *Manette Salomon* (1866) as 'that laughter which jeers at the grandeur, the holiness, the majesty, the poetry of all things.'

Operetta embodied the spirit of *blague* perfectly. Offenbach, whose name is synonymous with this novelty, and whom Manet included in *Music in the Tuileries*, won great acclaim for *Orpheus in the Underworld* (1858) and *La Belle Hélène* (1864). These and other productions turned myth on its head in a titillating display of song, witticism and visual effect. That some operettas had taken as their theme the Judgment of Paris would not have gone unnoticed by Manet, who, as we have seen, alluded to Raimondi's *Judgment of Paris* in the *Déjeuner*. Alby and Commerson's one-act *Le Jugement de Paris* was first performed at the Théâtre de Folies Nouvelles in February 1858, and Hippolyte Lefebvre's *Le Nouveau jugement de Paris*, an operetta described as a 'classical comic study after the antique', opened at the Théâtre du Vaudeville late in 1861.

In its penultimate scene, Paris discloses that he is not a 'shepherd from arcady', but simply a 'lad from Normandy'. He does not award the apple to Venus but instead eats it himself!

Operetta translated myth into caprice in ways similar to *tableaux vivants* or *poses plastiques*. This fashionable parlour game was at the height of its popularity at exactly the same time as Manet was working on *Le Déjeuner sur l'herbe*. Octave Uzzane, looking back at this period from the turn of the century, writes: '... balls, concerts and dancing-parties ... were supplanted ... by the new mania ... for tableaux vivants of the classic order. ... [The] cocodettes of the Second Empire took an almost fiendish delight in the construction of the very primitive draperies necessary to the representation of such scenes as the Judgement of Paris, Jupiter and Leda, Diana and Endymion, and a host of others, highly picturesque, but eminently suggestive.' In one sense, Manet's

LES TABLEAUX PLASTIQUES DANS LE MONDE

FAUST ET MARGUERITE (scène de la séduction).
— Entre nous, je ne le trouve guère séduisant, ce Faust !
— Aussi on ne laisse tourner que cinq minutes, il n'a pas le temps de se retourner !

LE TRIOMPHE D'ESTHER
Après la représentation, Esther s'adressant à un célèbre banquier lui dit:
— Souvenez-vous, baron, que j'ai sauvé le peuple juif; j'espère que vous n'oublierez pas le peuple parisien.

30 Gillot 'Les Tableaux plastiques dans le monde', from *La Vie parisienne* 1 May 1863

31 Manet *Young Woman Reclining in Spanish Costume* 1862

38

Déjeuner sur l'herbe is a *tableau vivant*, although of course its 'Old Master' source remains hidden.

Le Déjeuner sur l'herbe was an ambitious work. It was Manet's largest canvas to date (the second biggest in his entire œuvre), and intended for the Salon of 1863. In the event, the jury rejected it, together with two other paintings and three etchings. Not deterred, Manet, like many other artists who had suffered at the hands of a particularly severe jury, elected to show it in the Salon des Refusés. An initiative of the Emperor Napoleon III, this 'Salon of the Vanquished', as one critic described the Refusés, became an opportunity for 'the public to judge the judges'.

Other works by Manet from this period explore the theme of dressing up, make-believe, artifice. In *Fishing*, discussed earlier, he represented himself and Suzanne Leenhoff in the roles of Rubens and his wife Hélène Fourment. At about the same time, he painted *Young Woman*

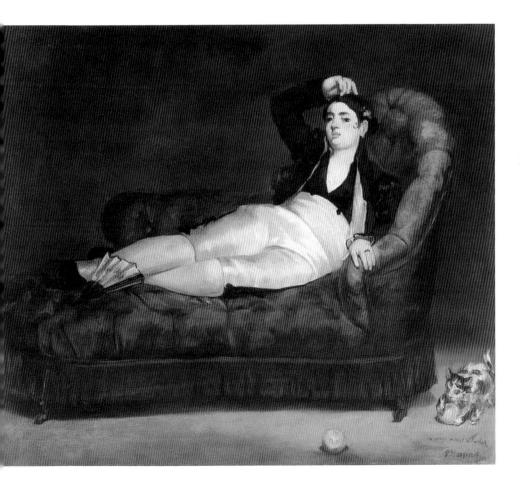

Reclining in Spanish Costume (1862), which he dedicated some years later to his photographer friend, Gaspard-Félix Tournachon, called Nadar (1820–1910). This eccentric depiction of a woman in the costume of a toreador reflected, on the one hand, the current taste for things Spanish, and on the other, the demimondaine's penchant for dressing up in male apparel. These references to 'la vie moderne', as always during Manet's early career, were matched by others to artistic sources – here, unmistakably to Goya's *Naked* and *Dressed Majas*, copies of which were available in

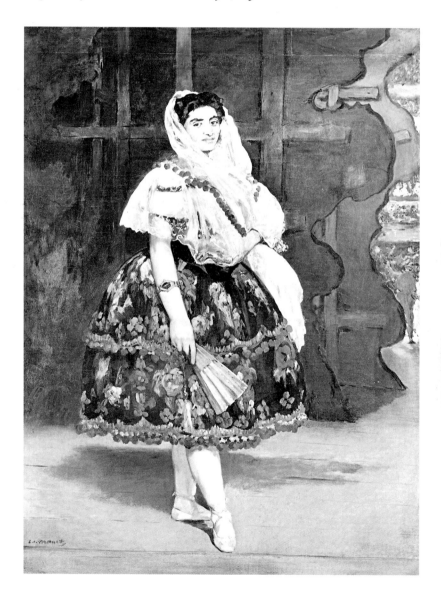

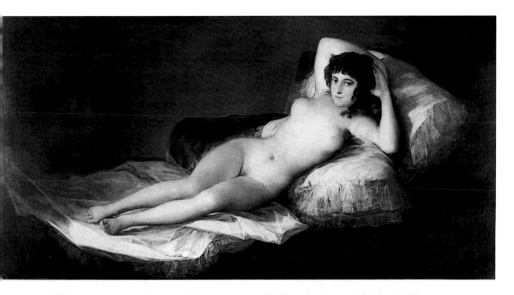

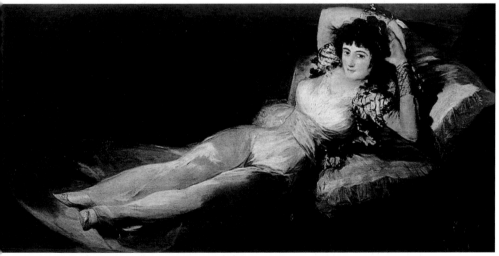

33 Francisco de Goya *Naked Maja c.* 1798–1805

34 Francisco de Goya *Dressed Maja c.* 1798–1805

32 Manet *Lola de Valence* 1862

Paris and which Baudelaire had asked Nadar to photograph. The *Young Woman* may have therefore been indebted to Goya, but it carries Manet's own inimitable stamp. The figure's pose is awkward, self-consciously nonchalant, and her manner smug. The puckered upholstery of the chaise longue is wittily echoed in her heavy, tightly wrapped figure, and a final frivolous note is struck by the inclusion of a cat – simply a grey and white smudge – playing with two orange balls.

Mlle V. in the Costume of an Espada and *Young Man in the Costume of a Majo* (1862) similarly raise questions to do with role-playing and artifice.

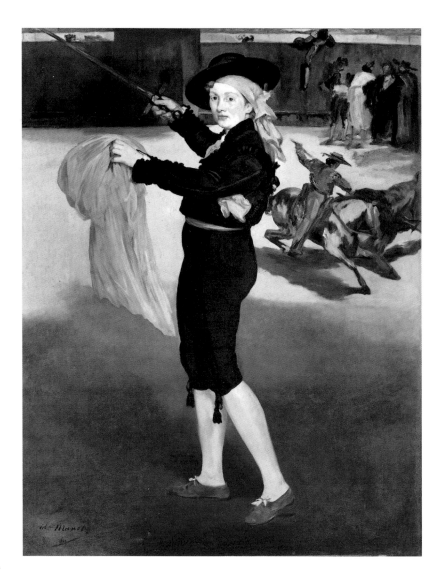

These are obviously models posing in the artist's studio, dressed up in Spanish costume and with striking contrasting attitudes. That both works were hung on either side of *Le Déjeuner sur l'herbe* in the Salon des Refusés, may have prompted inquisitive visitors to make a comparison. If so, they would have discovered that the naked Victorine had suddenly become an Espada (the model is the same), and that one of the bearded men in the *Déjeuner* had turned into a Majo.

So how did the critics and the public respond to Manet's work in 1863, especially to *Le Déjeuner sur l'herbe*? Time and time again we read that the 19

35 Manet *Mlle V.
in the Costume of an
Espada* 1862

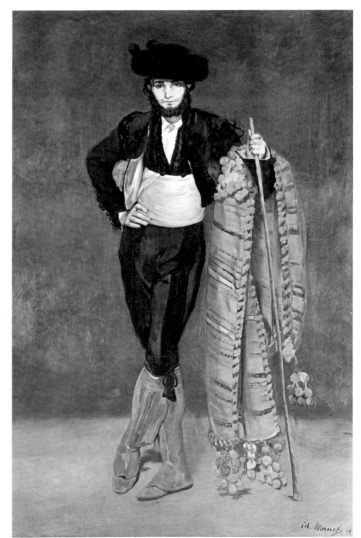

36 Manet *Young Man
in the Costume of a
Majo* 1862

37 Cariacture by Gillot of 'Salon de 1863: Les Refusés', from *La Vie parisienne* 11 July 1863

painting scandalized Paris, with some accounts saying that Napoleon III visited the 'centre of revolutionaries' and declared the picture an affront to modesty. More recently, Linda Nochlin has written that the picture must have constituted as provocative a gesture as that of Marcel Duchamp when he painted a moustache on the *Mona Lisa* in 1919.

Despite the initial excitement surrounding its opening, the Salon des Refusés received relatively little coverage in the press. *Le Moniteur universel*, the official organ of the government, failed to mention it, while important publications such as *Le Temps*, *L'Opinion nationale* and *La Revue des deux mondes* gave an overview without singling out artists by name. Cartoonists and humorist writers, usually quick to register their response to the most talked-about work in the Salon, made little mention of the Refusés. For those critics who did review the exhibition, their attention focused on Manet's three paintings, and *Symphony in White No. 1, The White Girl* by the American artist James McNeill Whistler (1834–1903). 38 'In the middle of the *refusés*', wrote D'Arpentigny, 'two painters in particular display enormous qualities of unbelievable boldness and temperament: they are MM. Manet and Whistler.'

The catalogue and supplement of the Salon des Refusés list a total of 781 works, although one commentator referred to a number closer to 1500. That reviewers singled out Manet's paintings for relatively lengthy discussion must itself have pleased him. Although critics were quick to point out how the public scoffed at the exhibition, we do not know to what extent their jeers were aimed at the *Déjeuner*. Then again, there is a difference between dismissive laughter and a knowing chuckle, the latter not inappropriate in front of Manet's canvas. What we can say with some degree of certainty, however, is that critics were not unanimous in declaring the juxtaposition of a naked woman with clothed men singularly offensive.

Some reviewers faulted Manet's technique, especially the handling of relief and his 'shocking' colours, while others, who thought the painting 'vulgar', conceded that it had admirable qualities and succeeded as a good 'sketch'. Capitaine Pompilius in *Le Petit journal* felt unable to call Manet an innovator because Goya and Courbet had preceded him. The 'unfinished' character of the *Déjeuner* disappointed Pompilius, but he believed that Manet would become a master one day as he possessed all the necessary qualities. The influential critic of *Le Constitutionnel*, Ernest Chesneau, found nothing to redeem the painting, but his concluding remarks suggested that Manet was not wholly without talent: 'At this point I will not pronounce on the future of the artist. It all depends on him.'

That *Le Déjeuner sur l'herbe* brought Manet notoriety is clear, but not, as history would have it, as a figure of disdain and ridicule. The critic Jules Claretie's observations, made on the occasion of the 1865 Salon, are a far more accurate assessment: 'Once upon a time there was a young man called Manet who, one fine day, bravely exhibited among the rejected paintings a nude woman lunching with some young men dressed in sack suits and capped with Spanish sombreros [*sic*]. Many cried shame, some smiled, others applauded, all noted the name of the audacious fellow who had something to say and who promised much more.'

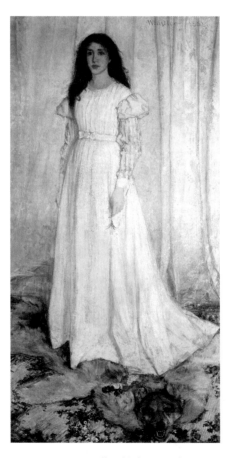

38 James McNeill Whistler *Symphony in White No. 1, The White Girl* 1862

'A Parcel of Nude Flesh or a Bundle of Laundry'

If *Le Déjeuner sur l'herbe* has won a special place in the annals of modern art, so has *Olympia*, also painted in 1863 but not shown at the Salon until two years later. The uproar it caused on that occasion is legendary: some 70 critics discussed the picture, almost all in the most disparaging and vitriolic ways. *Olympia*, without doubt, was a *succès du scandale*. So much so, that during the last few days of the Salon it was re-hung in a less favourable position. Jules Claretie wrote in *Le Figaro*: 'You had seen Manet's *Venus with a Cat* (this critic's name for *Olympia*), flaunting her wan nudity on the stairs. Public censure chased her from that place of honour. One found the wretched woman again, when one did find her, at a height where even the worst daubs had never been hung, above the huge door of the last room, where you scarcely knew whether you were looking at a parcel of nude flesh or a bundle of laundry.' 43

Manet's painting of this 'wretched woman', compared with portrayals of the female nude by Salon favourites such as Alexandre Cabanel, Paul Baudry, Félix-Henri Giacomotti and Adolphe Bougureau, shows vividly the extent to which it parted company with convention. In place of classical myth and allegory, pretexts for titillating yet sanitized nudes, 40 41

39 Paul Baudry *The Pearl and the Wave* 1862

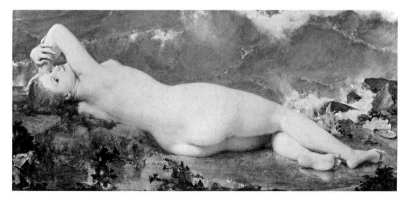

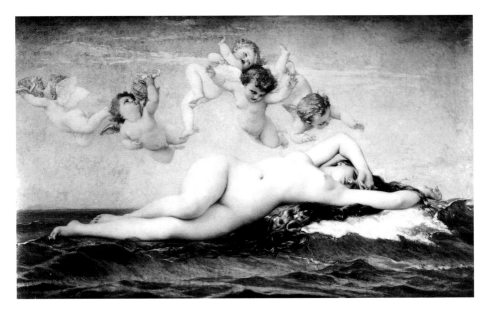

40 Alexandre Cabanel
Birth of Venus 1863

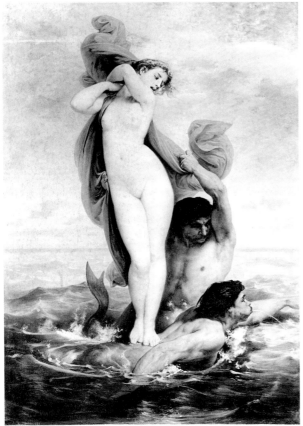

41 Félix-Henri Giacomotti
The Abduction of Amymone 1865

Olympia evokes a sense of contemporaniety at once confrontational yet removed.

The model for *Olympia* was Victorine Meurent (1844–1928), who had already posed for *Mlle V. in the Costume of an Espada*, *Le Déjeuner sur l'herbe* and *The Street Singer* (1862). An artist herself (during Manet's lifetime she exhibited twice at the Salon, in 1876 and again in 1879), Victorine would later appear in *A Young Woman* (*Young Lady in 1866*), *Woman with a Guitar* and *The Railroad*. Her relationship with the artist was evidently a close one, as a letter she wrote to Manet's wife six years after his death reveals: 'No doubt you know that I posed for a great many of his paintings, notably for *Olympia*, his masterpiece. M. Manet took a lot of interest in me and often said that if he sold his paintings he would reserve some reward for me. ... Certainly I had decided never to bother you and remind you of that promise, but misfortune has befallen me: I can no longer model, I have to take care of my old mother all alone ... and on top of all this I had an accident and injured my right hand. ... It is this

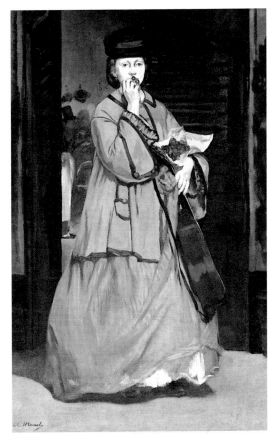

42 Manet *The Street Singer* 1862

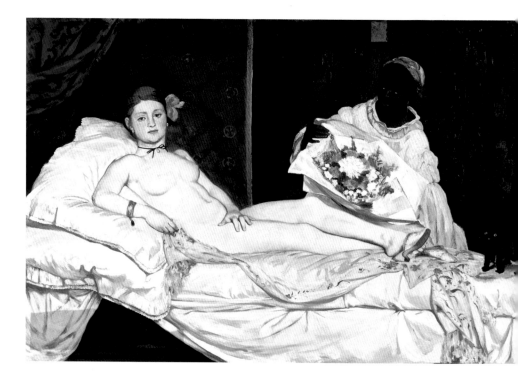

desperate situation, Madame, which prompts me to remind you of M. Manet's kind promise.'

Art historians often single out *Olympia* as the most Baudelairean of all Manet's paintings. This is understandable, as the woman's expression, the black cat, the Negress, and the bouquet of flowers, all find their echoes in Baudelaire's poetry, especially *Les Fleurs du mal*, the subject of a famous obscenity trial in 1857. One may cite, for example, this extract from *Les Bijoux* (Jewels):

La très-chère était nue, et, connaissant mon coeur, / Elle n'avait gardé que ses bijoux sonores, / Dont le riche attirail lui donnait l'air vainqueur / Qu'ont dans leurs jours heureux les esclaves des Mores. ... Les yeux fixés sur moi, comme un tigre dompté, / D'un air vague et rêveur elle essayait des poses.

(The beloved was naked, and, knowing my heart, / She had kept on only her sonorous jewels, / Whose finery lent her the conquering air / Of Moorish slaves on happy days. ... Staring at me, like a tamed tiger, / With a vague and dreamy expression, / She tried various positions.)

43 Manet
Olympia 1863

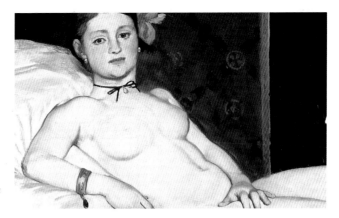

44–46 Details of *Olympia*
1863

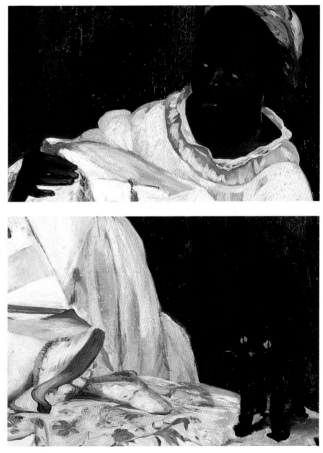

Three modern variations on
the Olympia theme

47 Caroline Coon
Mr Olympia 1983

48 Annette Bezor
Odelympia 1988

49 John O'Reilly
*Preparing to Photograph
Olympia* 1984

Or this passage from *La Géante* (Giantess):

Du temps que le Nature en sa verve puissante/ Concevait chaque jour des enfants monstrueux,/ J'eusse aimé vivre auprès d'une jeune géante,/ Comme aux pieds d'une reine un chat voluptueux.

(When Nature in her vital power/ Each day conceived monstrous children,/ I would have loved to live beside a young giantess,/ Like a voluptuous cat at the feet of a queen.)

That such evocations of woman bring to mind *Olympia* is true, but Manet's painting, as we shall see, raises other very different issues.

One direct outcome of Manet's close association with Baudelaire was his portrait of the poet's Creole mistress, Jeanne Duval. Executed in his studio on the rue Guyot in 1862, this candid depiction of a reclining woman anticipates the equally forthright Olympia. Duval, partly paralysed since 1859 and in poor health when Manet painted her, sits on a

50 Manet *Portrait of Jeanne Duval* 1862

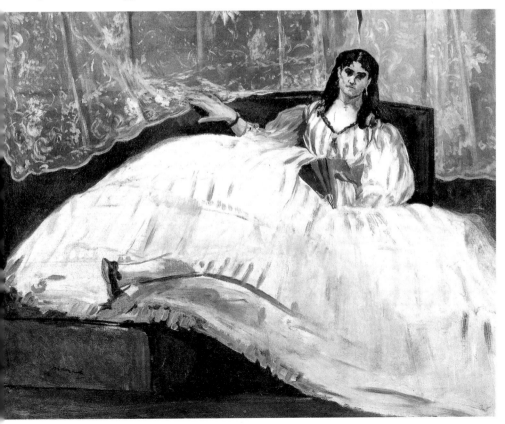

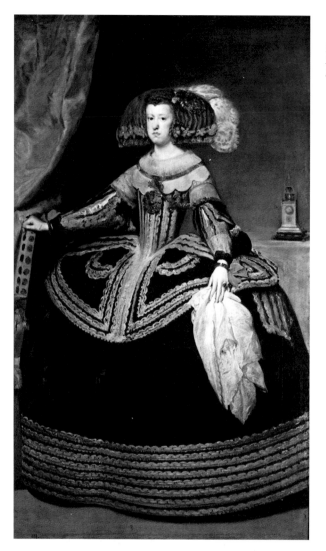

51 Diego Velazquez
Portrait of Queen Mariana of Spain c .1635

52 Titian
Venus of Urbino 1538

large green sofa. Her body is swamped by a 'vast, billowing skirt of *café au lait*' (Jacques Emile-Blanche, 1924), stretching the entire length of the canvas and flattening out the picture space. She balances herself with her right hand and looks determinedly out, and down, at the viewer. This extraordinary image of a stricken woman emphasizes her dignity and formidable presence in ways which recall Velazquez's paintings of court dwarfs. The Spanish artist's portraits of Queen Mariana and the Infanta

Maria Teresa also invite comparison with Manet's painting. I am thinking particularly of the voluminous dresses that engulf Velazquez's figures and dominate much of the canvas, in ways similar to the portrait of Duval. Manet admired Spanish art, especially Velazquez (and critics often commented upon their affinities), but his first and only visit to Spain was in 1865. Not one of the works mentioned above was in the Louvre's collection, but it is possible that he may have seen painted copies or prints in Paris.

The other great Spanish painter to have impressed Manet was, of course, Goya. As we have already seen, the *Young Woman Reclining in Spanish Costume* looked teasingly at Goya's *Dressed* and *Naked* Majas. While the latter work may also have been a precedent for *Olympia*, Manet's nude had a more specific pictorial source in Titian's *Venus of Urbino*, copied by him on a visit to Italy in 1853. Although their similarities are obvious, it is the changes Manet makes that significantly locate his 'Venus' in an altogether different context.

In the Titian, our eye travels from the sumptuous bed on which the woman lies to the two maids in the middle distance and finally to the potted shrub on the widow sill and the sky beyond. This spatial progression gives way in *Olympia* to a shallow space dominated by the nude and the fixity of her gaze. Unlike Titian's figure who looks alluringly out at

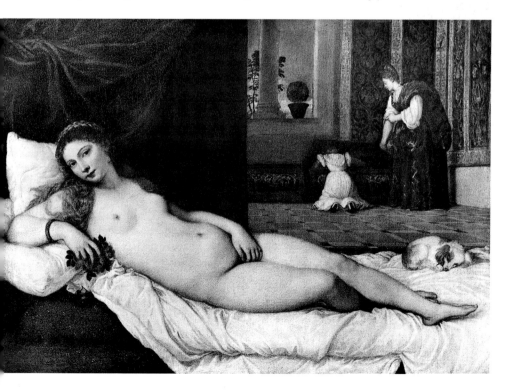

the spectator with whom she makes direct eye contact, Olympia looks down slightly, her expression a mixture of introspection and aloofness. She places one hand firmly over her crotch in contrast to Venus who curls her fingers and appears to caress herself. This gesture parallels the way the spectator is enticed into exploring the soft contours of her finely modulated body, whereas the angularity of Olympia's physique prevents this. Titian's picture is all about the fantasy of female flesh, seductively laid out and available. Manet's nude alludes to this tradition, but subverts it in striking ways. This is perhaps why only two critics in 1865 had anything to say about *Olympia's* 'dependence' on the *Venus of Urbino*, while a third, Emile Cardon, writing in *Le Figaro-Programme*, actually mentioned the paintings in the same breath but failed to make any connection. The two critics who did discuss their relationship paid special attention to Olympia's hand: 'flexed in a sort of shameless contraction', wrote Amédée Cantaloube in *Le Grand journal*; 'shamelessly flexed', noted Pierrot in *Les Tablettes de Pierrot*. The irony, needless to say, is that these descriptions are far better suited to Titian's own Venus.

So what is the subject of *Olympia*? It seems clear that it is a painting of a prostitute; and this much, certainly, critics recognized in 1865. But what type of prostitute was another matter. The thousands of words devoted to Manet's picture, in addition to the obligatory caricatures, all focused on this question in one way or an other. 'What is this Odalisque with a yellow stomach,' wrote Jules Claretie in *L'Artiste*, 'a base model picked up I know not where, who represents Olympia? Olympia? What Olympia? A courtesan no doubt.' Although the term 'courtesan' was one of those ambiguous descriptions which could embrace a range of meanings, as T.J. Clark has pointed out in his influential study of *Olympia*, it by and large denoted a powerful and wealthy *femme fatale*. At the opposite end of the scale to the courtesan was the low-class streetwalker, and for many commentators in 1865, Olympia was exactly that. Thus Geronte (the pseudonym of Victor Fournel), the critic of *La Gazette de France*, saw fit to refer to her as 'this Olympia from the rue Mouffetard'. And the rue Mouffetard was definitely not a salubrious locale: 'this squalid street, stinking in summer, muddy in winter and filthy throughout the year' was how the writer Charles Virmaître described it in 1868. So prostitution, no matter how you looked at it, raised questions to do with class, on the one hand, and public and private behaviour, on the other. These issues, it would seem, were at the heart of the *Olympia* scandal.

Two cartoons sum this up well. One by Bertall (the pseudonym of Charles-Albert d'Arnoux) appeared in *Le Journal amusant* on 27 May 1865, and the other, by G. Randon, two years later in the same magazine,

'This picture by M. Manet is the bouquet of the exhibition. ...
The great colourist has chosen the moment when the lady is about to take a
bath, something which she certainly seems to need.'

53 Caricature by Bertall of Manet's *Olympia*, from *Le Journal amusant* 27 May 1865

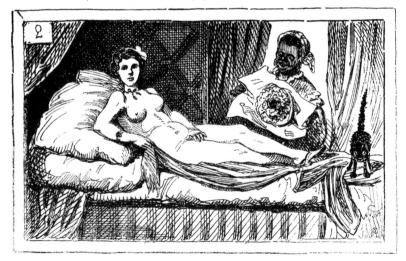

'Madame.' 'What is it?' 'D'ere's a man dat wants to see you ...
on business.' 'Show him in.'
(Apparently that's the way things are done among certain 'ladies'.)

54 Caricature by G. Randon of Manet's *Olympia*, from *Le Journal amusant*
29 June 1867

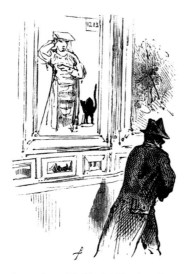

Conclusion: M. Manet cleans up after his cat, sends the bouquet to Teresa and the coal-merchant's wife to La Batignolles.

When the guards aren't looking, M. Manet's cat jumps out of her own picture and rubs herself against Landelle's *Italian Lady*. Poor thing, one can understand that she has to do something to make up for her bad luck.

on 29 June 1867. The occasion then was Manet's private exhibition on the Place de l'Alma, a subject I shall return to in the following chapter.

Bertall places Olympia in a grubby interior: the bed linen is unkempt; the mattress is shabby; and there is a chamber pot under the bed. This is not the boudoir of a prosperous courtesan, but rather the run-down dwelling of a poor prostitute. Olympia's body is grotesque: she appears to be wearing a body stocking and a clown's mask; her right arm is ungainly; her feet, ridiculously large. This image turns the working-class prostitute into a figure of ridicule, while at the same time it renders her female attributes ambiguous. In contrast, Randon's cartoon portrays Olympia as distinctly regal, a *Venus courtisane*, if you like.

But even in this seemingly innocuous image, where neither Olympia nor the Negress are subject to any outlandish distortions, Randon turns the black cat into an object of ridicule. This animal, in fact, was the target of unusual abuse and sarcasm in 1865. It became synonymous with Manet's name, and in future years featured prominently in a variety of written and visual contexts, even appearing alongside an illustration of 'the Realist' Courbet in Louis Leroy's little book *Artistes et rapins*. One of the few critics who chose to review Manet's private exhibition in 1867 would say: 'There is something more to Manet than the black cat which everybody knows.'

M. Manet's cat gets hot chestnuts out of the fire
for M. Verlat.

55–57 Caricatures of Manet's black
cat, 1865

58 Illustration by Cook: Courbet as
'Le Realiste', from Louis Leroy *Artistes
et rapins* 1868

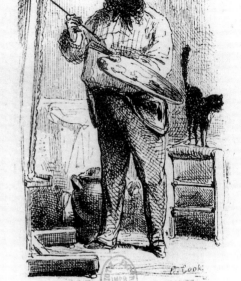

De l'épaisseur, de la vulgarité et une noble indépendance
à l'endroit des convenances. (P. 59.)

How do we account for the animal's notoriety? Olympia's *chat noir*, it
must be said, cuts a very different figure from the dog curled up and fast
asleep at the foot of Titian's Venus. On guard, tail in the air, and staring at
the viewer, it is the very antithesis of Olympia's generally relaxed pose,
whereas the dog in the Titian, signifying fidelity, echoes comfortably the
soft contours of his nude. That Manet included a cat, and portrayed it the
way he did, was no simple whim. By the 1860s the creature had become
intimately linked in the popular imagination with a promiscuous and
potentially dangerous sexuality, evidenced in its most benign form by the
use of the word 'chatte' to describe the female genitals. But the term
could also designate a 'cocotte', one of the many euphemisms for a regis-
tered prostitute. These and other associations have recently been explored
in a book on petkeeping in nineteenth-century Paris by Kathleen Kete,
provocatively entitled *The Beast in the Boudoir*. In it she quotes Alphonse

59 Jean-Auguste-Dominique Ingres *Odalisque with Slave* 1842

Toussenel who, in 1855, wrote explicitly about the relationship between cats and prostitution: 'An animal so keen on maintaining her appearance, so silky, so shiny, so eager for caresses, so ardent and responsive, so graceful and supple ... an animal who makes the night her day, and who shocks decent people with the noise of her orgies, can only have one analogy in this world, and that analogy is one of the feminine kind.' For other commentators, however, the cat's gender was unimportant: both the female and the male were considered to have voracious sexual appetites.

These beliefs resonate in the cartoons of *Olympia* where the animal's rampant sexuality is regularly emphasized. But it doesn't stop there. In both Randon's and Bertall's images the animal's wide-eyed expression and grimace is related to that of the Negress, echoing perhaps the commonly held view that black women were more sexually potent than white women. Bertall, especially, turns the cat and maid into frenzied partners in some erotic sub-plot. His are vicious and racist exaggerations

53

which have nothing to do with Manet's picture, where the black woman looks intently, but with some reserve, at the nude, while the startled cat confronts the spectator. Manet, as we know, found the subjugation of black people abhorrent. In *Olympia*, however, he still keeps to the well-established tradition of showing a black maid waiting upon a white woman, but the relationship, as Françoise Cachin has pointed out, is more that of 'warden of purchased favours' than harem slave.

The attendant and the bouquet of flowers she holds were mentioned in the five lines of verse inserted underneath the painting's title in the Salon catalogue. Written in April 1864 by the poet and critic Zacharie Astruc, they formed the first stanza of his lengthy poem 'Olympia, La Fille des iles' which he dedicated to 'my dear friend, Edouard Manet' (the manuscript of the poem is in the Bibliothèque d'Art et d'Archéologie, Paris). Astruc had met Manet in the mid-1850s, and the two remained close friends until the artist's death. It was Astruc who had written praising *Le Déjeuner sur l'herbe* in 1863, and it was he who would carefully plan Manet's trip to Spain a few months after the *Olympia* debacle.

Astruc's stanza reads:

Quand, lasse de songer, Olympia s'éveille,
Le printemps entre au bras du doux messager noir;
C'est l'esclave, à la nuit amoureuse pareille,
Qui vient fleurent le jour délicieux à voir:
L'auguste jeune fille en qui la flamme veille.

(When, tired of dreaming, Olympia awakens,
Springtime enters on the arms of the sweet black messenger;
It is the slave, who like the amorous night,
Comes to adorn with flowers the new day delightful to behold:
The august young woman in whom ardour is ever wakeful.)

With one or two exceptions, art historians have persistently dismissed these verses as laboured, pretentious and ultimately irrelevant; in short, a serious miscalculation on Manet's part to have them inserted in the Salon catalogue. That they are not exactly arresting is true, although a reading of the entire poem shows how Astruc had looked closely at Olympia's features. For example, he describes her as '*Cette indolence reine*' (this queenly indolence); refers to her '*formes graciles*' (slender body); and asks: '*quels mirages vermeils fixent tes yeux tranquilles*'? (what luminous mirages capture your peaceful gaze?) Regardless of what we may make of the poem, however, the fact is that it appealed to Manet. Indeed, as a gesture

of thanks to Astruc, he would go on to paint his portrait in 1866 in ways which clearly identified it with *Olympia* and that picture's source in Titian's *Venus of Urbino*. The poet is shown seated in front of what appears to be a screen with a gold border which resembles the one in *Olympia*. The draped curtain at the top right corner of the portrait also brings to mind the same motif in Manet's earlier painting. Further emphasizing their relationship is the view to the left of Astruc, where the back of the woman and the strongly defined verticals of the hanging curtain find their equivalents in the kneeling maid and the 'panels' of dark and light tones in Titian's picture.

Reaction to Astruc's verses in 1865 was a mixture of frustration and anger. Indeed, in some of the extant catalogues the stanza does not even appear, suggesting that the Salon authorities were of two minds about publishing them. What irritated the critic Victor de Jankovitz was the disparity between 'the august young woman' of the poem and Olympia: 'I am reminded of the fairground stalls in which a distinguished gentleman promises in elegant language, extraordinary, unique, incomparable marvels, and, as soon as you have entered, you are shown a two-headed nag one of whose heads is made of cardboard.' Fournel took exception to Olympia's 'bouquet of a questionable allegory', while Postwer suggested that there were 'two "black messengers"': a cat which has unfortunately been flattened between two railway sleepers; a Negress who has nothing about her that recalls "the amorous night", unless it be a bouquet bought at the florist's on the corner, and paid for by Monsieur Arthur, which tells me a great deal about the painting. Arthur is certainly in the antechamber waiting.' These and other critics were right: the verses did relate to the picture but in strongly ironic ways. Olympia was certainly no 'august young woman', and the flowers, presumably a gift of a client – Postwer's 'Monsieur Arthur' – had little to do with 'Springtime'. Furthermore, and Manet no doubt recognized this, the poem's references to sleep and nocturnal activities – 'the amorous night' – would have evoked thoughts of clandestine sex. Toussenel's writings, quoted previously in connection with cats and prostitution, once more shed light on this matter. Talking about the female cat, he observed: 'Lazy and frivolous and spending entire days in contemplation and sleep, while pretending to be hunting mice … incapable of the least effort when it comes to anything repugnant, but indefatigable when it is a matter of pleasure, of play, of sex, lover of the night.'

61 *Olympia* was not Manet's only work to create a furore in 1865. His *Jesus Mocked by the Soldiers* (1865), hung in the same room, also met with a hostile reception. This provocative pairing of a religious subject and a

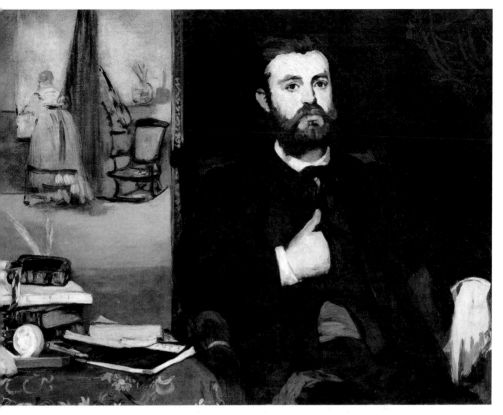

60 Manet *Portrait of Zacharie Astruc* 1866

picture of a Parisian prostitute was not lost on critics. For many, Manet's
Christ, like his naked Olympia, was all too real. Shown in the presence of
contemporary personages, Christ appears forlorn, almost to the point of
exaggeration, and his arms hang limply to one side. On his left stands a
powerfully built soldier, eyes wide open and mouth ajar, who stares
vacantly out at the spectator. Flesh and muscularity seem as much
Manet's concern as the religious dimension of the work.

The painting 'beggars description', commented an exasperated
Théophile Gautier *fils*, in *Le Monde illustré*. Gautier *père*, writing in *Le
Moniteur universel*, was equally outraged: 'With some repugnance I come
to see the peculiar paintings by Manet … the artist seems to have
taken pleasure in bringing together ignoble, low and horrible types
[in *Jesus Mocked by the Soldiers*] … *Olympia* can be understood from no
point of view, even if you take it for what it is, a puny model

63

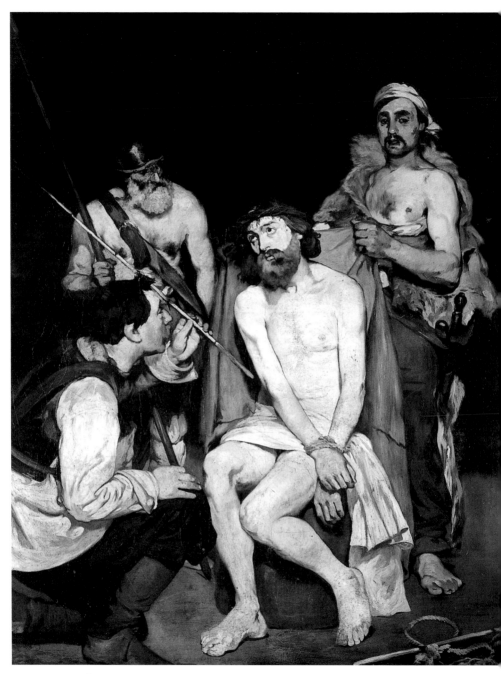

stretched out on a sheet. The colour of the flesh is dirty, the modelling non-existent.'

Dirty flesh? As T.J. Clark has pointed out, a common view among critics was that Olympia was unwashed. 'Her body is filthy', observed Francis Aubert. For Bertall, in a cartoon in *L'Illustration*, she was 'this beautiful coal lady whose modest contours have never been outraged by water, that banal liquid.' Bertall's other caricature, discussed earlier, pursued exactly the same theme. Its caption says: 'This painting is the bouquet of the exhibition. M. Courbet has been overshadowed by the celebrated black cat. The moment chosen by the great colourist is that one where this lady is about to take a bath, something which she certainly seems to need.' So this explains the steam clouds in the background of the cartoon. Or perhaps these represent the foul smell rising from Olympia's absurdly large feet! Bertall's exaggeration of this part of her anatomy, incidentally, may be a sly allusion to the ungainly feet of Christ in *Jesus Mocked by the Soldiers*. Bertall dubbed that painting 'The Foot Baths', and portrayed Jesus as a rag-and-bone man surrounded by 'four employees of the grand sewer collector'.

53

61 Manet
Jesus Mocked by the Soldiers
1865

62 Caricature by Bertall
of Manet's
Jesus Mocked by the Soldiers,
from *Le Journal amusant*
27 May 1865

LE BAIN DE PIEDS, par M. MANET.
Quatre employés du grand égout collecteur se proposent de faire prendre un bain de pieds à un vieux chiffonnier de leurs amis qui n'en avait jamais pris. — Étonnement du chiffonnier.

CHAMPFLEURY — par GILL

63 Caricature by Gill of Champfleury, cover of *L'Eclipse* 29 March 1868

In 1868, three years after the *Olympia* scandal, dirt still clung to Manet's name. On 29 March a caricature by Gill of the writer and critic Champfleury appeared on the cover of *L'Eclipse*. It shows him with his feet in a bowl (or is it a chamber pot?) of water on which is inscribed the word 'Réalisme'. He exposes one of his feet which is being stared at, or licked, it's uncertain, by a cat, an unambiguous reference to the *chat noir* at the feet of Olympia. Champfleury, as we have discussed in Chapter One, was a well-known champion of Realism. Gill's cartoon suggests in no uncertain terms that Realism – and, by implication, Manet – should clean itself up.

66

Manet, Zola and 'Le Jugement Public'

Soon after the Salon of 1865 opened Manet wrote to Baudelaire, who was then in Brussels, expressing deep unease over the hostile criticism levelled at *Olympia* and *Jesus Mocked by the Soldiers*: 'Abuse is raining down on me like hail, I have never known anything like it before. ... All this howling is tormenting, and clearly someone must be in the wrong.' This soul-searching letter is one of the rare occasions Manet writes directly about his work and its reception. His letter is undated, but Baudelaire's reply carries the date 11 May; its wording indicates that he had written to Manet on the same day he received his letter by way of a certain M. Chorner, in other words, on the morning of 11 May: 'I thank you for the good letter which Chorner brought me this morning. ... So I must speak to you of yourself, I must try to show you what you are worth. What you demand is really stupid. *They make fun of you; the jokes aggravate you; no one knows how to do you justice, etc., etc.* ... Do you think you are the first man put in this predicament? Are you a greater genius than Chateaubriand or Wagner? Yet they were certainly made fun of. They didn't die of it. And not to give you too much cause for pride, I will tell you that these men are examples, each in his own field and in a very rich world; and that you, *you are only the first in the decrepitude of your art*. I hope you won't be angry with me for treating you so unceremoniously. You are aware of my friendship for you.'

The latest date Manet could have composed his letter was 10 May. The Salon opened on the first, which means that he put pen to paper sometime between then and the tenth. Only after 10 May, however, were the majority of reviews that mentioned Manet's name published. One important exception, though, was Gautier *fils*' article in *Le Monde illustré* on 6 May. He was at a loss for words to describe *Jesus Mocked by the Soldiers*, but conceded that 'In *Olympia* Manet seems to have made some concessions to public taste. In spite of his prejudices one sees pieces which demand no more than to be thought of as good.' Admittedly this evaluation would not have entirely pleased Manet, but at least Gautier *fils* had found some admirable qualities in *Olympia*.

Manet's anxiety as revealed in his letter to Baudelaire, 'All that howling

is tormenting, and clearly someone must be in the wrong', was evidently not the result of a bad press. The only other source was public reaction, witnessed, no doubt, first hand at the Salon. Manet's sensitivity to public opinion, his desire for popular recognition, was an integral part of his make-up and often commented upon by his contemporaries. The Irish writer George Moore remembered Degas telling him that Manet had said: 'Degas, you are above the level of the sea, but for my part, if I get into an omnibus and someone doesn't say "M. Manet, how are you, where are you going?" I am disappointed, for I know then that I am not famous.' Madame Morisot, the mother of Manet's close friend and sister-in-law, Berthe Morisot (1841–95), wrote to another daughter saying: 'Manet seems mad. He expects success, and then suddenly he is over-come by doubts which make him moody.' Berthe Morisot herself described how she had found Manet in the Salon, 'his hat over his eyes,

64 Manet
Portrait of George Moore 1879

looking bewildered; he begged me to look at his painting (*The Balcony*) since he did not dare himself. ... He laughed uneasily, declaring at one and the same time that his painting was very bad and that it would be very successful.'

This need for popular approbation is most tellingly evidenced by the events leading up to Manet's private show of 1867, a project he undertook to 'settle the question with the public'. In the planning of this exhibition, the 26-year-old art critic, Emile Zola, was to play a decisive role.

They had first met early in 1866 when Zola, accompanied by the painter Antoine Guillement, had visited Manet's studio on the rue Guyot. There he saw among a number of early works the two new canvases rejected by the Salon, *The Fifer* (1866) and *The Tragic Actor* (1865). 66, 67 Both these paintings were indebted to Velazquez, especially his portrait of the court jester, *Pablillos de Valladolid*, which Manet had seen on his recent

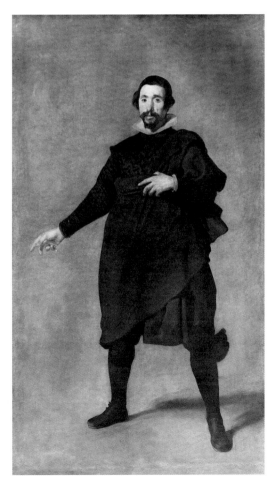

65 Diego Velazquez
Pablillos de Valladolid 1632-34

66 Manet *The Fifer* 1866

67 Manet *The Tragic Actor* 1865

visit to Spain. Writing to Fantin-Latour from Madrid on 3 September 1865, he described the Velazquez as, 'The most astonishing example in this splendid œuvre, and perhaps the most astonishing piece of painting ever done. … The background vanishes, and atmosphere envelops the good fellow, a vital presence dressed in black.' While Velazquez's influence is pronounced in Manet's two canvases, there are also stylistic similarities between the seemingly 'flat' fifer and the simplified designs found in Japanese prints.

We do not know what words passed between Manet and Zola during the critic's visit, but evidently impressed by what he had seen, Zola soon took up the artist's cause in the pages of *L'Evénement*, a weekly publication he wrote for under the pseudonym of 'Claude'.

On 7 May 1866 Zola's first article on Manet appeared. In it he wrote:

It appears that I am the first to praise Manet without reservation. This is because I care little for all those boudoir paintings, those coloured images, those miserable canvases wherein I find nothing alive. … I am so sure that Manet will be one of the masters of tomorrow that I should believe I had made a good bargain, had I the money, in buying all his canvases today. In 50 years they will sell for fifteen or twenty times more, and then certain 4,000 franc paintings won't be worth 40 francs. It is not even necessary to have very much intelligence to prophesy such things.

On the same day that Zola's article was published, Manet wrote to him expressing his gratitude: 'I do not know where to find you in order to greet you and tell you how happy I am to be defended by a man of your talent. What a fine article! A thousand thanks.'

A revised and expanded version of Zola's article came out on 1 January 1867, in the *Revue du XIXe siècle*, under the title, 'A new style in painting: M. Edouard Manet'. Zola divided his study into three sections: 'The Man and the Artist', 'The Work', and 'The Public'. In the first he set about salvaging Manet's personality and demeanour from those who had insisted on turning him into a 'bohemian, a rascal, a ridiculous bogeyman'. In reality, Zola wrote, Manet had a 'distinguished gait', an 'attractive appearance', and took 'secret delights in the fragrant, glowing refinements of evening parties'.

Zola was not the first to emphasize these characteristics. Some one and a half years earlier, on 15 May 1865, the critic Francis Aubert had written in *Le Pays* that Manet was 'a man of the world (not in the least dishevelled), extremely natural and straightforward, in no way influenced by frenzied artistic doctrines, a modest and sincere worker, a most intelligent

appreciator of his colleagues, in short, a serious artist.' Aubert, like Zola, was careful to separate Manet's art from his persona as an elegant boulevardier. In this respect, he was simply reflecting the prevailing assumption, discussed in Chapter One, equating Realism with bohemian conduct and appearance. But Aubert did not stop at Manet's urbanity; he insisted upon the artist's uncomplicated make-up, describing him as 'extremely natural and straightforward'. Zola picked this up in 1867 and embellished it, declaring that Manet knew 'neither how to sing nor to philosophise. He knows how to paint, and that is all.'

Although these views would hardly have pleased Manet, who was anything but an ingénu, he was shrewd enough to keep any reservations to himself. On 2 January, the day after Zola's study came out in the *Revue du XIXe siècle*, he wrote to thank the critic and to inform him of his plans to hold a private exhibition:

> My dear Zola, what a famous New Year's present you've given me in your remarkable article, which is very gratifying. It comes at a good time, for they have judged me unworthy to profit, as have so many others, from the advantage of the preferred list. So, as I expect nothing good from my judges, I will take care not to send them any of my paintings. ...
>
> I have decided to hold a private show. I have at least forty-odd pictures to exhibit, and have already been offered sites in very good locations near the Champ de Mars. I'm going to stake the lot, and backed by men like yourself, I am hopeful of success.

In 1867 Paris was host to an Exposition Universelle. Manet's mention of 'the preferred list' in his letter to Zola refers to the convoluted procedure for submitting works to this prestigious event. Artists were required to have presented a written and signed declaration of paintings they wished to exhibit by 15 December 1866. Works of 'unquestioned renown' would then be selected from these lists, and artists notified by 1 January 1867. In the absence of an official response by that date (coincidentally, the day on which Zola's article came out in the *Revue du XIXe siècle*), Manet chose not to pursue the matter. As he tells Zola, he only expected 'one or two' paintings to be accepted, 'and the rest, as far as the public is concerned, I might as well throw to the dogs'.

Manet not only withdrew from the Exposition Universelle, but he also decided against sending work to the Salon. He would not have forgotten, of course, the jury's rejection of *The Fifer* and *The Tragic Actor* in 1866; the likelihood of a more sympathetic judgment, just one year later, he might have concluded, was slight. At the same time, he probably realized

EXPOSITION UNIVERSELLE DE 1867
A PARIS.

CATALOGUE OFFICIEL PUBLIÉ PAR LA COMMISSION IMPÉRIALE.

E. DENTU, Éditeur de la Commission impériale.

Doit *Monsieur Manet 17 rue St Petersbourg*

Pour insertions dans la partie des renseignements du Catalogue officiel.

huit Lignes à 15 francs (Catalogue général) *120*

Id. à 8 id. (Groupes)

Reçu de *Monsieur Manet*

la somme de *Cent vingt francs*

pour la première partie de ses insertions, payable sur le vu de l'épreuve ci-annexée, en vertu de son traité en date du

Paris, le *26 Mars 1867*

68 Manet's signed application to place an advert in the 1867 Exposition
Universelle catalogue

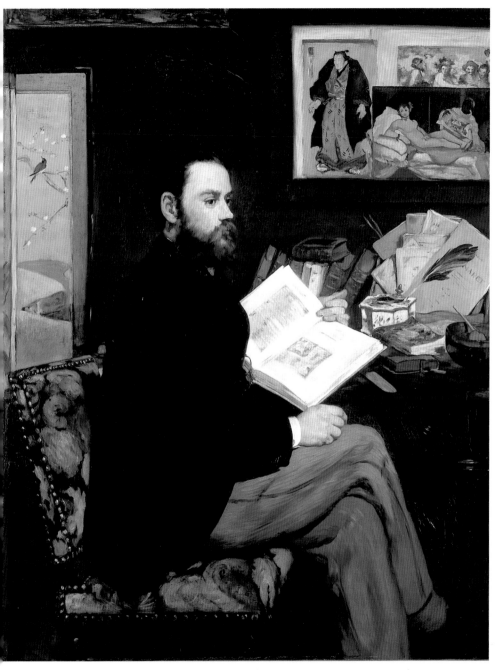

69 Manet *Portrait of Emile Zola* 1868

that the Salon would end up playing second fiddle to the Exposition Universelle. Always sensitive to the exigencies of the moment, he determined that a private exhibition, within striking distance of the exposition, would be the best guarantee of public exposure. To this end, he placed an advertisement in the *Catalogue général* of the Exposition: 'Edouard Manet. Exhibition of 50 paintings from his œuvre, avenue de l'Alma, near the pont de l'Alma, every day; between 10 and 5 pm – entry: 1 franc.'

Manet's decision to bypass the Salon was not without precedent. Courbet had held a private exhibition in 1855, and in 1867 he was to do so again, on a site very close to Manet's. Although these two events would not have gone unnoticed by Manet, his resolve to 'go it alone' was symptomatic of a more general discontent with the Salon system.

The question of review by jury, central to Salon procedure, had been the focus of criticism ever since the Salon des Refusés of 1863. Some nine months before Manet took the decision to hold his own exhibition, the issue had once again become topical. In April 1866, Cézanne wrote to the Superintendent of Fine Arts, Count Alfred de Nieuwerkerke, urging another Salon des Refusés: 'I wish to appeal to the public and show my pictures in spite of them being rejected. My desire does not seem to me to be extravagant, and if you were to ask all the painters in my position, they would reply without hesitation that they disown the jury and that they wish to take part in one way or another in an exhibition that should be open as a matter of course to every serious worker. Therefore, let the Salon des Refusés be re-established.'

Cézanne's plea was ignored, however, and it was left to his close friend Zola to pursue the argument. He did this in two important articles written for *L'Evénement* (27 and 30 April 1866), the same newspaper that would soon carry his article on Manet. In characteristic polemical style, Zola heaped scorn on the jury which, he said, simply 'hacks at art and offers the crowd only the mutilated corpse'. He concluded by urging the re-establishment of a Salon des Refusés: 'I entreat all my colleagues to join with me, I should like to magnify my voice, to have supreme power to obtain the reopening of those exhibition rooms where the public would judge the judges and the condemned in turn.'

It was against this background, then, that Manet determined to 'stake the lot' on a private show. He borrowed 18,305 francs from his mother to build a pavilion on the Place de l'Alma, on the corner of the Avenue Montaigne and just across from Courbet's own exhibition. When the show finally opened on 22 May (or 24 May), it contained 53 paintings, including three copies after 'Old Masters' and three etchings. With the

exception of the portrait of his parents, there were all the works accepted or rejected by juries over the preceding years, among them, *The Absinthe Drinker, The Spanish Singer, The Angels at the Tomb of Christ* (1864), *Le Déjeuner sur l'herbe, Olympia, The Fifer* and *The Tragic Actor.* Also included were paintings first seen at Martinet's gallery in 1863, works such as *Music in the Tuileries* and *The Old Musician* (1862). To this impressive list Manet added the *Battle of the Kearsage and Alabama* (1864), displayed a few years earlier in the shop window of the art dealer Alfred Cadart's, as well as an important new work, *Young Lady in 1866.* 71

Manet evidently had great expectations for the exhibition, and the poor response of critics and the public was no doubt bitterly disappointing. With the exception of a handful of articles, among them a positive review by Jules Claretie for the Belgium newspaper, *L'Indépendance Belge,* and two pages of caricatures by Randon in *Le Journal amusant,* the event passed largely unnoticed.

Those critics who did consider the exhibition paid particular attention to the preface in Manet's catalogue entitled 'Motifs d'une exposition particulière' (Reasons for a Private Exhibition). This was understandable, since even up until Manet's death the document remains the closest he ever came to publicly discussing his work and aspirations. Yet even here, typically, he maintains a distance by writing it in the third person. In writing a statement at all, he may well have been reacting to comments made by Gautier *fils* in his review of *Olympia* and *Jesus Mocked by the Soldiers* at the Salon of 1865. That article, part of which was discussed at the beginning of this chapter, included the following suggestion: 'The jury ought indeed to have been good enough to ask Manet for a statement of his tendencies which should have been printed as a brochure. Perhaps that would have enlightened public opinion.'

The first part of the 'Motifs d'une exposition particulière' considers the artist/jury set-up, drawing attention to how official recognition and recompense influence the public for or against the artist. It is this frustrating situation which persuaded Manet to bypass the jury and go directly to the public. We are told that 'The artist does not say today, "Come and see faultless work", but, "Come and see sincere work".' The disarmingly modest nature of these preliminary remarks is pursued in the next paragraph where 'sincerity' is once more cited to explain the provocative nature of Manet's work: 'This sincerity gives the work a character of protest, albeit the painter merely thought of rendering his impression'. And again: 'M. Manet has never wished to protest. It is rather against him who did not expect it that people have protested, because there is a traditional system of teaching form, technique, and appearances in painting,

and because those who have been brought up according to such principles do not acknowledge any other.' Manet, the text continues, 'has merely tried to be himself and not someone else.' The statement concludes with a direct appeal to the public: 'Therefore it is now only a question for the painter of gaining the goodwill of the public which has been turned into a would-be enemy.'

70 Caricature by Bertall of Manet's *Young Lady in 1866*, from *Le Journal amusant* 19 May 1867

JEUNE DAME EN 1866.

Manque de tenue et de distinction ; mais si vous l'aviez vue ce matin déjeunant sur l'herbe, sans chemise et sans façons, avec des camarades, vous diriez comme moi que c'est une bonne fille, et surtout pas bégueule.

71 Manet
Young Lady in 1866
1866

78

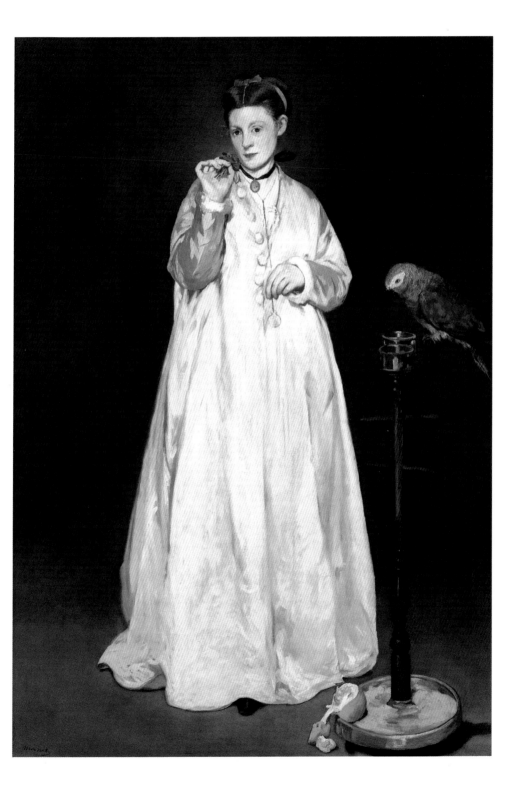

The tone of the 'Motifs d'une exposition particulière' is conciliatory throughout. While it acknowledges that Manet's work may be 'shocking' or 'surprising', it immediately qualifies this: 'Little by little you understand and accept it. Time itself imperceptibly works on paintings and softens the original hardness.' Significantly, the statement reserves its major criticism for the jury and the critics: it is the jury which prevents Manet showing his work to the public, and it is the critics in turn who shape public opinion.

It is likely that Manet enlisted Zola's help to write the 'Motifs d'une exposition particulière'. He was in constant touch with him in the months leading up to the exhibition, and had agreed, albeit with reservations, to have the critic's article from the *Revue du XIXe siècle* republished as a brochure. Zola's descriptions of the artist as a sincere, unassuming young man simply obeying his own instincts find their echo in Manet's preface, as does the critic's emphasis on how the 'new' is gradually absorbed and accepted. Yet for all their similarities, the 'Motifs' has little in common with Zola's polemics, especially his constant deriding of the public which he likened to 'big children' who look at works of art 'to amuse themselves, to be cheered up a little'. By contrast, the 'Motifs d'une exposition particulière' is a gentle, almost contrite statement designed to win over the public.

Although the exhibition was a critical and popular failure, it did succeed in consolidating the friendship between Manet and Zola. An early outcome of this was his portrait of the critic which he sent to the Salon of 1868. Undertaken as an expression of thanks to the writer (although there is the possibility that it was Zola's initiative rather than Manet's), the painting in many respects takes on the character of a self-portrait, a view put forward by Lane Faison in 1949 and subsequently refined by other scholars. It should be pointed out, however, that at least one critic in 1868 had said exactly the same thing: in the satirical journal, *Le Bouffon*, 10 May 1868, Edw. – or Edouard – Ancourt described the *Portrait of Emile Zola* (1868) as a 'Portrait of Manet, spicily painted by himself'.

Each of the three small images in the brown frame above Zola's desk refers to Manet's own preoccupations. His great admiration for Velazquez, whom he described as the 'painter of painters', is referenced by Célestin Nanteuil's lithograph after Velazquez's *Drinkers*, a work Manet had alluded to in his earlier *Old Musician* (see p. 147). His interest in Japanese art is shown in the print of a Sumu wrestler by Kuniaki II, a contemporary Japanese artist. And, finally, the print or photograph of *Olympia* draws attention to what was his most controversial painting to date.

69

Olympia, of course, is not out of place in a portrait of Zola. The critic, after all, had singled this work out as Manet's crowning achievement: 'It will endure as the characteristic expression of his talent, as the highest mark of his power'. Perhaps in playful tribute to the writer, as Theodore Reff suggested in an article of 1975, the gaze of Olympia in the portrait is turned away from the spectator and directed at the critic. But there is another way of viewing this gesture: her averted gaze may be a gentle dig at Zola for generally failing to see any significance in *Olympia* other than technical achievement. In his brochure on Manet, which is the pale blue item prominently displayed among the items on the table, Zola had dealt at length with the artist's innovative technique: 'Olympia, reclining on the white sheets, is a large pale spot on the black background. ... Thus at the first glance you distinguish only two tones in the painting, two strong tones played off against each other. ... The lips are two narrow pink lines, the eyes are reduced to a few black strokes. Now look closely at the bouquet. Some patches of pink, blue and green. Everything is simplified and if you wish to reconstruct reality you must step back a bit.' Towards the end of this formalist reading, however, Zola seems to have a change of mind. Almost as an afterthought, he adds that Olympia is 'a girl of our times, whom one would have met in the streets pulling a thin shawl of faded wool over her narrow shoulders'. This recognition, finally, of Olympia's modernity would not have been lost on Manet. Perhaps in sly acknowledgment of it, he makes her shoulders in the portrait distinctly more solid and muscular than in his original painting. 43

Although critics said little about *Olympia*'s relationship to the *Portrait of Emile Zola*, some mentioned the 'Venus with the Cat' in their reviews of *A Young Woman*, Manet's other submission to the Salon. Painted two years previously, and first exhibited in his one-person show under the title *Young Lady in 1866*, it was clearly a rejoinder to Courbet's own *Woman with a Parrot*, a popular success at the Salon of 1866. In that work Courbet shows a reclining nude, head thrown back and hair in disarray, with a parrot sitting on the fingers of her raised hand; its wings are spread as if to emphasize her parted legs. Designed with the erotic fantasies of the male spectator in mind, this image is far removed from Manet's distinctly ordinary yet puzzling picture. He dresses his figure in a long, voluminous pink peignoir which conceals more of her body than it reveals; a single black slipper, tongue-like in appearance, sticks out from beneath this garment. The woman holds a bunch of violets in one hand and a monocle in the other. To her left is a parrot on a perch, at the base of which is a half-peeled lemon. Unlike the sexually charged creature in Courbet's painting, Manet's seems to take the role of a passive yet attentive witness. 73

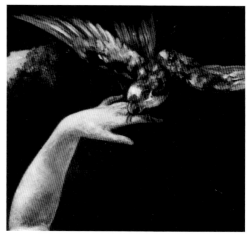

73 Detail of Courbet *Woman with a Parrot* 1866

72 Detail of Manet *Young Lady in 1866* 1866

In *La Presse*, the critic Maurice Chaumelin wrote: 'Parrots and black cats have never pleased the classicists. Allowances can be made for black cats, fantastic as they may be, but what about parrots? Manet, who ought not to have forgotten the panic caused by his black cat in *Ophelia* [*sic*] has borrowed a parrot from his friend Courbet and placed it on a perch beside a young lady dressed in a pink dressing gown. These realists are capable of anything! The misfortune is that this cursed parrot is not stuffed like the portraits of Cabanel, and that the pink dressing gown is too strong in colour. The accessories even prevent one looking at the face, but nothing is lost in that.'

Written three years after the *Olympia* 'panic', Chaumelin's half-serious, half-facetious words show how that painting still haunted the imagination. Olympia has now become an 'Ophelia' (hardly an error on Chaumelin's part), and the issues of female sexuality, ugliness, and technique, highlighted in the debate surrounding *Olympia*, are still being negotiated.

'That Subtle Feeling for Modern Life'

The historian Pierre de la Gorce has described the mood of Paris in 1867, the 'year of the Exhibition', in the following terms: 'Of all the Exhibitions, that of 1867 remains memorable for two reasons; first by the display of magnificence which no one had dreamt of before; in the second place by the violent gusts of uneasiness which, cutting across the public gaiety, came near to dispersing it all more than once.' One of these 'violent gusts' was the attempted assassination of a visiting dignitary, Tsar Alexander of Russia, by a Polish extremist on 6 June. Some two weeks later, however, an event of far greater significance came to the attention of the French government. On 1 July, the day of the official prize-giving ceremony of the Exhibition, Napoleon III received the alarming information that the Archduke Maximilian, whom he had placed on the throne of Mexico, had been executed on 19 June. Shortly after this news broke in Paris, Manet began working on the theme of the execution. The resulting three paintings would represent his most ambitious attempt at history painting. More than that, they also give the lie once and for all to his alleged indifference to political matters.

The category of history painting was still generally considered the highest form of art in the 1860s. In essence, it dealt with heroic or religious narrative subjects. Then, in descending order, came genre portraiture, landscape and finally still life. This hierarchy of subjects and their appropriate realization in terms of technique and size was, however, becoming increasingly blurred. As early as 1855, the critic Eugène Loudun had noted that 'our landscape school is superior, in its way, to our history painters', while Théophile Gautier, writing at the same time, maintained that the term 'history painting' could 'also be applied to pictures which are raised above genre painting by "style", by the grandeur of their figures or the breadth of their execution.'

Manet's *The Angels at the Tomb of Christ* and *Jesus Mocked by the Soldiers* 74 may be construed as history painting, but certainly there was little 'grandeur' in his figures and their execution, in the eyes of his contemporaries, left much to be desired. When Manet turned to everyday life to create a modern-day history painting, his approach was similarly

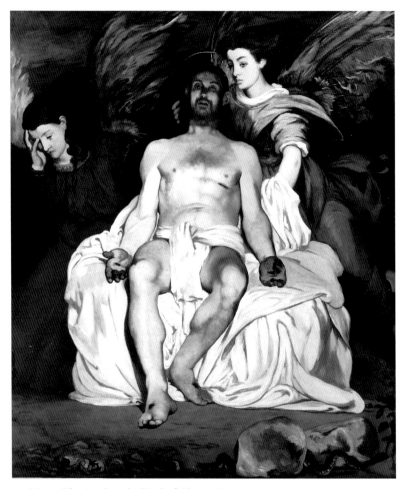

74 Manet *The Angels at the Tomb of Christ* 1864

unconventional. He had first tackled such a subject three years before *The Execution of Maximilian*, in 1864, when his interest was fired by an event in the American War of Independence, the sea battle between the Confederate ship *Alabama* and a Union corvette *Kearsage* off the French coast near Cherbourg. His large canvas shows the *Alabama* under fire and sinking; in the left foreground, a small sailboat is about to pick up a sur-vivor who is hanging onto a piece of floating timber. The painting was first exhibited in the window of a Paris art dealer, Cadart, in July 1864,

78, 79

84

when it caught the eye of an approving critic, Philip Burty. Eight years later Manet showed the work at the Salon.

If two early accounts are to be believed, Manet, who was in Boulogne in the summer of 1864, had gone to Cherbourg and witnessed the battle from a pilot boat; later historians have questioned this claim, citing as evidence the incorrect rigging of the *Alabama*. While the accuracy of such details may be faulted, it is unlikely that this was Manet's primary concern. What he does emphasize, rather, is the contrast between the

75 Manet *Battle of the Kearsage and Alabama* 1864

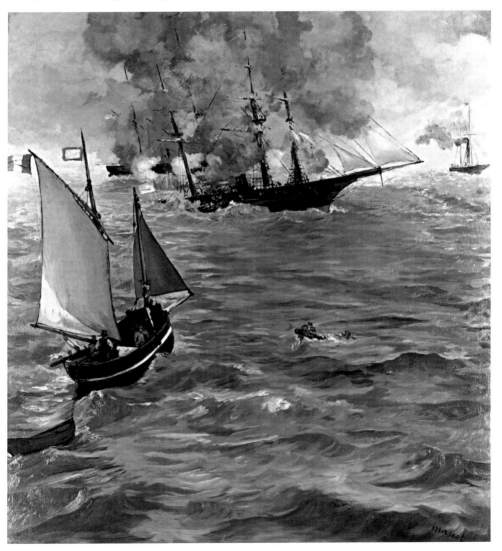

76 Caricature by Stop of Manet's
Battle of the Kearsage and Alabama,
from *Le Journal amusant*
25 May 1872

77 Adolphe Yvon
Capture of the Malakoff Tower,
8 September 1855 (Crimea)
1857

death-throes of the *Alabama* and the almost casual nature of the rescue effort. The great sweep of dark green water rises upwards towards the high horizon and seems to push against the picture surface, a convention employed to greater effect in his later *The Escape of Rochefort* (1880) (see Chapter Eight). A dense cloud of smoke disperses across the face of the canvas. All this adds to the intimacy of the work; it is as if the viewer were there in the water observing the incident. This insistence on the verticality of the picture was the subject of amusement for cartoonists in 1872. Stop (pseud.), in *Le Journal amusant,* said that the artist had little time for 'the everyday bourgeois laws of perspective. Manet has had the ingenious idea of giving us a vertical section of the ocean so that we can read on the fishes' faces their impressions of the battle taking place above them.' The critic Jules Claretie also faulted the perspective, 'treated too much in the Japanese style', but reserved his main reproach for Manet's inattention to the drama: 'I was actually at Cherbourg at the time of the battle', wrote Claretie, 'and Manet's picture doesn't show me the dramatic side of it. Some spectators on a bark watch from afar the two steamers bombarding each other. A brownish-green ship's hull, a bit of sky, flakes of smoke, and that's the battle!'

172

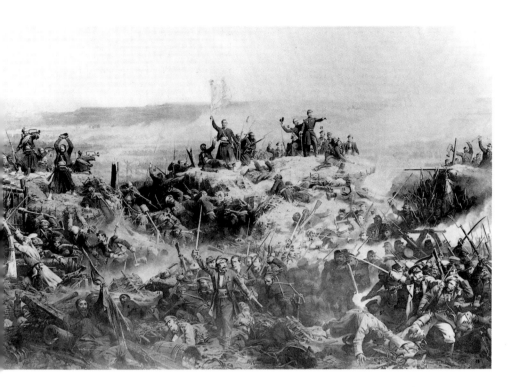

Needless to say, *Battle of the Kearsage and Alabama* has little to do with the sensationalism of, for instance, Adolphe Yvon's monumental canvas, *Capture of the Malakoff Tower, 8 September 1855 (Crimea)*, exhibited at the Salon of 1857. Manet brings to bear a quality of (apparent) disinterest on his picture, which can be seen even more forcefully in his painting of Maximilian's execution.

The history of French intervention in Mexico, and the events leading up to and after the execution of Maximilian, including a detailed analysis of Manet's paintings, was the subject of a major exhibition at the National Gallery, London, in 1992. The scholarship of Juliet Wilson-Bareau, John House and Douglas Johnson, to which I am indebted, has shed much new light on Manet's project, and the reader's attention is directed to their illuminating catalogue.

Manet made three versions of the *Execution*, based on contemporary newspaper reports and photographs. What emerges from a study of these sources is a fascinating picture of how the artist responded to the ever-changing accounts of the execution that began circulating in France between July and October 1867. The event profoundly affected the national psyche; it raised important questions to do with domestic and

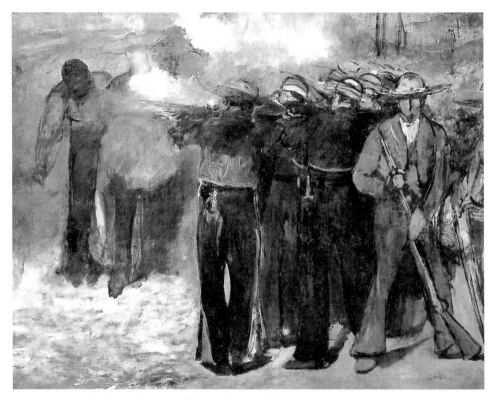

78 Manet *Execution of Maximilian* 1867 (Boston)

foreign policy, and was debated at great length in official and other circles. Manet's decision to paint the subject, therefore, was both topical and controversial.

While his three versions generally follow the same compositional design, there are significant changes. The picture in the Museum of Fine Arts, Boston, has the character of a hastily painted, 'first impression', in which details are subordinated to an overall effect. The second version in the National Gallery, London, only known in its fragmented state (damage to the original canvas resulted in it being cut up and, more recently, the surviving sections restored), is a more carefully realized image. The firing squad is now dressed in smart uniforms and kepis which replace the earlier loose fitting outfits and sombreros, while the figure on the left of the first version, legs apart and staring out at the viewer, gives way in the London painting to a officer who clasps his musket in preparation for the *coup de grâce*. The third canvas (in Mannheim) shows the execution

81

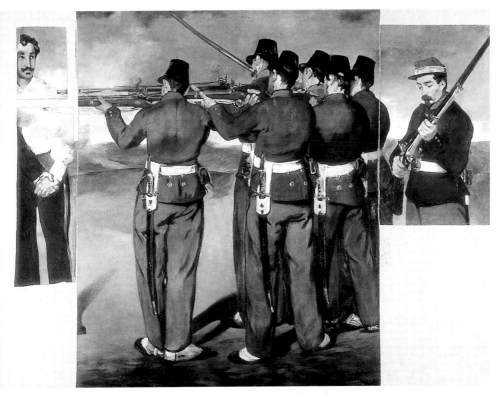

79 Manet *Execution of Maximilian* 1867 (London)

taking place in what appears to be a walled area. Beyond this we can make out crowds of spectators on a hill; blue sky and cypress trees to the left; and a compact group of figures peering over the wall. Just behind them is a woman wearing a mantilla and holding an open fan, whose presence among this motley gathering of onlookers reminds us that the Goya was not far from Manet's mind. We do not know which of the Spaniard's works he had actually seen when visiting the Prado, Madrid, in 1865, but the great *Executions of the Third of May, 1808* must surely have been inspirational for the *Execution of Maximilian*. Yet notwithstanding their marked similarities, the two images part company in important ways. The dramatic intensity of the Goya with its highlighting (literally) of the Christ-like, white-shirted victim, is replaced in Manet's final version by an anti-heroic matter-of-factness, qualities we have already seen in *Battle of the Kearsage and Alabama*. Maximilian, flanked by his generals, Tomas Mejia to his right and Miguel Miramon to his left, looks

80

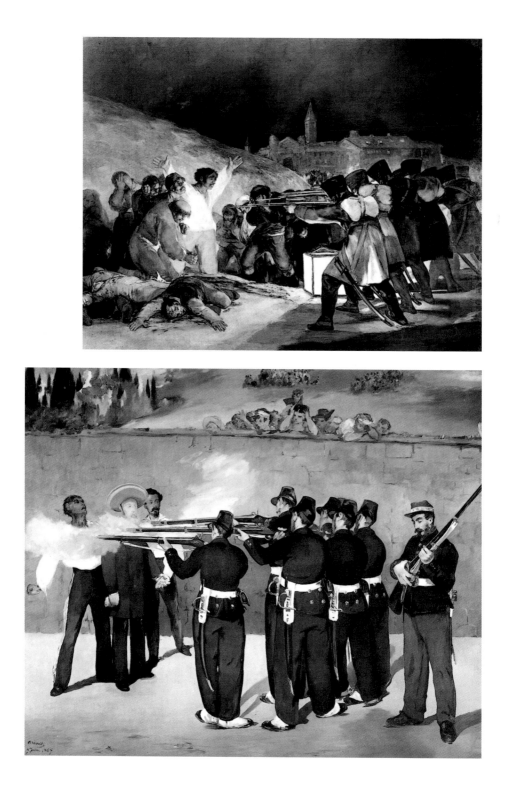

82 Jean-Léon Gérôme *Death of Caesar* 1859

steadfastly at his executioners. The firing squad, dressed to the nines in uniforms that resemble the French Imperial Guard Light Infantry, strike almost casual poses as they aim their rifles at what seems to be to the left of their target. Poor judgment? Obviously not. Imminent death? Of course. Is the picture political satire, reportage or history painting? Whatever the answer to these questions, it is clear that Manet's picture alludes to the tradition of history painting but finally denies it.

The *Execution of Maximilian* was destined never to be seen in France. The censors banned Manet's lithograph of the subject, and he was un-officially told that the canvas would be rejected if submitted to the Salon of 1869. Some ten years later, however, the painting was shown in America, first in New York and then Boston, after which it was returned to Paris where it remained until Manet's widow sold it in 1898 to the art dealer Durand-Ruel for 5,000 francs.

In place of the *Execution of Maximilian*, Manet was represented at the 1869 Salon by *The Balcony* (1868–69) and *The Luncheon*, two works that returned to the theme of Parisian life. Goya's influence is again seen in *The Balcony*, where the general composition recalls his *Majas on the*

84, 85

80 Francisco de Goya *Executions of the Third of May, 1808* 1815

81 Manet *Execution of Maximilian* 1868–69 (Mannheim)

Balcony, a painting Manet may have known directly or from its reproduction in the first French monograph on Goya written by Charles Yriarte in 1867. For his models Manet used three friends: Berthe Morisot shown seated in the foreground, the concert violinist Fanny Claus (1846–77) to her left, and behind them Antoine Guillemet (1842–1918), a landscape painter Manet had met at the Académie Suisse; appearing out of the shadows in the background is a boy carrying a pitcher.

83 Caricature by Pons of *The Balcony*, from *La Parodie* No. 1 1869

84 Manet
The Balcony 1868–69

The presence of Berthe Morisot in what is effectively a group portrait signalled the beginning of her close friendship with Manet, to whom she was introduced by Fantin-Latour in 1868. The youngest daughter of an upper-middle-class family, Berthe and her sister Edma had attended the art classes run by Joseph-Benoit Guichard before going on to study under Corot and his pupil Oudinot. 'I agree with you, the young Morisot girls are charming,' wrote Manet to Fantin-Latour from Boulogne-sur-Mer in August 1868 where he was spending the summer, 'it's a pity they're not men; but being women, they could still do something in the cause of painting by each marrying an academician and bringing discord into the camp of those old dodderers, though that would be asking for considerable self-sacrifice – meanwhile, give them my respects.' These comments are more revealing of Manet's admiration for the 'women' then any patronizing or sexist agenda; as it turned out, Berthe Morisot was to marry Manet's brother, Eugène, in 1874, the same year that she exhibited in the first Impressionist exhibition (see Chapter Six).

84 *The Balcony* is a disconcerting image of the *haute bourgeoisie* at leisure. The elegantly dressed figures, sandwiched between the green shutters, stare out in different directions. They form a compact group, but are not engaged either emotionally or physically. Morisot clasps her hands, Claus plays with her glove, and Guillemet, who apparently posed fifteen times for Manet, appears self-important. 'One doesn't quite know what these good people are doing on the balcony', wrote Paul Mantz in the *Gazette des beaux-arts*. The picture, he concluded, was 'devoid of thought', merely a pretext for combining colours which Manet did quite well. For the

83 cartoonist Pons, the painting was a 'little green hoax'; his caricature in *La Parodie* includes a bemused cat standing on its hind legs and leaning on the ironwork of the balcony.

The painting, obviously, is not a joke, any more than it is simply a decorative exercise 'devoid of thought'. To be sure, the formal elements of picture-making always concerned Manet, but never to the exclusion of other matters. The absence of any obvious narrative in *The Balcony*, a cause for concern among critics, was likewise noted in *The Luncheon*, Manet's other work in the Salon of 1869. Painted while he was in Boulogne the previous summer, it also depicts three figures, but now in an indoor setting. The young man leaning on the table is Léon Koëlla-Leenhoff (1852–1927), in all likelihood Manet's son, dressed in an outfit that resembles the one he wore in Manet's earlier *View of the 1867*

142 *Exposition Universelle* (see p. 155). To the right is Auguste Rousselin, a former pupil of Charles Gleyre and of Couture, who was holidaying in

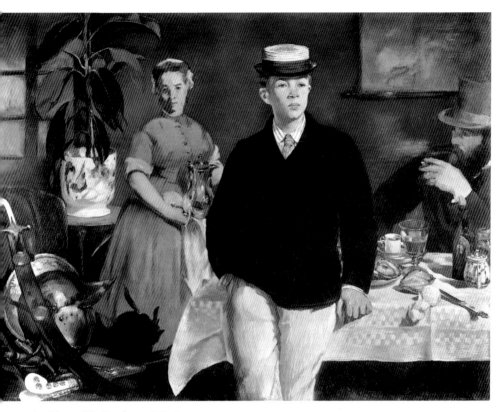

85 Manet *The Luncheon* 1868–69

Boulogne. A maid stands in the background holding a silver coffee pot, recalling the male servant carrying a similar item in *The Balcony*. Remains of a meal are scattered on the table, while at the bottom left there is a curious collection of motifs: a helmet, some swords and a black cat cleaning itself (the cat in the Pons' cartoon referred to above may allude to this animal or, of course, to the one in *Olympia*).

The Luncheon is one of Manet's more puzzling pictures. Its 'harmony of very effective grey tones', noted by Chaumelin in 1869, is contradicted by the pronounced lack of geniality in the group. The items of armour, perhaps studio props, also sit uncomfortably in this domestic scene. 'Is it a luncheon which follows or precedes a duel?', asked an incredulous Théophile Gautier in his review of the Salon. This offhand remark identifies one of the real difficulties Manet's contemporaries encountered in his art. Although the paintings are clearly inspired by modern life, often

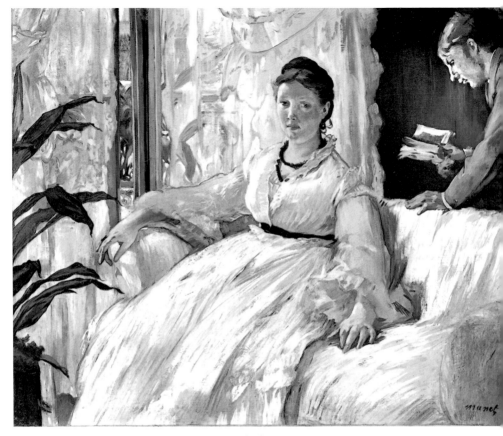

86 Manet *Reading, Mme Manet and Léon* 1865–73?

the relationship between the two is ambiguous. Gautier saw this as one of Manet's 'tremendous faults', yet he also recognized his 'knack of arousing one's lively curiosity. One worries about what he does. One asks oneself: "Will there be some Manets in the Salon?"... Very few remain indifferent to this strange painting, which seems the negation of art and yet which adheres to it.'

Between 1869 and 1870 Manet began work on his second portrait of Berthe Morisot, at the same time as he completed one of the young artist Eva Gonzalès (1849–97). The daughter of the novelist and playwright Emmanuel Gonzalès, Eva had trained under the painter and engraver Charles Chaplin before becoming Manet's pupil in 1869; she was, in fact, the only one he ever accepted. Gonzalès, like her teacher,

96

never exhibited with the Impressionists, choosing instead to submit to the Salon. Her debut there in 1870, at the age of 21, was the same year that Manet's portrait was shown, doubtless more than just a coincidence. In the portrait Gonzalès is depicted elegantly dressed in a long flowing white frock, dabbing at a flower still-life on an easel. A diaphanous blue scarf wraps round the lower left frame of this canvas, and surrounding her on the floor there is a portfolio, a rolled print on which Manet has placed his signature, and a large white flower. Considered together, these four items may be seen to signify both artistic activity and femininity.

One of Gonzalès' own works in the 1870 Salon was *The Little Soldier*, a painting which recalls Manet's *The Fifer* in its choice of subject and 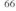 66

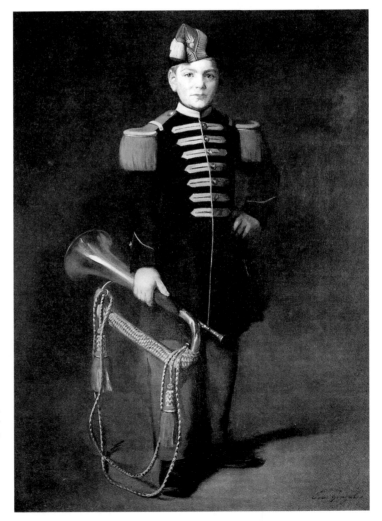

87 Eva Gonzalès
The Little Soldier
1870

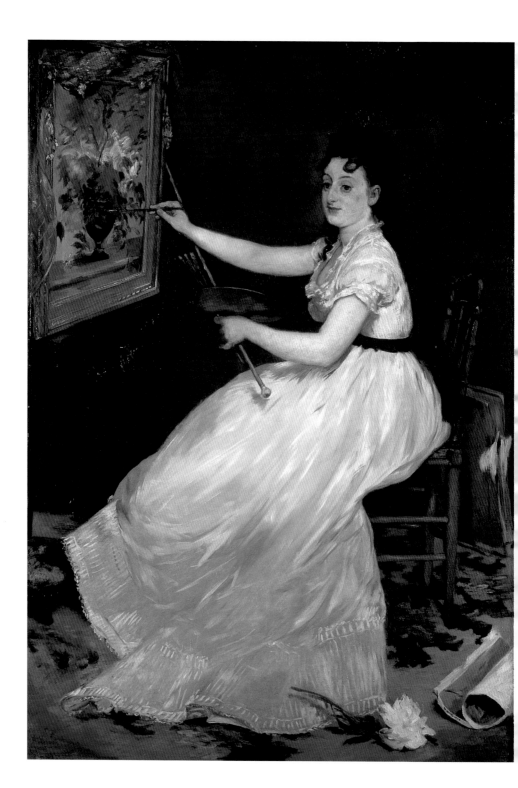

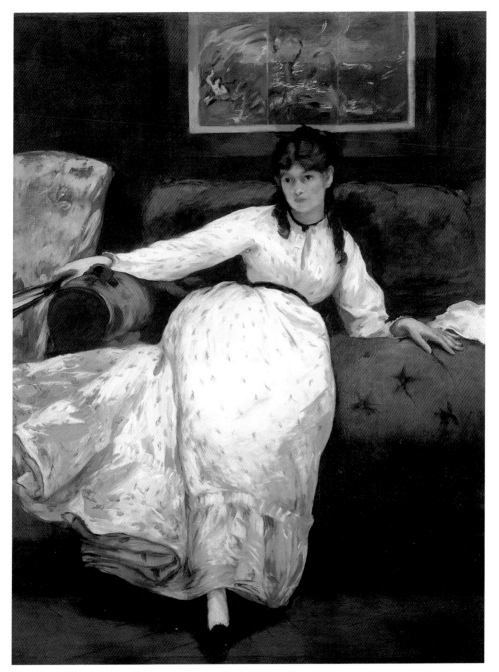

89 Manet *Repose* 1869–70

88 Manet *Portrait of Eva Gonzalès* 1870

placement of the young boy against a neutral background. The critic Castagnary was quick to point out that she had picked up Manet's 'faults', saying that she 'works a bit with black and tends, like that artist, to suppress the half tones'. Gonzalès' association with Manet may have prompted the jury's rejection in 1874 of her *A Loge at the Théâtre des Italiens*. When she resubmitted that work to the Salon of 1879, and it was accepted, one critic compared the bouquet in the painting to its equivalent in *Olympia*. Such a comparison is not entirely fanciful, as there are other tantalizing parallels. The angle of the woman's head in the Gonzalès, her choker, the bow in her hair, and the curtain pulled back at the left – all these correspond to features in *Olympia*. Notwithstanding the similarities, Gonzalès' choice of subject, an elegant couple in an opera box, is one that Manet never painted. As Tamar Garb has pointed out in her study of women Impressionists, while this theme allowed artists like Gonzalès and Mary Cassatt to paint modern urban life, it did not 'compromise their situation as bourgeois women for whom the activities of the demi-monde, so often painted by their male colleagues, would have been inaccessible'.

On 19 July, soon after the Salon of 1870 had closed, Napoleon III declared war on Prussia. The conflict was to prove disastrous for France; she had entered the war with no allies and from the outset her army was out-numbered and out-manoeuvred. On 2 September French troops were defeated at Sédan, the Second Empire dissolved overnight, and a provisional Government of National Defence was set up. Fearful for his family's safety, Manet took the precaution of sending them south. He informed Eva Gonzalès of this in a letter on 10 September (she was then in Dieppe): 'My mother and wife left on Thursday, I sent them off with Léon to the Basses-Pyrénées where I hope they will be safe. I think we poor Parisians are going to be caught up in a terrible drama. ... A lot of people are leaving. ... Madame Stevens [wife of the painter Alfred Stevens] is in Brussels, Mme and Mlle Morisot are staying, I believe. ... Champfleury has left, it's a debacle and people are storming the railway stations.'

Ten days after this letter, Manet wrote to his wife Suzanne with the ominous news: 'We've reached the decisive moment. ... There's fighting everywhere, all round Paris.' Together with others Manet had joined the National Guard, and he was stationed on the fortifications surrounding the city: 'It's very tiring and very hard. One sleeps on straw, and there's not even enough of that to go around.' With Paris now under siege, there was no guarantee that communications leaving the capital by balloon would reach their destination. 'I'm tormented by the thought that you're

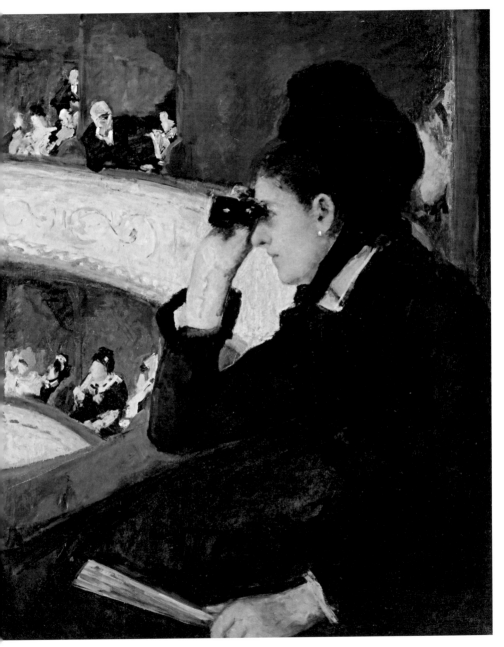

90 Mary Cassatt *Woman in Black at the Opera* 1880

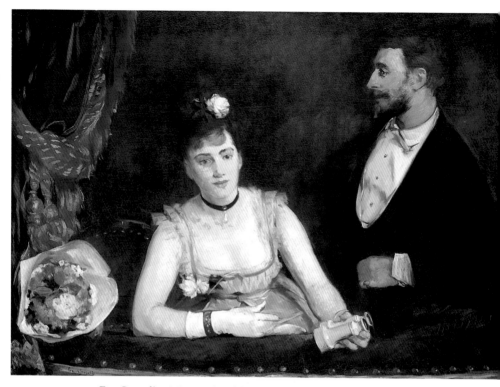

91 Eva Gonzalès *A Loge at the Théâtre des Italiens* 1874

without news of us', Manet confided to Suzanne, 'A balloon carrying letters is due to leave tomorrow, and I've been promised that mine will be on it so I hope it will reach you. It is still impossible to make firm predictions, but Paris is tremendously well defended.'

By late October, however, Manet's optimism was on the wane. To Suzanne he wrote: 'From day to day we're expecting a major offensive to break through the iron ring that surrounds us. We're really counting on the provinces because we can't send our little army off to be massacred. Those tricky Prussian bastards may well try to starve us out.'

With the rejection of an armistice, the war continued, and Manet and Degas joined the artillery as volunteer gunners. In a letter to Eva Gonzalès, Manet made light of his new circumstances: 'I'm looking forward to having you paint my portrait in my huge gunner's greatcoat when you're back.' But he also left Gonzalès in no doubt as to the true conditions in Paris: 'We're beginning to feel the pinch here, horsemeat is a delicacy, donkey is exorbitantly expensive, there are butcher's shops for

dogs, cats and rats – Paris is deathly sad, when will it all end – we've had more than enough.'

The war finally did end on 28 January 1871. Two days later Manet wrote to his wife: 'It's all over. … There was no way we could have held out any longer. They are dying of hunger here and even now there is still great distress. We're all as thin as rakes, and I've been ill myself from exhaustion and bad food these last few days. … I'll come and fetch you as soon as I can, and I'm longing for it.'

The National Assembly elected at the close of the war was largely composed of monarchists. Under the leadership of Adolphe Thiers, whom Manet described in a letter to the artist Félix Bracquemond as 'that little twit', the National Assembly gave orders on 18 March that the weapons held by the National Guard of Paris be surrendered. This decision, taken at a time of general demoralization and unemployment, was to trigger off revolution in the streets of Paris. When the National Guard refused to comply with Thiers' command, he withdrew all troops from the city and prepared to secure it by force. To resist this threat, Parisians elected a municipal government of working-class and professional people on 26 March, to be known as the Commune.

The suppression of the Commune, as the eminent historian Théodore Zeldin has noted, was 'perhaps more important than the regime itself'. During a week of bloody fighting in late May, between 20,000 and 25,000 Communards were killed either in street battles or in summary execution. Archibald Forbes, an English journalist in Paris during these fateful days, has left us with a vivid description of the horrors: 'Paris the beautiful is Paris the ghastly, Paris the battered, Paris the burning, Paris the blood-spattered, now. And this is the nineteenth century, and Europe professes civilization, and France boasts of culture, and Frenchmen are braining one another with the butt end of muskets, and Paris is burning.'

It is not clear if Manet was back in the city and witnessed these atrocities first hand, but he had certainly returned by early June 1870. At any rate, a drawing and a lithograph based on the 'terrible events', as he described them in a letter to Berthe Morisot on 10 June, testify once again to his political sensitivities.

The ink, wash and watercolour drawing, *The Barricade* (1871), may have been a preparatory study for a major painting of the Commune. It is derived from Manet's earlier *Execution of Maximilian*, specifically the lithograph of the subject which he had been prevented from publishing in 1869 (there is a tracing [in reverse] of the lithograph on the verso of *The Barricade*). The Mexican firing squad are now replaced by French soldiers with greatcoats, breeches and gaiters. The figure of Maximilian

92

78, 79

gives way to a hollow-eyed Communard who raises his kepi in a gesture of defiance; to his right, a fellow victim drops his head, recalling the similar movement of General Tomas Mejia in the first version of the *Execution of Maximilian*. That painting, as we have already said, was indebted to Goya's *Executions of the Third of May, 1808*, and there is much about *The Barricade* that relates it closely to the Spaniard's work. The raised arm of the Communard and the fallen victim at his feet both recall similar motifs in the Goya, while the emotional intensity of the *Executions of the Third May, 1808*, largely absent from the final version of Maximilian's execution, reverberates in Manet's picture.

80

The vertical format of *The Barricade*, with buildings seen rising in the background, gives way to a more intimate view of a dead soldier lying near a barricade in *Civil War*, Manet's other response to the Commune. He has placed his signature and the date 1871 on a stone from the barricade at the extreme left, but the lithograph was not published until three years later. Directly opposite this inscription on the far right the legs of a civilian project into the work. In characteristic fashion, Manet has turned to one of his earlier images, *The Dead Toreador* from *c.* 1864, for the figure

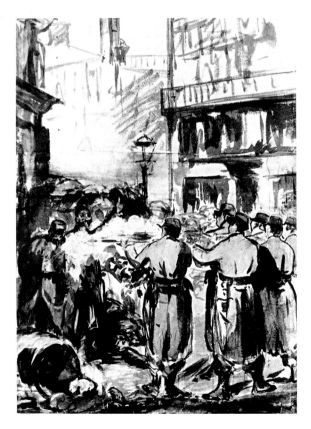

92 Manet *The Barricade* 1871

93 Manet *Civil War* 1871–73

94 Manet *The Dead Toreador* 1863–65

95 Manet
Boy with a Sword 1861

of the slain soldier. Now, however, the context has shifted unmistakably from the bullring to the streets of Paris. Yet the representations of death in these two images have this important thing in common: both remove tragedy from the realm of the rhetorical and place it firmly in that of everyday life.

In the Salon of 1872, the first to be held after the Franco-Prussian War, and the first under the new Third Republic, Manet was represented by the *Battle of the Kearsage and Alabama*, the work he had already shown in Cadart's window in 1864. His decision to exhibit it again eight years later was perhaps based, as George Heard Hamilton has suggested, on the fact

75

that the paintings he had recently sold were all early ones. These included *Mlle V. in the Costume of an Espada, The Angels at the Tomb of Christ, The Fifer, The Street Singer* and *The Tragic Actor*, all bought by the influential art dealer Durand-Ruel, and the *Boy with a Sword* (1861), purchased by another dealer called Fevre. The art critic Théodore Duret, whom Manet had first met in Madrid in 1865, soon acquired the *Matador Saluting* (1866).

If Manet's decision to exhibit *Battle of the Kearsage and Alabama* was dictated in part by market demands, it was probably also influenced by the fact that the sinking of the *Alabama* had once again become

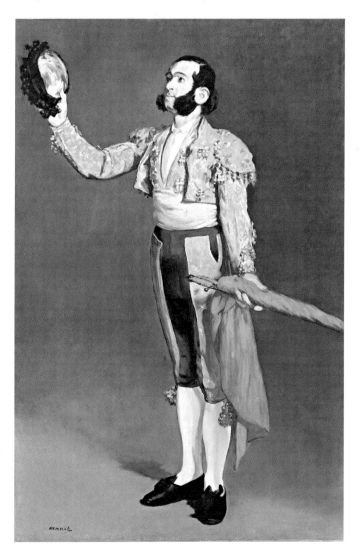

96 Manet
Matador Saluting
1866

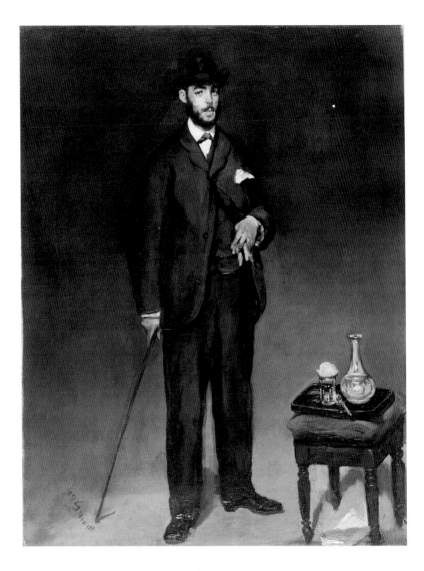

news, a point made by Juliet Wilson-Bareau. Early in 1872, in the February–March issue of the magazine *Le Journal illustré*, Manet would have found an article on its front page detailing the original battle between the *Alabama* and the *Kearsage*, and referencing the recent Anglo-American commission in Washington convened to consider English and American claims emerging from the Civil War. By showing the work, Manet was therefore making a statement about a topical

issue which, he may have felt, had implications for France in the wake of its own civil war.

Soon after the Salon closed, Manet went with his wife to Holland. There he visited the Frans Hals Museum which had recently opened in Haarlem and the Rijksmuseum in Amsterdam. He was full of admiration for Hals, whose *Jolly Trooper* probably gave him the idea for *Le Bon Bock* (1873), a picture he began to work on once back in Paris and settled in his new studio at 4, rue de Saint-Pétersbourg (now the rue de Leningrad) near the Gare Saint-Lazare.

Le Bon Bock shows a jovial, rotund man seated at a table with a glass of beer in one hand and a pipe in the other. Together with a portrait of Berthe Morisot entitled *Repose* (1870), Manet sent both works to the Salon of 1873. This ironic coupling of a happy-go-lucky man and an introspective young woman sprawled out on a sofa reminds us that he thought carefully about his Salon submission. In 1865 he had shown a religious and a secular work, *Jesus Mocked by the Soldiers* and *Olympia*; in the previous year, a dead toreador in *Episode from a Bullfight* together with *The Angels at the Tomb of Christ*. And in 1872, no doubt aware of the renewed interest in a sea battle from the American War of Independence, he exhibited his *Battle of the Kearsage and Alabama* from an earlier period.

99

89

97 Manet
Portrait of Théodore Duret
1868

98 Frans Hals
Jolly Trooper
1629

99 Manet
Le Bon Bock 1873

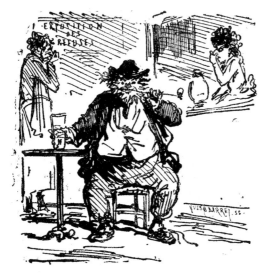

100 Caricature by
Cham of Manet's
Le Bon Bock, from
Le Charivari
8 June 1873

Repose, begun in the summer of 1870, is the second in Manet's series of portraits of his close friend and colleague, Berthe Morisot, and perhaps his most insightful. At the time of its painting, Morisot was going through a period of uncertainty, both professionally and personally. Her mother had supported her artistic pursuits, but now was beginning to have doubts. 'I am earnestly imploring Berthe not to be disdainful', Madame Morisot would write to her other daughter, Edma, on 22 June 1872: 'Everyone thinks that it is better to marry, even making some concessions, than to remain independent in a position that is not really one.' No doubt such pressures weighed heavily on Berthe, who throughout her life sought a balance between the roles of bourgeois woman and professional artist. She did in fact go on to marry Manet's bother, Eugène, in December 1874; one month after the marriage, however, she confided in a letter to her brother, Tiburce: 'I must not complain, however, since I have found an honest and excellent man, who I think loves me sincerely. I am facing the realities of life after living for quite a long time in chimeras that did not give me much happiness – and yet, thinking of my mother, I wonder if I have really done my duty. All these questions are complicated, and it is not easy, for me at least, to distinguish clearly between right and wrong. ...'

The title 'Repose' is hardly an accurate description of the picture's subject. Berthe's right leg is stiff and pushed out in front of her, and she seems in danger of slipping off the voluminously proportioned sofa; she

101 Manet
*Berthe Morisot with a
Bunch of Violets*
1872

appears both ill at ease and lost in reverie. She casually stretches out her right hand which holds a fan, while her left arm is bent at the elbow and the hand placed self-consciously on the upholstery. Prominently placed on the wall behind her is a Japanese triptych of a seascape, Kuniyoshi's *The Dragon King Pursuing the Ama with a Sacred Jewel*, owned by Manet. Although its details are not easily made out, one can see a naked woman on the left caught in a gigantic wave (in the original, this figure holds a dagger in her raised hand). Sitting conspicuously directly above Morisot's head, the Kuniyoshi may be read as a visual metaphor for her emotional agitation. It was perhaps the combination of this image and Morisot's uncomfortable posture that prompted the caricaturist Bertall to call the portrait 'Seasickness!' This lampooning aside, the fact of the matter is that the painting does not represent a woman at rest in a middle-class setting. While she is certainly not 'wilted, wretched, and ill-humoured', the contemptuous words of the critic Armand Silvestre, neither is she calm and composed. Rather, she exudes a melancholic air. This quality is not immediately apparent in Manet's slightly later portrait of Morisot (*Berthe Morisot with a Bunch of Violets*, 1872) where she effects a smile, but even in that work there is 'a presence of absence', as the poet Paul Valéry so cogently put it in 1932.

101

If *Repose* failed to win Manet admirers, then *Le Bon Bock* certainly did. A painting of the engraver Emile Bellot at the Café Guerbois, the venue frequented by Manet and his friends, it proved to be the most popular of all his works to date. The critic Philippe Burty, for one, acknowledged that he had achieved a 'legitimate success. ... It has been said that he has taken a step towards the public. Oh, no! The public is going to him and understands him better.' And for the poet Théodore de Banville, the painting was 'fine, sensitive, charming in colour: it is truth itself, seized, so one would believe, in a moment of luminous improvisation, if one did not know how much knowledge and study are needed to make works which seem to blossom so spontaneously and effortlessly.' Glowing words, to be sure, and ones which address the question of 'improvisation', soon to be taken up in debates about Impressionism. But it was *Repose*, understandably, which finally captured De Banville's attention:

> Manet's other canvas, *Repose*, is an engaging portrait which holds our imagination by an intense character of *modernity*, if we may use this now indispensable barbarism. Baudelaire was indeed right to esteem Manet's paintings, for this patient and sensitive artist is perhaps the only one in whose work one discovers that subtle feeling for modern life which was the exquisite originality of the *Fleurs du mal*.

Manet and the Impressionists in 1874

The success of *Le Bon Bock* came at a time when others in Manet's circle, principally Monet, Renoir, Degas and Pissarro, artists soon to be dubbed 'Impressionists', were finalizing plans for an independent exhibition. The idea had first begun to circulate in 1867, when the twenty-six-year-old Frédérick Bazille, pupil of Gleyre and Renoir, wrote to his parents with the news that a planned exhibition of 'a group of young people' had been abandoned because of insufficient funds. By 1869, however, the project was once more being mooted. In another letter to his parents Bazille bemoans the fact that the Salon had rejected one of his two paintings, and announces that a 'dozen talented people' have resolved 'that each year we will rent a large studio where we will exhibit our works in as large a number as we wish. We will invite any painter who wishes to send us work. Courbet, Corot, Diaz, Daubigny, and many others … have promised to send us paintings and highly approve of our idea. With these people, and Monet, the best of all of them, we are certain of success.'

Manet was not to go down the path of Bazille and his friends. In the years between Bazille's first mention of an independent exhibition, and its final realization in 1874, he distanced himself from the project. This disapproval notwithstanding, he still allied himself with those seeking changes to the principles governing the selection of the jury. Early in 1870, he joined a committee formed by the animal painter, Jules de la Rochenoire (whose portrait he would later paint), which compiled a list of candidates from which, it was hoped, the jury would be chosen. Little came of this move, however, and officially sanctioned artists such as Gérôme, Cabanel, Meissonier and Gleyre were appointed. In 1873 Manet also joined forces with the likes of Renoir, Pissarro, Cézanne and Fantin-Latour in requesting another Salon des Refusés. The protests were so intense that the Director of the Beaux-Arts, Charles Blanc, relented and an 'Exposition artistiques des œuvres refusés' opened on 15 May in wooden barracks behind the Palais de l'Industrie, where the official Salon was held.

Meanwhile those artists advocating an independent exhibition had received a ringing endorsement from the socialist critic, Paul Alexis. A

102 Auguste Renoir
Portrait of Bazille
1867

103 Manet
Portrait of Jules de la Rochenoire
1882

close friend of Monet, Pissarro and others in the Impressionist group, his article in *L'Avenir national* of 5 May 1873 recommended the abolition of the jury system and the formation of artists' syndicates which would present their own exhibitions. Monet responded to Alexis' article immediately and with enthusiasm: 'A group of painters assembled in my home has read with pleasure the article which you have published in *L'Avenir national*. We are happy to see you defend ideas which are ours too, and we hope that, as you say, *L'Avenir national* will kindly give us assistance when the society which we are about to form will be completely constituted.' Alexis published this letter on 12 May with an explanatory note naming 'several artists of great merit' who had already joined Monet, including Pissarro, Jongkind, Sisley, Béliard, Amand Gautier and Antonin Guillaumin: 'Their association, however, will not be a small clique. They intend to represent interests, not tendencies, and hope all serious artists will join them.'

115

Monet and his friends, after months of haggling, finally agreed to model their association on the charter of a professional bakers' union Pissarro had consulted in his hometown of Pointoise. The result was a constitution which treated all members in an even-handed way. Membership was 60 francs a year, with ten per cent of each artist's sales going into a common fund. To avoid arguments over hanging, it was agreed that positions would be determined by lot. On 27 December 1873 the 'Société anonyme co-operative des artistes peintres, sculpteurs, graveurs etc.' was officially constituted. That the artists chose such a non-descript title says much about the loosely knit nature of the group, which included, among the founding members, artists from both avant-garde and traditional camps. There was Monet, Pissarro, Renoir, Sisley, Degas and Morisot, names intimately associated with Impressionism. But there were also others, now forgotten or largely ignored: the two close friends of Pissarro, Edouard Béliard and the landscape painter Antonin Guillaumin; Degas' three friends, the Vicomte Ludovic-Napoléon Lepic, engraver and student of Gleyre and Cabanel, the landscape painter Jean-Baptiste Léopold Levert, and the collector and amateur Stanislas-Henri Rouart. There was also the sculptor Auguste Ottin and the enamellist Alfred Meyer.

With the formation of the Société anonyme, the Impressionists were one step away from their first exhibition. Adding to the momentum were the encouraging results of an auction held at the Hôtel Drouot in January 1874. Works by Monet, Pissarro, Sisley and Degas, formerly part of the collection of the part-time art critic and department store owner, Ernest Hoschedé, reached relatively high prices; one Degas, for example, made a remarkable 1100 francs. If the artists considered these sales augured well for an independent show, Théodore Duret remained unconvinced. In a much quoted letter to Pissarro on 15 February 1874 he counselled against participating in the Impressionist show:

You have still one step to take, that is to succeed in becoming known to the public and accepted by the dealers and art lovers. For this purpose there are only the auctions at the Hôtel Drouot and the big exhibitions at the Palais de l'Industrie. You possess now a group of art lovers and collectors who are devoted to you and support you. Your name is familiar to artists, critics, a special public. But you must make one more stride and become widely known. You won't get there by special exhibitions put on by special groups. The public doesn't go to such exhibitions. … The Hoschedé sale did you more good and advanced you further than all the special exhibitions imaginable. … I urge you

strongly to round that out by exhibiting this year at the Salon. Considering what the frame of mind seems to be this year, your name now being known, they won't refuse you. ... Among the 40,000 people who, I suppose, visit the Salon, you'll be seen by 50 dealers, patrons, critics who would never otherwise look you up and discover you. ... I urge you to select pictures that have a subject, something resembling a composition, pictures that are not too freshly painted. ... I urge you exhibit; you must succeed in making a noise, in defying and attracting criticism, coming face to face with the big public. You won't achieve all that except at the Salon.

Although this argument failed to persuade Pissarro, it would certainly have struck a chord in Manet for whom 'the big public' was always the prize goal. Indeed, the failure of his own show in 1867 to attract any substantial attention had probably made him very wary of private exhibitions. Added to this was the more recent success of *Le Bon Bock* at the Salon. Degas, meanwhile, was doing his best to secure new members. To James Tissot, who had settled in London after the Franco-Prussian War, he wrote: 'You just have to exhibit on the boulevard. It'll do you good (it is a way for you to show yourself in Paris, which people say you are evading) and it will be good for us, too. Manet seems to become obstinate in his decision to remain apart; he may very well regret it.'

The exhibition finally opened on 15 April 1874 at 35 boulevard des Capucines in two large rooms that were the former studios of the photographer Nadar. Visitors were charged an entrance fee of one franc, and an

104 Nadar's studio at 35 boulevard des Capucines, *c.* 1860; venue for the first Impressionist exhibition which opened 15 April 1874

105 Stanilas Lépine
Banks of the Seine 1869

106 Paul Cézanne
A Modern Olympia 1872–73

107 Claude Monet
Boulevard des Capucines
1873–74

additional 50 centimes for a catalogue. It listed 30 artists and 165 items ranging from paintings and prints to marble and terracotta sculpture. What has been called the core of the Impressionist group (Degas, Monet, Pissarro, Morisot, Sisley and Renoir) was represented by some 45 works. More traditional artists largely made up the remainder: among others there were Stanislas Lépine (three outdoor scenes), Lepic (seven works which included portraits and watercolours), and Louis Debras who showed a picture of Rembrandt and three other works. In addition to these names, now for the most part forgotten, but in their time regular contributors to the Salon, there was Cézanne. He was represented by three canvases, one of which, *A Modern Olympia*, described in the catalogue as an 'esquisse' (painted sketch), was a playful yet provocative reference to Manet's own painting of the same name.

This first exhibition, like the seven ensuing ones (the last would be held in 1886, three years after Manet's death), was a decidedly mixed bag. But this did not prevent Louis Leroy, in his now celebrated satirical dialogue published in *Le Charivari* on 25 April, from emphasizing the sketchy, 'unfinished' quality of the work and baptizing the group 'Impressionists'. Even among the core members, however – artists such as Monet, Renoir and Morisot – approaches differed. In his aerial view of the *Boulevard des Capucines*, for instance, Monet breaks up form in

108 Berthe Morisot
The Cradle 1873

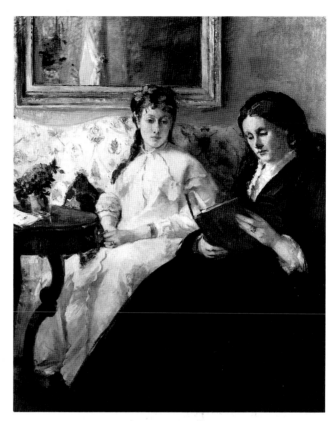

109 Berthe Morisot
The Lesson 1869–70

extravagant ways, reducing pedestrians to smudges of paint. By contrast, Berthe Morisot's *The Cradle* and *The Lesson* show a greater attention to modelling and pictorial structure, qualities also found in Renoir's *The* 112 *Opera Box* and *The Dancer*. Notwithstanding these differences, the term 113 'Impressionism' rapidly passed into the vernacular of art criticism; even the artists were to employ it at the time of their third exhibition in 1877, on which occasion a relative newcomer to their ranks, Gustave Caillebotte (1848–94), was represented by works which certainly could not be described as 'sketchy' or 'unfinished'.

Three days before the opening of the Impressionists' inaugural exhibition, a lengthy article with the imposing title, 'The Painting Jury of 1874 and Manet', appeared in *La Renaissance littéraire et artistique*. Written by the poet and critic Stéphane Mallarmé whom Manet had met in September of the previous year, the article lambasted the jury for not

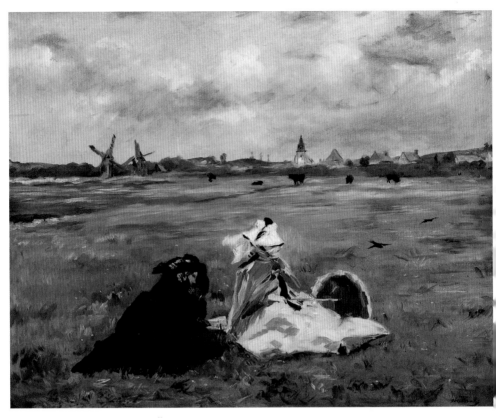

110 Manet *Swallows* 1873

accepting all the artist's submissions. Manet, who as we have already seen abstained from the Impressionist exhibition, had sent four works to the Salon, doubtless expecting all to be accepted given the earlier popularity of *Le Bon Bock*. In the event, only his watercolour *Polichinelle* (1874) and *The Railroad* (1873) were hung. The two refused were *Swallows*, a small sketchily painted canvas depicting his wife and mother sitting in a field, and *The Masked Ball at the Opera* (1873–74).

In his article, Mallarmé argued that the public should have the right to see Manet's work and judge for itself, echoing what the artist himself had written some years earlier in his 'Motifs d'une exposition particulière'. Mallarmé then went on to talk in detail about the two rejected paintings. He described *The Masked Ball* as 'paramount in the painter's work', but conceded that it was 'certainly the work which stood the least chance of receiving unanimous approval'. As for *Swallows*, a picture of 'serene

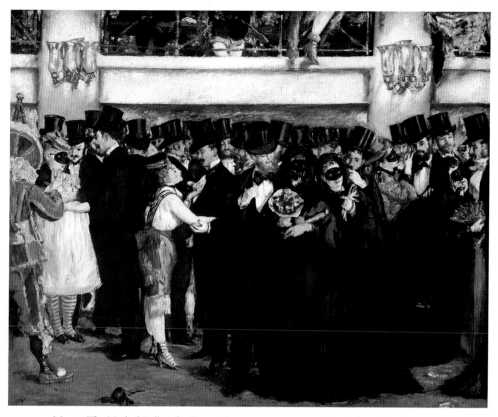

111 Manet *The Masked Ball at the Opera* 1873–74

charm' that academic critics would consider 'not "finished" enough', he wrote, 'What is an "unfinished" work, if all its elements are in accord. ... Besides I could, if I wished to be explicit, point out that this criterion, applied to the merit of a painting without previous study of the quantity of the impression given, should logically be used to judge the too finished as well as the slovenly work of art.'

If the lack of 'finish' had encouraged the jury to reject Manet's *Swallows*, a feature seen also to good effect in the picture of his mother and brother, Eugène, on the beach at Berck, where the family was spending the summer and where Manet had also painted *Swallows*, then *The Masked Ball at the Opera* would have raised other more problematic questions to do with its content.

This relatively small picture (59 x 72.5 cm) takes us into the world of the demimonde and sexual barter, a favoured theme of Manet. In its

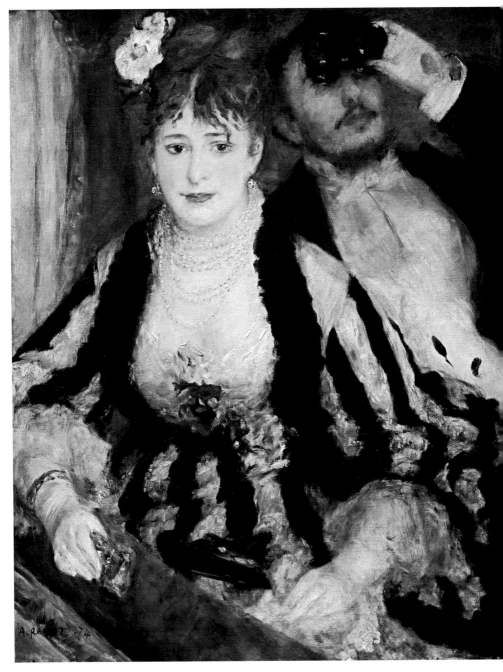

112 Auguste Renoir
The Opera Box 1874

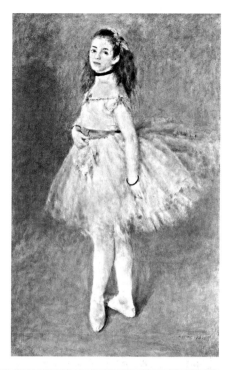

113 Auguste Renoir
The Dancer 1874

114 Gustave Caillebotte *Self-portrait at the Easel*
c. 1879–80

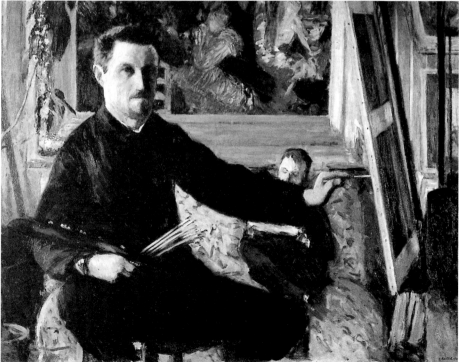

subject matter and pictorial structure, it recalls earlier paintings such as *Music in the Tuileries* and *Olympia*, and looks forward to works like *Nana* and *A Bar at the Folies-Bergère*. The scene Manet depicts is the Opéra on the rue Le Peletier, specifically the promenade behind the boxes rather than the dancing in the main hall. We see a tightly packed group of some two dozen top-hatted men in evening-dress mingling with seven or so women, all of whom wear masks except the one left of centre who engages a man in earnest conversation. She and the woman behind her wear fancy dress; both stand out from their more sombrely attired companions in dominoes. In the foreground at the far left, the rear view of a brightly costumed Polichinelle greets us; his right arm is raised as if in surprise, and his body is cropped dramatically by the edge of the canvas. Towards the top of the picture, running horizontally from left to right, is the balcony of the Opéra; two ghostly white pillars drop from this into the sea of top-hats beneath. On the balcony can be glimpsed fragments of bodies and apparel: the torso of a woman; a red sash and a woman's leg; and a shawl at the far right. The anonymity of the dangling limb is repeated in the single white-stockinged leg emerging from the mass of black in the gathering below. This motif again appears in *A Bar at the Folies-Bergère*, but there the legs *sans* body belong to a trapeze artist balancing high above the crowd.

177

The horizontal format of *The Masked Ball* with its gathering of top-hatted *hommes du monde* invites comparison with the earlier *Music in the Tuileries*, but whereas in that work specific individuals can be easily recognized, in the *The Masked Ball* identification is inconclusive. Among others in the crowd is Théodore Duret, the composer Emmanuel Chabrier, the collector Albert Hecht, and perhaps even the artist himself: he is generally seen as the man second from the right who stares directly out at the viewer, in much the same way that Manet did when he placed himself on the periphery of the crowd in *Music in the Tuileries*. If the figure in the *The Masked Ball* is indeed a self-portrait, then Manet has once again presented himself as both onlooker and participant. A dance card with his signature lies on the floor in front of him, a forlorn item like the flower petals just beyond it and the discarded mask near the feet of Polichinelle.

9

Polichinelle, a French variant of the Pulichennela from the Commedia dell'Arte, had first featured in etchings Manet designed as frontispieces for an album of his prints in 1862. The character then reappears in the watercolour Manet showed at the Salon of 1874. This small work was a sketch for a lithograph which he had hoped would form part of a larger edition to be offered to subscribers of the Republican newspaper

116

Le Temps. The police prevented this, evidently because Polichinelle bore a resemblance to Marshal MacMahon, the newly elected president of the Third Republic. If indeed Manet was making a veiled criticism of MacMahon and his right-wing policies, then the presence of Polichinelle/MacMahon in the *The Masked Ball*, as more recent writers have observed, adds a provocative political twist to this scene of bourgeois indulgence.

Nothing could be further removed from fancy dress, sexual commerce, and political intrigue than *The Railroad*, the second of Manet's two works in the Salon of 1874. Posed by Victorine Meurent and the daughter of Alphonse Hirsch, a friend of the artist, the painting nonplussed the critic Duvergier de Hauranne: 'Is Manet's *Railroad* a double portrait or a subject picture?' he asked. As well he might. For although the picture's ostensible subject is the Gare Saint-Lazare, a site familiar to Manet by its

115 Manet *The Railroad* 1872–73

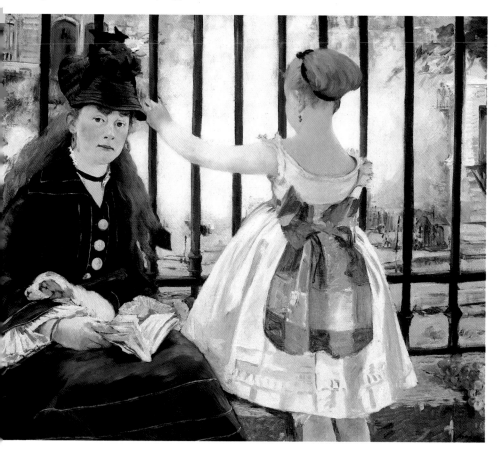

proximity to his studio on the rue de Saint-Pétersbourg, the hustle and bustle of the station and the grandeur of its architecture are clearly not his concerns. In characteristic fashion, he approaches this icon of modern Paris obliquely, by relegating it to the background of his picture and by concentrating on the vignette of everyday urban life in the foreground. Yet underpinning the ordinariness of this scene, its outward serenity, is a sense of unease and tension. Trapped in the narrow space between the grating and the bottom margin of the painting, Victorine, book in hand and dog fast asleep on her lap, looks dreamily out at the viewer, while the girl, a strange combination of child and adult (the nape of her neck and hairdo belie her youth), grasps the fence and stares in the opposite direction. Unlike *Le Bon Bock* of the previous year, a picture of simple pleasures and uncomplicated narratives, *The Railroad* focuses on a 'slice of life', but in ways which problematize rather than simplify the 'modern'.

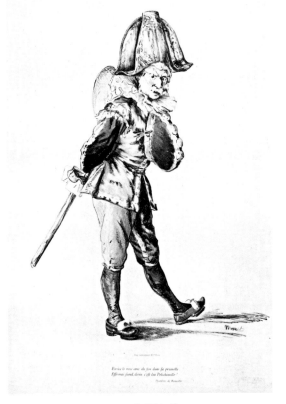

116 Manet *Polichinelle* 1874

Modern Paris, Modern Pleasures

Impressionism was anything but a cohesive movement. Artists of very different persuasions moved in and out of its orbit, and styles of painting and choice of subjects varied accordingly. These could range from the loosely treated 'impressionistic' scenes of suburban pleasure spots by Monet, Renoir and Morisot, to the more 'realistic' pictures of urban Paris by Degas and Caillebotte. What linked all these artists, Manet included, however, was a preoccupation with modern life and a determination to find suitable means of representing it.

In the late 1860s Renoir, accompanied by Monet, made frequent visits to La Grenouillère (literally 'frogpond'), a popular rowing and bathing site on the Island of Croissy at Bougival, a short train ride from Paris' Gare Saint-Lazare. In their paintings of La Grenouillère, lively and staccato brushstrokes evoke the vitality of the venue. We can easily identify the small island, affectionately called 'Camembert', connected to the shore by a footbridge. To the right of this island there is one of the two barges used by the proprietor, Seurin, as a restaurant and dance-hall. Boats are moored in the foreground, and well-dressed day trippers, more summarily painted in the Monet than the Renoir, mingle on 'Camembert'. A few swimmers are seen to the left of the island. While these works speak unambiguously about the sensual pleasures of sunlight, bathing and bonhomie, they are also about the commodification of the country, a process greatly facilitated by competitive rail fares which had turned places like Asnières, Bougival, and Argenteuil into attractive day trips; ideal temporary retreats for the weary city-dweller.

It was in Argenteuil, in fact, that Monet spent much of the period from 1871 to 1878. A place intimately associated with the early years of Impressionism, he had set up home there helped financially by Manet. In the summer of 1874, shortly after the closing of the Impressionists' exhibition, Manet, who was then holidaying at his family's property in Genevilliers, visited Argenteuil where he worked alongside both Monet and Renoir. In *The Monet Family in the Garden* (1874), one of his very few paintings in which people actually seem at one with their world, he shows a relaxed but bemused Camille Monet with her son splayed out at

118, 117

120

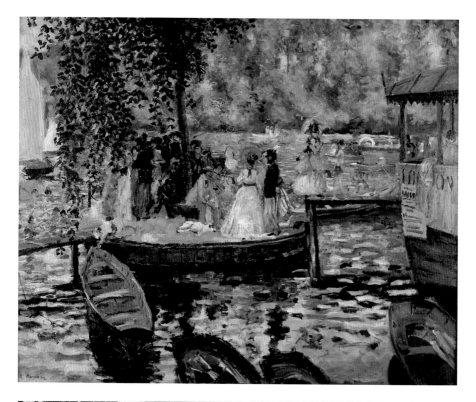

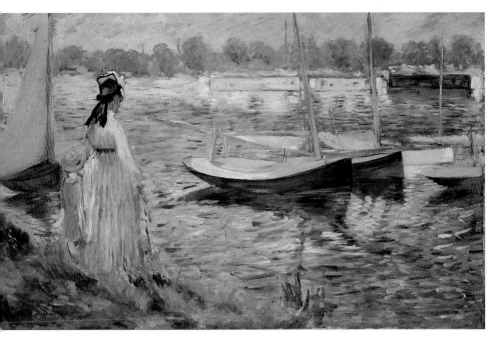

119 Manet *The Seine at Argenteuil* 1874

117 Auguste Renoir *La Grenouillère* 1869

118 Claude Monet *La Grenouillère* 1869

her side. In the background, Monet *père* tends to the garden, while in the left foreground a cock, chick and hen, witty equivalents of their human counterparts, prance about. Renoir's version of the same subject, also painted *en plein air* but from a slightly different angle, provides a close-up view of Camille and her son and the watchful cock.

These small canvases, like Berthe Morisot's *Hide and Seek* (1873), a work loaned by Manet for the purpose of the first Impressionist show, provide intimate glimpses of the middle-class family relaxing in a quasi-rural setting. In the Morisot, a well-groomed mother and child (probably posed by Berthe's recently married sister, Edma, and her daughter) play hide-and-seek behind a cherry tree. A gently seductive image of bourgeois domesticity in an unthreatening landscape, this picture contrasts with Manet's *The Seine at Argenteuil* (1874), where a mother and child (perhaps Camille and Jean Monet), their backs to us, stand on the banks

121

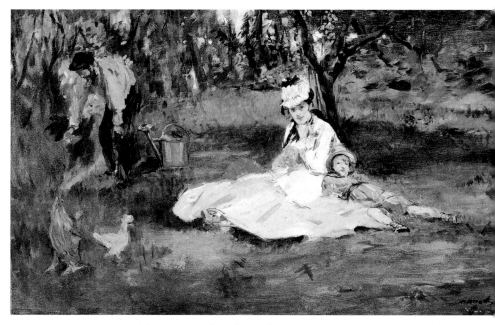

120 Manet *The Monet Family in the Garden* 1874

121 Berthe Morisot *Hide and Seek* 187·

of the river looking at some moored boats. Although this picture con-
tains all the elements of a suburban idyll, there is something rather for-
lorn about the two figures who, sentinel-like, appear transfixed by the
sight before them.

Two other paintings Manet did that summer at Argenteuil allude to the
holiday atmosphere of the place, but in so many other ways they echo his
images of urban life. The first, *Argenteuil* (1874), was a large canvas intend-
ed for the Salon. A man and his female companion dressed informally sit
on a mooring dock. Just behind them are some boats and rigging, and in
the distance, beyond the expanse of blue water, is a strip of land with a
factory chimney prominent amidst a line of buildings. The expression on
the woman's face is one of dejection; her shoulders are hunched and her
folded hands rest heavily on her lap; even the bunch of flowers she holds
(and the word 'holds' must be used with caution) appear wilted. As for

123

the man (posed by Rodolphe Leenhoff, Manet's brother-in-law), every-thing about his body language signals encroachment on the woman's space: the crossed legs, the tilt of his torso, the hand grasping a folded umbrella that hovers over her groin.

According to Manet's friend, the art critic Duret: 'Boatmen came from various walks of life, but the women they brought with them all belonged to the class of second-rate ladies of pleasure. Such is the one in *Argenteuil*.' Whether or not Manet set out to represent this category of prostitute is perhaps less important than what he finally does with his two figures. Physically close yet emotionally worlds apart, the couple is reminiscent of many other works by Manet in which he chooses to 'paint psychic and social distances between people', as the art historian Eunice Lipton pointed out in 1975. We have seen this in *Le Déjeuner sur l'herbe*, *The Balcony*, and *The Luncheon*, and now again in *Argenteuil*.

133

It is also an important feature of *Boating*, another large picture done in the summer of 1874, but not shown in the Salon until five years later. The man at the stern of the boat (again posed by Rodolphe Leenhoff), oblivious to the woman uncomfortably seated in the foreground, looks out into the spectator's space. She meanwhile stares fixedly to her front; her gaze, as it were, running along the surface of the canvas, in much the same way that the wedge of mast at the top right appears to lie parallel to the picture plane. This effect of two-dimensionality, the picture's 'flatness', is further emphasized by the mass of blue water rising from the bottom to the upper margin of the work. Unlike *Argenteuil*, where the distant buildings create a sense of foreground and background, here the

123 Manet *Argenteuil* 187

122 Manet *Boating* 1874

124　Manet *Café-Concert* 1878

125 Manet *Corner in a Café-Concert* 1878 or 1879

viewer's attention is firmly fixed on the activity or, to be more precise, the inactivity of the man and the woman.

Manet's two paintings have little to do with the pleasures one might associate with Argenteuil, a place described by a local resident in 1869 as a haven for summer holidaymakers, where 'happy boaters come to indulge their nautical pastime.' There is no 'happiness' in Manet's boaters, just as there is none in their urban counterparts in *Café-Concert*, a work from 1878 exhibited in the gallery of the weekly magazine *La Vie moderne* two years later.

The café-concert had grown enormously in popularity during the Second Empire. At the Ambassadeurs, the Alcazar d'été and other establishments female *chanteuses* sang risqué songs to an audience of middle and upper-class people as well as the rank and file. Seated at the table in Manet's *Café-Concert* is a young, lacklustre working-class woman smoking a cigarette; at her side, but staring vacantly in the opposite direction, is an elderly bourgeois man. Between them, a few paces back, is a waitress, and in the distance, La Belle Polonaise, a well-known singer who performed at the Brasserie de Reichshoffen; she appears in profile with more than a hint of caricature. There is little cheer in this sombre scene. The man and the woman have nothing to say to each other, and the performer, who may in fact only be a reflection in a mirror, is an insignificant addition. The one figure who does signal geniality is the waitress, standing assertively with her hand on her hip and quaffing from a glass of beer.

The dreary mood of this image gives way to a more animated atmosphere in *Corner in a Café-Concert*. Painted at about the same time as its companion piece (the setting is again the Brasserie de Reichshoffen), the top-hatted gentleman is now replaced by a worker in the foreground with blue smock, cap and clay pipe. He cuts a nonchalant figure as he draws on his pipe and observes the performer on the distant stage; two other customers, a man wearing a grey trilby and a woman, look in the same direction. A waitress deposits a glass of beer on the table, all the while keeping an attentive eye on her other clients. Beyond her, at the far left and right, we can make out details of two musicians.

At the Café was originally the left half of a larger canvas that included *Corner in a Café-Concert* discussed above. The man and woman at the table were posed by Manet's friends, the actress Ellen André and the engraver Henri Guerard. On their left, a girl who remains unidentified looks determinedly to her front. Typically, Manet juggles with questions of interpersonal politics. He makes the black border of the woman's hat seemingly flow into the brim of her top-hatted partner, suggesting an

124

125

126 Manet *At the Café* 1878

intimacy which is belied by their respective expressions and actions: she, self-satisfied, engages the viewer, while the man, who leans on her shoulders – another suggestion of intimacy – is lost in idle thought. The young girl, meanwhile, is the very embodiment of disinterest.

In these three pictures of café life Manet's focus is very much on the clientele and those who service it. In contrast, for Degas, the café-concert was an opportunity to negotiate the sexual exchanges between the entertainers and the entertained. In *Aux Ambassadeurs* and *Café-Concert*, 127, 128 we see extravagantly dressed women with bouquets and fans sitting in

127 Edgar Degas *Aux Ambassadeurs* 1876–77

128 Edgar Degas *Café-Concert* 1876–77

129 Edgar Degas *Women in Front of a Café, Evening* 1877

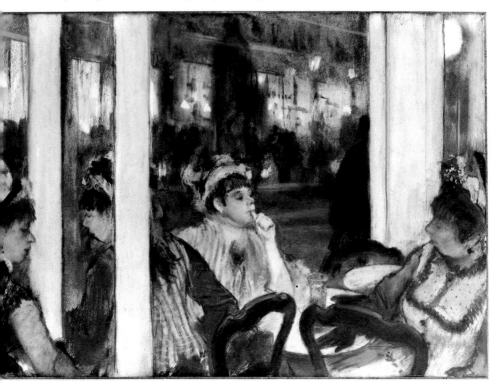

the special area reserved for them behind the performer. The singer motions towards herself in *Café-Concert*, while in *Aux Ambassadeurs* she gesticulates towards the audience which now can be seen sitting behind the assortment of heads and hats that make up the orchestra. A musician turns around and casts a furtive glance at one of the female spectators; she fails to reciprocate, instead staring resolutely to her side. A final note of male sexual bravado is wittily struck by the viola player's instrument standing out prominently in both pictures.

The pointed humour of these works and others by Degas depicting the world of backstage was not lost on critics when they first saw them in the third Impressionist exhibition of 1877. For the anonymous reviewer in *La Petite république française*, the pictures were 'just so many little masterpieces of clever and accurate satire'. This satire, however, becomes inextricably linked with pathos in *Women in Front of a Café, Evening*. Degas shows a group of prostitutes sitting at a sidewalk café, but there is little in the way of sexual swaggering. The central woman sucks her thumb, while her companion opposite, eyes closed, balances herself by pushing firmly down on the table with her gloved hand. A glass containing some beverage separates them. The two women on the left, caught between the cream-coloured pillars of the café, appear withdrawn and disoriented. An air of alcoholic stupor hangs over this forlorn foursome who are oblivious to the ghostly figure of a man sweeping past them. If here the café is a site for the trading in sex, it is also the site for despair.

A similar mood is evoked by Degas' absinthe drinker in his painting *L'Absinthe*. Forlorn and pathetic, she is a victim of that 'terrible and frightening drink', as one writer described absinthe in 1862. Seated at her side is a fellow habitué whose glassy-eyed stare complements her drugged expression; his hat dips back over his head, while her bonnet drops forward mimicking the droop of her shoulders. Thrown onto the wall behind these two figures are their shadows, as insubstantial as the marble table-tops that paradoxically seem to float past in the foreground.

When Manet turned his attention to the solitary female drinker the result was quite different. In *La Prune* he shows a young woman nursing a brandy-soaked plum on the table in front of her. Cigarette in one hand, and the other cushioning her cheek, she is introspective and alone, but there is none of the dejection so evident in Degas' *L'Absinthe*. Unlike the troubling marble tops in that picture, Manet's cuts dramatically across his canvas, repeating the horizontals of the bench and the wood frame beyond. This stabilizes his figure, whereas the drifting marble surfaces and the shadows in the Degas underline the vulnerability of the woman. Manet's own version of an absinthe drinker, painted at the outset of his

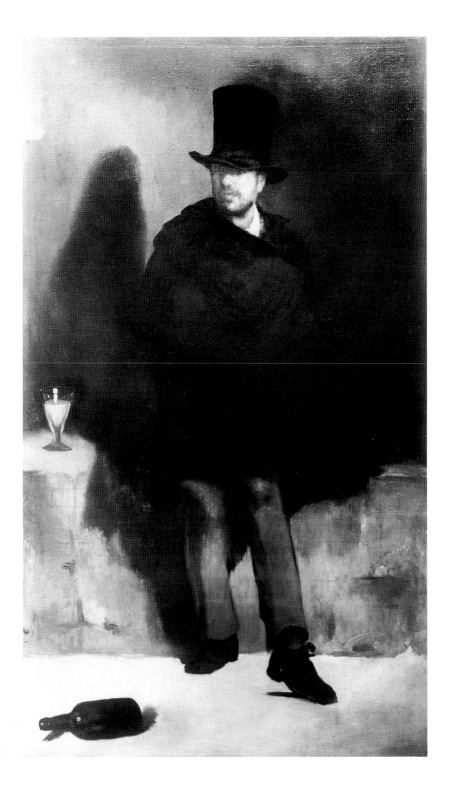

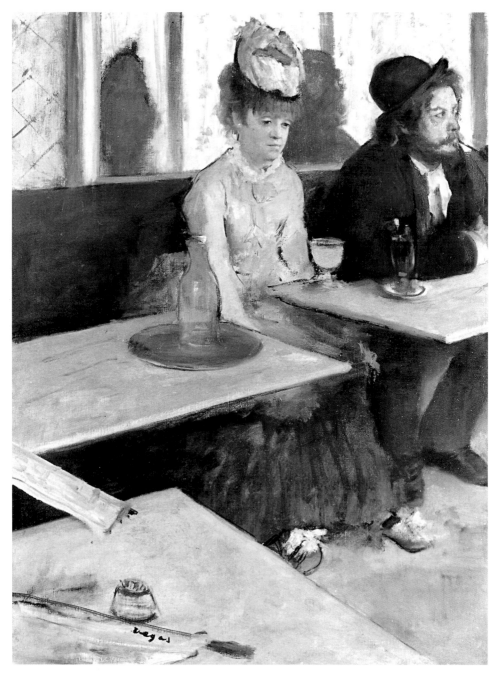

131 Edgar Degas *L'Absinthe* 1875–86

132 Manet *La Prune* 1878?

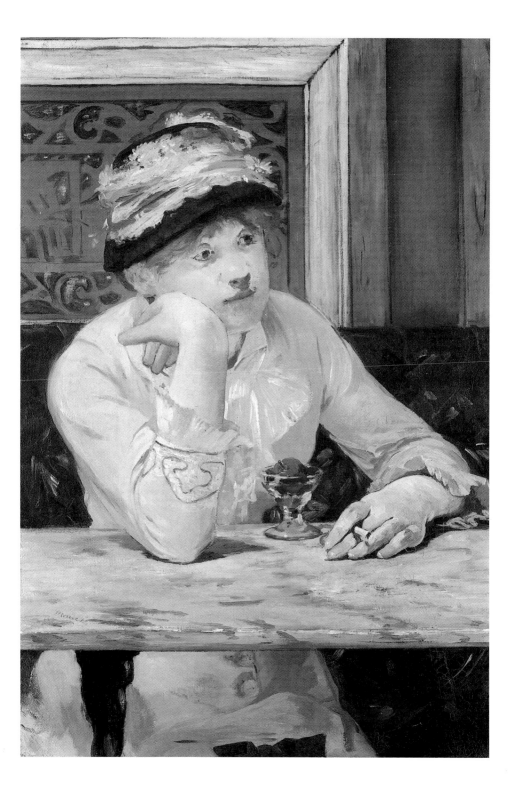

career in 1859, but subsequently reworked, likewise presents a very different picture of the subject. The setting is not a café but an ill-defined outdoor scene with a low wall on which rests a glass of absinthe, recognizable by its greenish colour; an upturned bottle lies on the floor. Standing in the centre of the composition is a top-hatted, cloaked figure, who sticks out his left leg in a gesture that is both awkward and pretentious.

When this painting was sent to the Salon of 1859, and rejected presumably on account of its 'vulgarity', the figure was three-quarters length and the bottle and glass were not present. Their absence would suggest that Manet's real interest did not lie in the association of his subject with absinthe drinking; indeed, even in its present state, the picture's ostensible theme is cast in doubt by the appearance of the man, a strange combination of down-and-out and dandy.

On hearing of the rejection of his painting, Manet is reputed to have said: 'I painted a Parisian character whom I had studied in Paris, and I executed it with the technical simplicity I discovered in Velazquez. No one understands it. If I painted a Spanish type, it would be more comprehensible.' The 'character' in *The Absinthe Drinker* was in fact a ragpicker (*chiffonier*) called Colardet whom Manet had met at the Louvre. Together with countless other itinerants, *chiffoniers* were among those directly affected by Baron Georges-Eugène Haussmann's massive rebuilding programme. Appointed Prefect of the Seine by Napoleon III in 1853, Haussmann's modernization of the city involved large-scale demolition and the uprooting of many thousands of people. What Manet felt about the effects of Haussmannization on the fabric of Parisian society is not known, but paintings such as *The Absinthe Drinker* and others from the early and mid-1860s signal an awareness of dispossessed and marginalized people. The ragpicker Colardet actually reappears in *The Old Musician* (1862), a large canvas perhaps inspired by the destruction of the Petite Pologne, a ramshackle district in Paris situated close to Manet's own studio on the rue Guyot. This curious picture shows a group of disparate urban types: a young girl with a baby in her arms, two small boys, a bearded violinist modelled by the gipsy Jean Lagrene, the absinthe drinker, and the cut-off figure of the Wandering Jew on the far right, posed by Guéroult whom Manet described in his notebook as the 'old Jew with a white beard'. While the painting is clearly based on direct observation, it also contains allusions to older art, to works such as Velazquez's *The Drinkers*, a picture showing a motley gathering of figures in a shallow space, Louis Le Nain's *The Halt of the Horseman*, and Watteau's *Gilles*, the latter resembling the little Pierrot figure in Manet's picture.

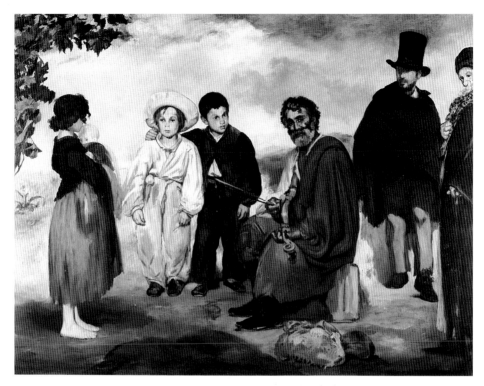

133 Manet *Old Musician* 1862

The *Old Musician* was painted at the same time as the much smaller *Music in the Tuileries*, but unlike that work which celebrates Paris fashionable society, the *Old Musician* draws our attention to a very different world. It is one that Manet would revisit some years later when, on his return from Spain in August 1865, he began work on two pictures of 'beggar-philosophers'. At the back of his mind was Velazquez's own renderings of a similar subject, his *Aesop* and *Menippus*, which had recently 134 captured his attention: 'The philosophers, what exciting works', he wrote in a letter to Fantin-Latour from Madrid. The *Philosopher* (1865–67) illus- 135 trated here is clearly indebted to the *Menippus* of Velazquez, but whereas that figure looks over his shoulder in a mocking way, Manet's is full-face and world-weary. A sharp light emphasizes his bearded features, in the same way as it captures the oyster shells at his feet; the latter replace the books and ewer in the Velazquez and add a sardonic note to this picture of poverty. Manet's *Philosopher* may have taken its cue from the art of the

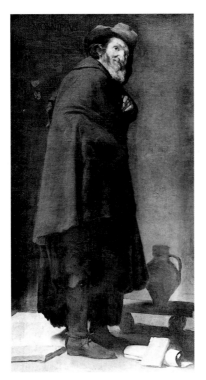

134 Diego Velazquez
Menippus 1639–40

135 Manet
Philosopher 1865–67

museums, as did so many of his other works in the 1860s, but the actuali-
ties of everyday Paris were very much its concerns.

By the end of Haussmann's prefecture in 1870 the face of the city had
changed irrevocably. There was now an extensive network of long, tree-
lined streets – the ubiquitous boulevards; there were four new bridges
and ten reconstructed; 27,500 houses were pulled down in the
Department of the Seine, and over 102,500 were built or rebuilt; and
there were new public squares and parks.

These physical transformations, welcomed by some and criticized by
others, rarely feature in the work of Manet as they do in paintings by
Monet and Caillebotte. Monet was especially attracted to the capital's
136 renovated spaces and painted the famous Parisian parks, the Tuileries and
137 the Parc Monceau. The latter, originally a private garden belonging to
the duc d'Orléans, was acquired by the city in 1860 and transformed by
Adolphe Alphand, Haussmann's director of park services, into a charm-
ing affair of grottoes, classical ruins and waterfalls. In one of Monet's
more intimate views of the park, he sidesteps Alphand's adornments,
empties the site of people, and gives it over largely to troughs of grass,

148

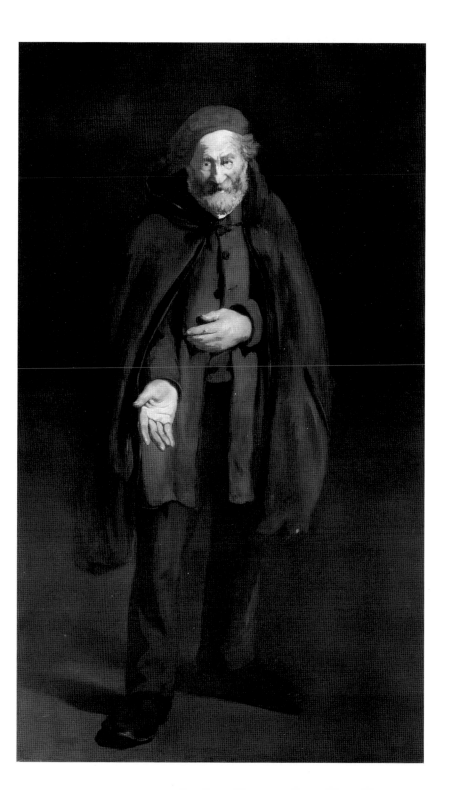

136 Claude Monet *Tuileries c.* 1876 137 Claude Monet *Le Parc Monceau* 1876

foliage and trees. While this painting 'is clearly urban, elegant, up-to-date Paris', as the art historian Paul Tucker correctly observes, 'it is also personalised, free of the crowds, strains, and pace of the downtown area.'

The strollers one might have expected in the Parc Monceau are to be found in the fashionably dressed Parisians of Caillebotte's *Paris Street: A Rainy Day*. The near life-size figures occupy a canvas approximately seven by ten feet (considered too big by some contemporary critics), and take their place in an environment that is Haussmann through and through. The district was once a sparsely populated area outside the city limits, but under the Second Empire it was developed into a residential district for the upper-middle classes.

Paris Street: A Rainy Day literally foregrounds the *haute bourgeoisie* in the two smartly dressed Parisians who appear to be walking out of the picture. With the exception of a working-class woman in a white apron and a house-painter carrying his ladder (placed, respectively, in the negative shapes to the immediate right of the woman's and her escort's head), this painting, like Manet's *Music in the Tuileries*, is very much about the identity of a particular class. Nonetheless, there is an uneasiness to the scene in which everyone is united by the rain (which cannot be seen), and yet isolated in the portable worlds demarcated by umbrellas. The vacant expressions of the couple, and the dramatic cropping of the figure whose back is turned to the viewer, simply reinforce this sense of dislocation.

138 Gustave Caillebotte *Paris Street: A Rainy Day* 1877

Paris Street: A Rainy Day attracted a great deal of critical attention when it was exhibited in 1877. A reviewer by the name of E. Lepelletier (no doubt a pseudonym, one taken from the name of the street, rue Le Peletier, where the Impressionists held their exhibition) considered the picture to be the 'most outstanding work in the show'. Of particular interest is this reviewer's reference to the cleanliness of the boulevard, 'the meticulously clean paving stones, where I have difficulty in recognising my old and always dirty Parisian pavement', and the pointedly modern look of the couple, 'a gentleman and a lady, modern dress, contemporary physiognomies, sheltered under an umbrella that seems freshly taken from the racks of the Louvre [department store] and the Bon Marché.' In this linking of cleanliness and modernity it should not be forgotten that one of Haussmann's significant achievements was the drainage of the city; his great collector sewer actually became a tourist attraction. Yet the main purpose of the new sewers was to remove rain-water and prevent flooding, and not to dispose of refuse. Still, as the critic quoted above recognized, the new Paris as represented in Caillebotte's picture was certainly cleaner than the old.

In *Le Pont de l'Europe*, painted in 1876, Caillebotte turns his attention to the huge bridge, constructed in the mid-1860s but now completely rebuilt, that spanned the yards of the Gare Saint-Lazare. Manet, as we have already seen, had painted this same site some years earlier in *The Railroad*, and Monet would do various views of it in 1877. Each of these

three artists, however, approach the subject in sharply contrasting ways. Dominating Caillebotte's canvas are the double iron trellises of the bridge, emerging from the right-hand section of the picture and plunging dramatically into the distance where large buildings can be seen. This sweeping view sucks in the onlooker whereas Manet's close-up, almost claustrophobic space keeps the spectator at a distance. In both paintings, however, the industrial landscape, far more emphatic in the Caillebotte, sets the stage for other narratives. The woman and child in Manet's *The Railroad* evoke an image of domesticity in a public setting: secluded, quiet, yet strangely disconcerting. Caillebotte, on the other hand, looks at the men and women who inhabit the public space: bourgeois, workers, a solitary soldier in the distance, and even a dog who negotiates a path between the well-to-do and the worker leaning on the railing. The top-hatted and frock-coated man (a self-portrait of Caillebotte) is the very essence of the nineteenth-century *flaneur*, roaming at will and observing the city literally through male eyes. He seems to be saying something to the woman a few steps behind him – who looks impassively to her right – a fact that did not go unnoticed by critics. This is how the critic Jacques (pseud.) described the scene: 'A young dandy walks past an elegant woman, exquisite beneath her flecked veil, a common little vignette that we have all observed with a discreet and benevolent smile. The figure of a worker leaning on the railing is an audacious touch; it stops the action.'

While both Caillebotte and Manet draw attention to the human dimension of the Gare Saint-Lazare and its environs, Monet's various views stress its other-worldly qualities. In one version he paints the Pont 140 de l'Europe from the vantage point of the rail yards, looking up at the structure so that it acquires a monumentality equal to the neighbouring buildings. Everything in this picture, from the locomotive and workers in the bottom left to the bridge itself, is enveloped and softened by a veil of blue and grey vapour. When Monet turns to the interior he still 141 emphasizes the engulfing quality of smoke and light, but now focuses on the cathedral-like character of the huge building with its glass roof and vast hall.

For Jacques, the critic quoted earlier in connection with Caillebotte's *Le Pont de l'Europe*, Monet's Gare Saint-Lazare series was equivalent to a 'pictorial symphony'. The same could be said about his earlier *Boulevard* 107 *des Capucines*, where the hustle and bustle of the public street is translated into its formal equivalents of colour and pigment. Here, however, the 'black tongue-lickings', to use Bertall's mocking phrase, evoke not only the activity of the boulevard, but also the anonymity of the individual pedestrian, literally a blur, a painted smudge among smudges.

139 Gustave Caillebotte *Le Pont de l'Europe* 1876

140　Claude Monet *Le Pont de l'Europe* 1877

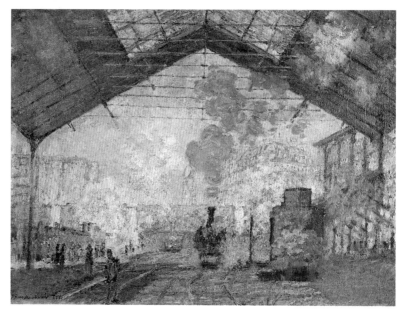

141　Claude Monet *Gare Saint-Lazare* 1877

142 Manet *View of the 1867 Exposition Universelle* 1867

Anonymity has no place in Manet's *View of the 1867 Exposition Universelle*, where carefully delineated social types, similar to those found in Caillebotte's *Le Pont de l'Europe*, parade in front of a panoramic view of the city; in the middle distance are the buildings of the Exposition on its site on the Champ de Mars. Manet, as we have discussed elsewhere, was excluded from the Exposition Universelle, and had held his own show in a pavilion on the Place de l'Alma, a short walk from the Exposition. The Pont de l'Alma, the bridge leading to his exhibition, is actually given special prominence in this painting: its exaggerated columns appear on the extreme left. Among other identifiable landmarks are Notre Dame and the dome of the Invalides, and two of the Exposition's most prominent structures, the French and English light-houses, the latter distinguished by its skeletal framework. Yet it is the diverse crowd in the foreground that finally captures our attention. On the left there is a gardener and behind him a group of working-class and well-to-do women. Next comes an informally dressed couple, a woman on a horse, and children playing on the grass. Alongside them stand two self-important *flaneurs*, and off to their right three Imperial guardsmen. At the opposite extreme of the gardener is a smartly dressed young man (posed by Leon Leenhoff) walking his dog. To complete the picture there is Nadar's balloon, *Le Géant*, wedged in the top right-hand corner – an exclamation mark in the sky.

This large canvas, never exhibited during Manet's lifetime, plays teasingly with scale and perspective. Nothing, really, is quite right: spaces are ambiguous, figures are either too big or too small, details rub shoulders with generalities – for instance, the rather comical figure of the boy/ adult and his unusually large, sketched-in dog; or the summarily painted fat working-class woman who contrasts with the more carefully treated, fashionably dressed young lady in orange. Manet has painted a view of Paris, but more importantly, he has painted the capital as viewed by its people. But even here things do not exactly add up. The labourer who has pride of place in the foreground turns his back on the vista, the horsewoman placed prominently in the centre of the picture looks out at us. And the young dandy is about to walk out of the scene. What we find here, then, are precisely the same disjunctions and the same ironies that Manet so regularly emphasizes in his more intimate 'slices of life'.

These qualities are also found in *On the Beach at Boulogne*, painted in the summer of 1868 or 1869, a work which has much in common with *View of the 1867 Exposition Universelle*. Like that picture it is a panoramic view of a crowd, but now the context has shifted from the city to the shore. The vacationers are certainly a far more homogeneous lot then the mix of social types in Manet's earlier painting, but they still strike contrasting attitudes and defy any naturalistic reading in terms of spatial placement. Some of them gaze at the sea and the boats in the distance, while others are absorbed in their own worlds. Just off centre there is a woman staring through binoculars (the equivalent of the tourist in *View of the 1867 Exposition Universelle* who observes Nadar's balloon through his binoculars), and alongside her an ambiguous black-robed figure. If he is a Franciscan accompanying his penitent to the beach, as Robert L.

143 Edgar Degas *Beach Scene* 1876–77

144 Manet *On the Beach at Boulogne* 1868 or 1869

145 Manet *Beach at Berck-sur-Mer* 1873

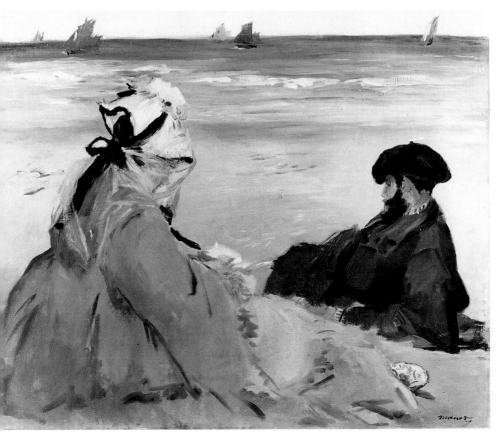

Herbert has recently suggested, then Manet would seem to be making a wry comment on the sensual pleasures of the seaside.

Sensuality, though, is very much at the heart of later work by Degas, his 143 *Beach Scene* from 1876–77, where a dozing child having her hair groomed by a sun-burnt nanny dominates the composition. They are surrounded by pieces of clothing, a picnic hamper, and a parasol, items that look like paper cut-outs stuck on the cream-yellow sand. At the top left a family of bathers follow closely behind a servant carrying a child, while behind them an elderly woman and her dog greet a man who dutifully removes his hat. Although Degas, like Manet, also treats scale in ambiguous ways, these incongruities do not detract from his central, haunting image of the child and her doting maid. With Manet, on the other hand, nothing in his picture invites particularly focused attention; rather, it is the disconnectedness of its elements that both engage and disturb.

There is little of this 'disconnectedness' in his small painting of his wife 145 Suzanne and brother Eugène on the beach at Berck-sur-Mer, painted while on holiday there in 1873, but even this tranquil scene has a hint of disquiet. Suzanne, seated closest to us, is a huge, intimidating presence; absorbed in her book, she contrasts with the more relaxed figure of the reclining Eugène who stares out at the sea. A different mood is evoked by *Swallows*, also painted at Berck-sur-Mer, where Manet shows his mother and wife in a pastoral setting. Probably executed *en plein air*, this picture brings to mind *The Monet Family in the Garden* discussed at the beginning of this chapter. Like that work, *Swallows* draws attention to simple pleasures enjoyed out of doors: cattle graze in the distance, two swallows dart across the field, and the strains of city life are forgotten. The painting, as we have pointed out elsewhere, was rejected by the Salon jury of 1874, and it was left to Stéphane Mallarmé to describe it in his article 'The Painting Jury of 1874': 'Two women are seated on the grass of a dune in northern France, which stretches back to a village on the horizon behind which one can feel the sea, so vast is the atmosphere surrounding the two figures. From afar off come the swallows which give the painting its title. One is first aware of the feeling of open air; and these women, lost in daydreams or contemplation, are really only accessories to the composition, as it is fitting that the painter's eye, arrested only by the harmony of their grey dresses and a September afternoon, should see them in so vast a space.' It is doubtful if Manet ever saw his human subjects as simply 'accessories to the composition', as Mallarmé would have it, but that notwithstanding, the poet's description does capture the picture's evocation of bourgeois contentment in the countryside.

'Dandy of Realism'

One consequence of Mallarmé's article mentioned at the end of the last chapter was an intimate friendship that was to last until Manet's death in 1883. 'I saw my dear Manet every day for ten years', wrote the poet in 1885, 'and I cannot believe that he is no longer here.'

An early product of this relationship was the drawings Manet did to illustrate Mallarmé's prose translation of the American Edgar Allan Poe's poem 'The Raven' in 1875. For Mallarmé, as indeed for Baudelaire whom he had always held in high esteem, Poe was a source of endless fascination. Manet took a keen interest in the project, even writing to the publisher, Richard Lesclide, to express his concern about how the port-folio would be bound: 'I'm much alarmed by the black silk you're

146 Manet *Portrait of Stéphane Mallarmé* 1876

147 Manet
Portrait of Edgar Allan Poe
1860–62?

148 Manet,
poster for 'The Raven'
1875

intending to put on the spine of the portfolio – it will look like a funeral announcement. Parchment, or a soft green or yellow paper similar to the colour of the cover, that's what we need.' A limited edition of 240 copies was finally published in 1875, signed by both Mallarmé and Manet.

That Manet had so enthusiastically participated in this collaborative work may simply have been his way of thanking Mallarmé for his article. As it was, he had written to the poet shortly after its publication, saying, 'My dear friend, thanks, if I had a few supporters like you, I wouldn't give a f... about the jury.' No doubt, too, Manet saw the project as a challenge to his skills as an illustrator. An added stimulus, though, would have been the nature of the poem itself. For contrary to most readings emphasizing the atmosphere of terror, 'The Raven' tempers this element in an ironic blending of the absurd and the sinister.

The narrator in the poem (who in Manet's illustrations is actually Mallarmé) responds to the 'raven perched upon my chamber door' in a telling way: 'then this ebony bird beguiling my sad fancy into smiling'. Further on, the raven is 'still beguiling my sad fancy into smiling.' Poe, it would seem, adopts a grim grin throughout the poem. The scenario of a raven sitting on a bust of Pallas and uttering the refrain 'Nevermore' to a nonplussed host is preposterous. This is all but acknowledged by Poe in his own commentary on the poem in *The Philosophy of Composition* (1845). He writes: 'For example, an air of the fantastic – approaching as nearly to the ludicrous as possible – is given to the Raven's entrance.' Poe's excessive use of alliteration and assonance, and the strained high-serious asides – '*is* there balm in Gilead?' – further belie any real sense of menace.

160

Manet's illustrations complement the poem's sardonic character well. His profile of the raven, which appeared on the poster, slipcase, and cover, shows a self-satisfied bird (with a hint of a smile), the very opposite (or is it?) of Poe's 'grim, ungainly, ghastly, gaunt and ominous bird of

LE CORBEAU

(THE RAVEN)

Poème d'E<small>DGAR</small> POE

T<small>RADUIT PAR</small> S<small>TÉPHANE</small> MALLARMÉ

Illustré de cinq Dessins de MANET

TEXTE ANGLAIS ET FRANÇAIS

Illustrations sur Hollande ou sur Chine

AU CHOIX

Couverture et Ex-Libris en parchemin. — Tirage limité.

PRIX : 25 FRANCS.

Avec Épreuves doubles sur Hollande et Chine : 35 francs.

Cartonnage illustré, en sus : 5 francs.

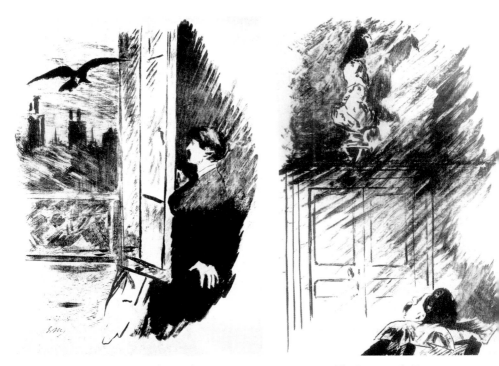

149 Manet *At the Window,*
illustration for 'The Raven' 1875

150 Manet *The Raven on the Bust,*
illustration for 'The Raven', 1875

yore'. The illustration of the raven's entrance has the narrator standing in
mock surprise at the window. Next follows an image of the bird roosting
smugly on the bust of Pallas, beneath which sits the mesmerized narrator.
This image sums up perfectly the outlandishness of the poem. Manet has
made the shadow of the raven angle sharply downwards, amusingly sug-
gesting its imminent fall; understood in the context of the last stanza,
'And the Raven, never flitting, still is sitting – still is sitting,' the irony of
the illustration becomes clear.

The pointed humour of these images is also seen in the earlier poster
and engraving Manet did for Champfleury's book, *Les Chats*, published
in late 1868. Dealing with the history and customs of the animal, it con-
tained 52 illustrations by Delacroix, Manet, Prisse d'Avennes, Ribot, etc.
Manet's poster, *Cats' Rendezvous*, shows the two animals staking each
other out on the rooftops of Paris. A black male, his tail sharply defined
against the skyline, looks piercingly at his white mate; she presents her

151 Manet's poster, *Cats' Rendezvous* 1868

rear to him in a pose that is both arrogant and inviting. The sexual implications of this rendezvous are obvious, but they are captured in a witty and graphically stylish manner.

That Champfleury enlisted Manet's help should come as no surprise, since he had known the artist for a number of years. Manet had included him in his *Music in the Tuileries*, and in 1864 the two had appeared in Fantin-Latour's *Homage to Delacroix*. At one stage, the writer was also to have accompanied Manet on his trip to Spain. By 1868, with their friendship well established, Champfleury would have felt at ease asking Manet to contribute to *Les Chats*. This simple explanation, however, may belie other more calculated motives. Manet's name, after all, was intimately associated with the black cat of the scandalous *Olympia* – as we have said elsewhere – and the animal effectively became his trademark. What is more, the cat even featured in the caricature of Champfleury on the cover of *L'Eclipse* in March 1868, the same year *Les Chats* was to be published. This caricature, discussed in Chapter Three, slyly acknowledged affinities between Champfleury's Realist projects and Manet's art. His decision to involve Manet in his book, considered in this light, now looks like an astute piece of marketing. No doubt he hoped that the fame surrounding the name of Manet and, in particular, his *chat noir* would help draw attention to his own venture.

152 Gustave Courbet *The Stonebreakers* 1849

Despite their friendship, Champfleury never defended Manet publicly. He did actively support Courbet in the 1850s, but then that artist's work, pictures like *The Stonebreakers* and *The Burial at Ornans*, had little in common with Manet's brand of Realism either in form or content. The operative word here, of course, is 'Realism', a term that meant different things to different people. For some, it denoted a preference for subjects drawn from working-class life; for others, fidelity to nature and sincerity were its chief characteristics. Never far from the lips of hostile critics was the 'glorification of the ugly', a principle of faith, so they argued, of Realist artists.

If Champfleury had failed to find in Manet a Realist in the mould of Courbet, others, as we have seen, felt differently. Especially in the 1860s, critics and caricaturists chose to associate him explicitly or implicitly with Courbet. Yet even at the height of the *Olympia* scandal in 1865, Manet's Realist credentials were to be questioned. Writing in the *Gazette des beaux-arts* for July 1, Paul Mantz declared: 'You will agree that from the moment when the painter of *Olympia* can pass as a realist ... the confusion of Babel will begin again, nonsense will be spoken, or rather there will be no more realists.' The 'confusion of Babel' did continue, however, and well into the 1870s. Critics may then have dropped their references to Courbet, but still they persisted in categorizing Manet as a Realist.

153 Gustave Courbet *The Burial at Ornans* 1849–50

In April 1876 this question was to take on a new dimension. On hearing that the Salon had refused his two paintings, Manet went ahead and exhibited them in his own studio. Probably influencing this decision was the fact that a number of newspapers had reported details of the jury's deliberations. One anonymous article in *Le Bien public* was especially explicit: 'It is true, entirely true, that Manet has almost unanimously been rejected. His two paintings, the *Laundry* (1875) and a portrait, have been blackballed without a word of protest. Here is what we learned this morning: when the jury came to examine Manet's paintings, one of the members exclaimed, "Enough of this. We have allowed Manet ten years to turn over a new leaf. He hasn't done so; on the contrary he grows worse. Reject him!"' Given that the matter had now entered into the public domain, Manet no doubt felt he should confront his detractors head on. Unlike 1867, however, when he had set up his own exhibition, this time his strategy was both more discreet and audacious: rather than take his work to the public, he would invite them into the privacy of his studio. He designed special invitation cards with the motto, 'BE TRUE COME WHAT MAY', and a suitably gracious message: 'M. Manet begs … to do him the honour of coming to see his pictures rejected by the Jury of 1876, which will be on exhibition in his studio, from 15 April to 1 May.' In opening his doors to the public two weeks before the commencement of the official Salon, Manet clearly hoped to secure as much attention as possible; certainly he did not want a repetition of 1867 when he had to compete with both the Salon and the Exposition Universelle. As it turned out, the show generated an enormous amount of interest: it was widely reported in the press and some 4,000 visitors turned up; Manet had become, in the words of one writer, 'the popular man of the moment'.

What took some critics by surprise was the austere, but attractive environment in which he worked. The pseudonymous Jean de Paris put it well in *Le Figaro* on 19 April: 'Manet, the realist painter, works in a truly agreeable environment; very beautiful, charming, even luxurious. … A little too solemn perhaps, with its oak panelling, its exposed beams and fireplace … but all very pleasing to the eye. … For a realist, M. Manet has made the mistake of removing all the traces of characteristic neglect, and artistic whims, which seem inherent in artistic circles. With a little imagination, we could in fact believe ourselves to be in a room at the Louvre.' A room at the Louvre, indeed! For Jean de Paris and others, it was inconceivable that a Realist could work in surroundings that were anything less than dingy. It is well to recall an earlier time, when critics were shocked to find in Manet an *homme du monde*, and not, as they had expected, an

unkempt bohemian. I am thinking particularly of Francis Aubert's article in *Le Pays* of 1865 (p. 72), and reviews of Fantin-Latour's portrait of Manet in the 1867 Salon (p. 20). Some ten years later, his appearance and the more intimate details of his private life were still contentious matters.

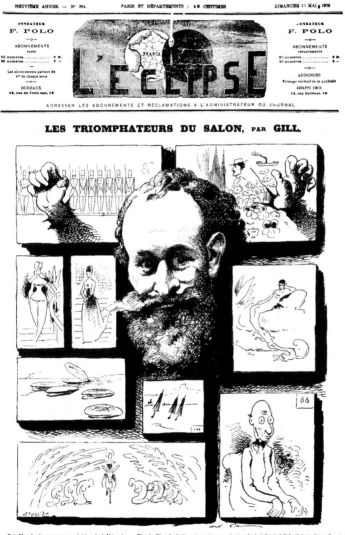

154 Caricature of Manet on the cover of *L'Eclipse* 11 May 1876

When critics finally turned to the object of their visit, Manet's two canvases, they found *The Artist* (1875), a full-length portrait of the etcher Marcellin Desboutin, and *The Laundry*, a picture showing a woman and child hanging out washing. Desboutin looks every inch the bohemian artist, a point emphasized by Junius (pseud.) in a review published in *Le Gaulouis* on 25 April: 'His face, vulgar and lyrical at the same time, is garnished with a dark beard and a mane that overflows his shiny felt hat. ... The intensity of life is without question in this piece. The whole of bohemian art is to be found in it.' If critics needed proof that Manet cut a very different figure, then this painting, appropriately seen in the context of his 'truly agreeable' atelier, certainly provided it.

While *The Artist* was generally well received – it even prompted the influential critic Castagnary to say that it 'would have been one of the

155 Manet
The Artist 1875

156 Manet *The Laundry* 1875

strongest pictures at the Salon' – *The Laundry*, with one or two exceptions, elicited derision. Painted in a looser style and with much lighter colours, it shows a young woman wringing out washing in a garden. A little girl with a quizzical expression places her hands on the wash-tub, and in the background various items hang drying on the line. Manet's title for his painting, *Le Linge*, is often translated as 'The Laundress', which is misleading, since he is not drawing attention to the worker, but rather to the object of the activity, the laundry. Characteristically, though, he ends up by negotiating other issues, specifically those to do with the intimacy between the woman and her tiny assistant (a mother and her daughter surely) as they go about their shared task.

157 Edgar Degas *Women Ironing* 1884–86

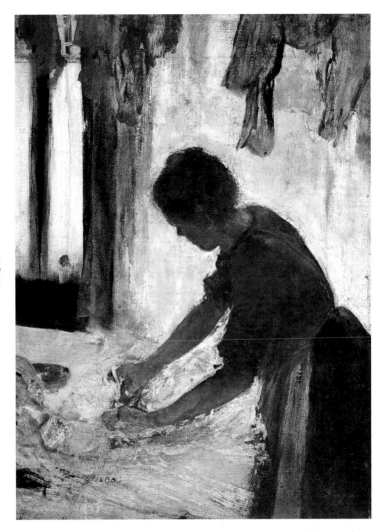

158 Edgar Degas
A Woman Ironing
1874

The Laundry has nothing in common with more conventional representations of the laundress, hugely popular at the time, that appeared in illustrated journals and in fiction. There the focus is on the working-class ironer or washerwoman, and it is her reputed loose morals and flirtatious behaviour that are regularly emphasized. It is this type of labourer Degas often depicts, but he seldom makes the woman's sexuality an issue. Nonetheless, his studies of commercial laundresses working in hot and cramped conditions are far removed from Manet's picture,

which is essentially a picture of middle-class family life presumably in some back garden. In Berthe Morisot's own treatment of a similar theme, her *Laundresses Hanging Out the Wash* from 1875, the private, domestic setting of the Manet gives way to a view of a field adjoining an estate, where women hang out linen and a male gardener tends to a small strip of cultivated land. Contrasted with this image of collective manual labour in the country are the chimneys spouting smoke on the horizon, a reminder that modernity is not far away.

The Laundry did not win Manet admirers. In the visitor's book which he had provided a joker noted: 'Manet is right: dirty linen should always be washed at home', while someone called Lord Kitte wrote: 'Pray, what does the woman hold in her hand and show to the little babe?' For

159 Berthe Morisot *Laundresses Hanging Out the Wash* 1875

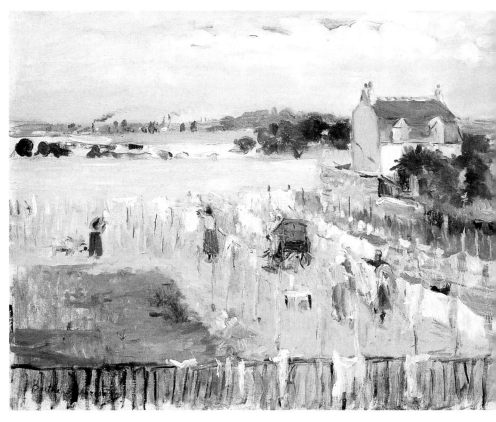

critics, it was Manet's treatment of the subject that left much to be desired: 'The woman is barely indicated; the drawing is weak; the planes do not exist; the arms of the girl are not defined', wrote Alex Pothey on 25 April in *La Presse*, sentiments echoed by Bertall in *Paris-Journal* a few days later: 'Nothing is described, nothing is finished. The child is a baby doll without form or drawing. The mother is dressed in an absurd fashion. Her gestures don't lack accuracy, but everything is applied with a messy broken touch, without precision and without effect.'

These comments remind us that it was Bertall who coined the pejorative term 'Impressionism' two years earlier. What confused matters, though, was Manet's abstention from Impressionist exhibitions, the second of which was running concurrently with his own show in the gallery of the art dealer Durand-Ruel. This did not go unnoticed by some reviewers, who wondered why Manet had not thrown in his lot with those artists. 'But why didn't he favour the exhibition of his colleagues and friends the Impressionists with his two canvases?', wrote Bernadille in *Le Français* on 21 April, 'Why go it alone? It's sheer ingratitude. What an impression Manet's presence would have made at the gathering place of those clever little mavericks of paintings.' Other critics, however, were not so sure, and their reviews show the difficulty they encountered in placing Manet in either the Impressionist or Realist camps. The anonymous critic of *Le Courrier de France*, for example, while welcoming Manet's decision not to side with the 'impressionalists', still found his two paintings problematic: 'In our opinion these pictures are neither better nor worse than Manet's previous works. ... Is Manet an excellent painter, who is at the same time a spirited fellow and a joker amusing himself at the public's expense, or is he indeed an ignorant painter of false vision who, at times, produces a fine piece of brushwork?' More revealing in terms of an attempt to categorize Manet was Simon Boubée's review of the Impressionists at Durand-Ruel, published in *La Gazette de France* on 5 April, ten days before the opening of Manet's show. Boubée wrote: 'Our impression is that the school of which M. Manet professed to be the grand master is, but for a few exceptions, a crowd of practical jokers, of pretentious and helpless people trying to impress, who discard composition because they do not know how to compose.' That said, Boubée noted that there were some exceptions, and these included Caillebotte and Manet himself. However, 'Tolerable impressionists are not impressionists: they are half-rebels, moderate left-wingers, or even centre-leftists.' (This terminology, incidentally, alerts us to the fact that in the debate on Impressionism, the political and the aesthetic often coalesced.)

What emerges from all of this is the uncertainty generated by Manet's work. It was not only his art that puzzled, however, but also, as we have seen, his elegant bearing and the conditions in which he worked. The critic Junius, cited earlier, paid special attention, like many others who visited Manet's studio in 1876, to its contents. He mentions the large fireplace and identifies some oriental porcelain vases, a tankard, a spotted ceramic cat, a clock, and, in 'the place of honour' on the mantelpiece, a stuffed raven (*un corbeau empaillé*) sitting on a bust of Minerva: 'Do you know Edouard Manet? He is the very embodiment of paradox.'

If Junius had seen Manet's illustrations for Mallarmé's translation of 'The Raven', then perhaps his bewilderment would have dissipated. For the object of his surprise, the *corbeau* on the bust of Minerva, was surely the model Manet had used for one of his drawings. That he had obtained it suggests a desire for veracity, but why display the object so prominently in his studio? For someone of Manet's ironic disposition, whom Junius elsewhere described as a 'Dandy of realism, rather than realist' – yet another attempt at finding a suitable name to describe him, but this time a rather apt one – the comic implications of the assemblage must have greatly appealed. Minerva's attribute in her traditional role as goddess of wisdom is the owl, often shown on a pile of books, the symbols of learning. Clearly this would have been an appropriate image to display in a studio: the deity bestowing her blessings on the artist's endeavours. A raven perched on Minerva's helmet, however, turns this conventional symbol neatly on its head. This calculated and witty manipulation of animal symbolism was typical of Manet who, in earlier works such as *Le Déjeuner sur l'herbe*, *Olympia* and *The Young Woman*, had used finches, frogs, cats and parrots in ways belying their literal meanings.

He does this again in *Nana*, a painting rejected by the Salon of 1877, but then exhibited in the window of the shopkeeper Giroux at 43, boulevard des Capucines, where it apparently caused a public outcry. Here Manet returns to the theme of the prostitute, one first negotiated some twelve years earlier in *Olympia*. Now, however, he turns his back firmly on the art of the past; there is no 'Old Master' lurking in the shadows, no suggestion of parody or homage.

The life-size, full-length Nana was posed by the actress Henriette Hauser, a *grande cocotte* well known as the mistress of the Prince of Orange. Attired in blue corset and petticoat, she looks beguilingly at the viewer as she goes about her toilette. Behind her, on a divan, sits a top-hatted gentleman. Cut in half by the edge of the canvas, he recalls the 'protectors' in Degas' theatre paintings, men of wealth and influence who were regularly seen in the foyer and backstage at the Opéra. Degas

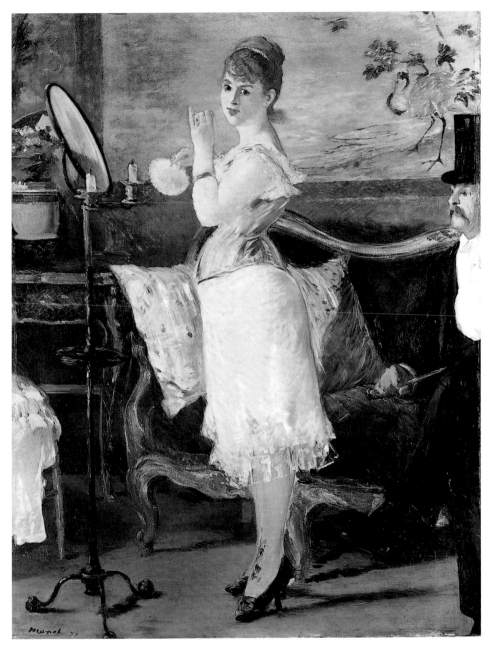

160 Manet *Nana* 1877

161 Edgar Degas
L'Etoile 1876–77

162 Edgar Degas
The Rehearsal on Stage 1874

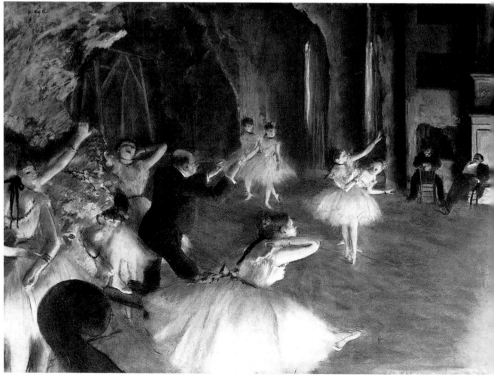

acknowledges their presence and occasionally mocks their self-importance by having pieces of scenery cut bodies in half. At other times, the 'protector's' sexual desires are clearly spelt out. In one pastel, an elderly man shares the intimacy of the dancer's dressing room; leaning forward, cane held firmly in hand, he seems mesmerized by the woman's groin. She stands to his one side, eyes cast down, while another woman, an assistant or perhaps her mother, makes some modification to her blue tutu.

The way Degas manipulates the gazes of his figures turns the actress into an object of desire for the man, and an object of care and attention for the other woman. Nana, by contrast, is very much her own mistress, literally and figuratively. Looking confidently out at the spectator, as did Victorine in *Le Déjeuner sur l'herbe* and *Olympia*, she is oblivious to the pompous admirer staring at her buttocks. He, however, is not the only one to do this: the crane on the Japanese decorative panel in the background also looks in the same direction, their shared view amusingly underlining the predatory nature of the scene. More than that, though, the crane may also be a sly allusion to Henriette Hauser's status as a 'kept woman', since the word *grue* (crane) was frequently used to designate a high-class prostitute.

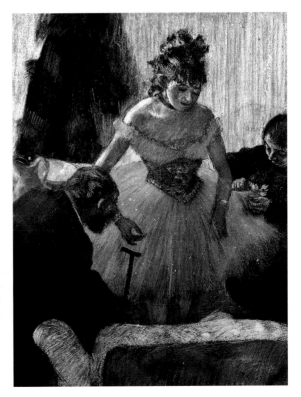

163 Edgar Degas
Before the Entrance on Stage c. 1880

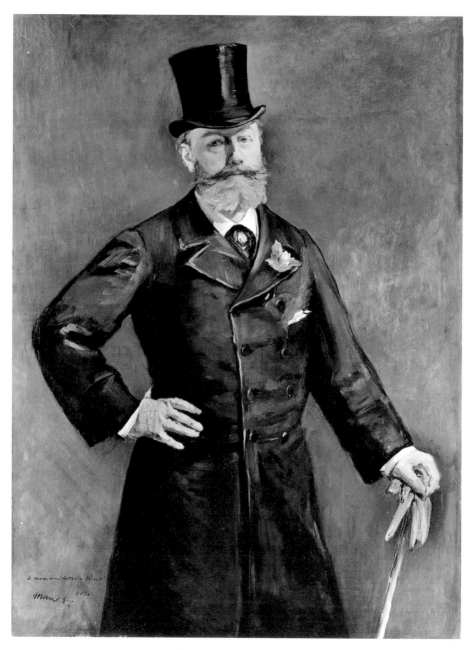

164 Manet *Portrait of Proust* 1880

Although *Nana* took its cue from contemporary life, there is the possibility that a literary source helped in its conception. At the very time Manet was working on his picture, the autumn of 1876, Emile Zola's *L'Assommoir* was published serially in *La République des lettres*. In its concluding chapters, the character Nana appears: she is the daughter of the book's heroine, the laundress Gervaise Macquart. The sexually precocious Nana grows up in a miserable environment: her father drinks, she is subject to beatings, and she turns eventually to prostitution. When she next surfaces in Zola's writings, she has become a celebrated courtesan in the novel named after her. Zola's working notes for *Nana* (1880) described the character as follows: 'Nana eats up gold ... eats up what people are earning around her in industry. ... And she leaves nothing but ashes. In short a real whore. Don't make her witty, which would be a mistake; she is nothing but flesh, but flesh in all its beauty. And, I repeat, a good-natured girl.' Zola wanted his Nana to be a combination of seductress and innocent, to embody destructive passion, on the one hand, and simplicity, on the other. Contrary to such representations, Manet places his *grande cocotte* on a stage far more suited to humans than gods.

Notwithstanding their very different approaches, Manet, it seems, was not displeased with Zola's *Nana*. Writing to Théodore Duret in late 1878, he told his friend how he had 'met some people who had been to see him [Zola]; he read them the first chapters of *Nana* which sounds wonderful and way ahead of everything else in realism – another triumph, no doubt.'

Further on in this letter, Manet expressed his thoughts on the forthcoming Salon: 'I've been working hard this summer and hope to have some good things in the next exhibition, and today Proust asked me to do his portrait for the next Salon.' As it turned out, Manet only completed the *Portrait of Proust* in 1880. To the Salon of 1879 he sent *Boating*, discussed earlier, and *In the Conservatory* (1879), works that continued to explore his interest in questions of modernity and leisure.

122
165

The Guillemets, owners of a shop at 19, rue du Faubourg Saint-Honoré, and friends of Manet, posed for *In the Conservatory*. A background made up of palms and exotic plants, enlivened here and there by red flowers, replaces the wall of blue water in *Boating*. Seated in front of this impenetrable green space is Mme Guillemet, parasol resting on her legs; leaning on the back of the bench is her husband, cigar in hand, who some critics felt resembled Manet himself. Mme Guillemet is caught in a rather stiff pose, and the two are engrossed in their own thoughts, but there is still a sense of happy coexistence. The cartoonist Stop, however, could not resist imposing a sexual reading on the scene: 'A poor young

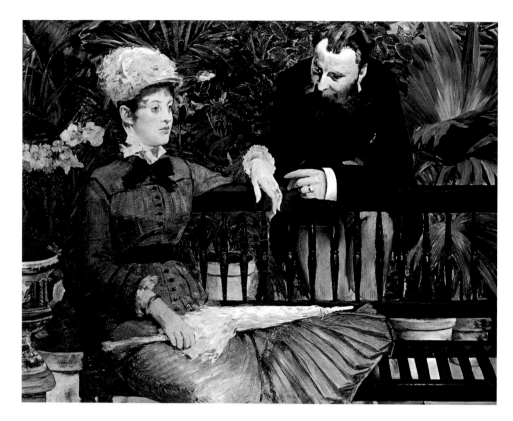

165 Manet
In the Conservatory 1879

166 Caricature by Stop
of Manet's *In the
Conservatory*, from
Le Journal amusant
24 May 1879

innocent person cornered in the conservatory by a treacherous seducer.' Perhaps at the back of Stop's mind, as Françoise Cachin has suggested, was the memory of Zola's novel, *La Curée* (1872). It was the character Renée Saccard, wife of a wealthy property speculator, who held secret assignations with her lover, Maxime, actually her stepson, in a conservatory: 'But there was one place of which Maxime was almost frightened, where Renée dragged him only on bad days, on days when she needed a more acid intoxication. Then they loved in the hothouse. It was there that they tasted incest.'

The conservatory provided Manet with an environment that was both private and public, indoors and outdoors. A corresponding setting is found in Marie Bracquemond's *On the Terrace at Sèvres* (1880), and Renoir's *The Canoeist's Luncheon* (1879–80), painted close in time to 168
Manet's picture. Bracquemond, who had studied under Ingres, was the wife of the distinguished etcher, Félix Bracquemond whom she had married in 1869. They lived in Sèvres, near Paris, where *On the Terrace at Sèvres* was executed. Two fashionably dressed women (according to the artist's son, the model for both was his aunt, Louise Quiveron) sit on either side of a man (possibly Fantin-Latour) whose wide-brimmed hat

167 Marie Bracquemond *On the Terrace at Sèvres* 1880

168 Auguste Renoir *The Canoeist's Luncheon* 1879–80

throws a shadow over his face. The veiled woman on the left stares directly at the viewer, while the other dreamily rests her head on her hand. In the distance, partially concealed by foliage, is a red-roofed building.

Bourgeois suburban life, the theme of this painting, is also at the heart of Renoir's *The Canoeist's Luncheon*. The underlying formality of Bracquemond's and Manet's pictures here gives way to a delicious informality. Painted probably at Chatou, a popular centre for boating a few miles from Argenteuil, the scene Renoir depicts is just after a meal. Two men lean back on their chairs, one of them contentedly smoking a cigar. The woman with her back to us appears to be talking to the figure on the left. Framed by the arch of the terrace are two orange-coloured boats: a racer with four rowers and a coxswain, and a single-seater with a

169 Manet *Chez le Père Lathuille* 1879

woman at the oars. Nothing in this small image escapes the softening
effect of Renoir's blue, not even the geometric pattern of the trellis.

Manet's *Chez le Père Lathuille* (1879), exhibited at the Salon of 1880
with *The Portrait of Proust*, likewise tackles the theme of leisure, but in
very different ways from Renoir. The setting is the garden terrace of the
popular café-restaurant, Père Lathuille, in the Batignolles quarter of Paris.
Seated at the table in the foreground is an elegant woman diner who is
being 'chatted up' by the young man squatting at her side. She looks
down her nose at him, literally and figuratively. Looking on, but at a dis-
creet distance, is a waiter holding a pot of coffee. Whereas Renoir's image
is a distinctly bucolic one devoid of all tension and discord, Manet's is
thoroughly urban and tinged with wit.

One wonders what Manet would have made of the commission, had he received it, to decorate a chamber in the new Hôtel de Ville. He was enthusiastic about the challenge, and had written in April 1879 to the Prefect of the Seine suggesting a series of murals representing the 'public and commercial life of our times. I would show the Paris Markets, Railways, River Port, Subterranean systems, Parks and Racecourses ... [and] all those eminent citizens who have contributed or are contributing to the grandeur and wealth of Paris.' It is highly unlikely that he would have taken recourse to allegory, the preference of the municipal authorities, any more than he would have heroicized the city's 'eminent citizens'. When he did turn his attention to important public events and personalities, it was with characteristic panache and irony.

His lithograph *The Balloon* (1862) depicts the Fête de l'Empereur held each year since 1852 on 15 August. Celebration of this national holiday took a number of forms. There were outdoor concerts and theatrical performances, and, in the evening, to conclude the festivities, fireworks. A

170 Manet *The Balloon* 1862

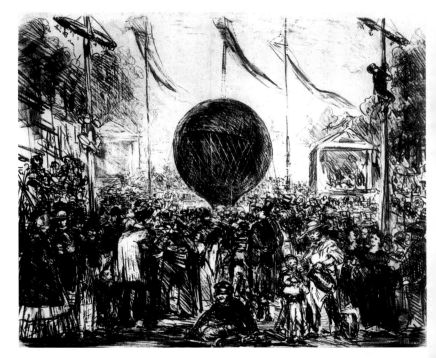

balloon ascent was another important feature of the day's entertainments. This popular event which took place at the Esplanade des Invalides is the more obvious subject of Manet's lithograph. He shows the balloon, a large crowd, the two stages erected for military pantomimes, and the *mâts de cocagne*, soaped poles topped by a ring-shaped structure from which prizes dangled. Manet gives the balloon pride of place in the centre of the composition, but he aligns it with the foreground figure of a young cripple, someone clearly incapable of climbing the *mâts de cocagne*. This boy, his back turned to the spectacle, looks defiantly at the viewer. We are being invited, it would seem, to question the real motives behind all this rejoicing, and to consider the unchanging lot of the poor and of the disabled.

The Rue Mosnier Decked with Flags (1878) is another sardonic commentary on a public festival, the Fête de la Paix of 30 June 1878. This was the first national holiday under the Third Republic, held to commemorate the Exposition Universelle then being staged in Paris. Manet's freely

171 Manet *The Rue Mosnier Decked with Flags* 1878

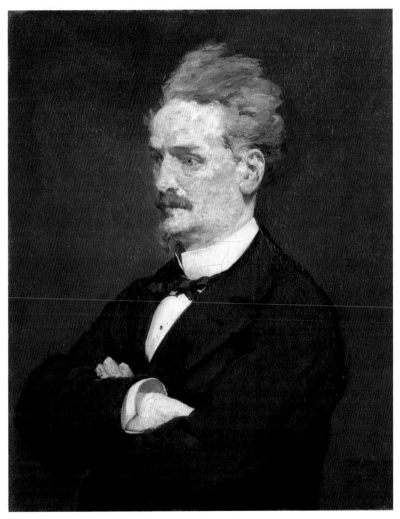

173 Manet *Portrait of M. Henri Rochefort* 1881

172 Manet
The Escape of Rochefort 1880–81 (large version)

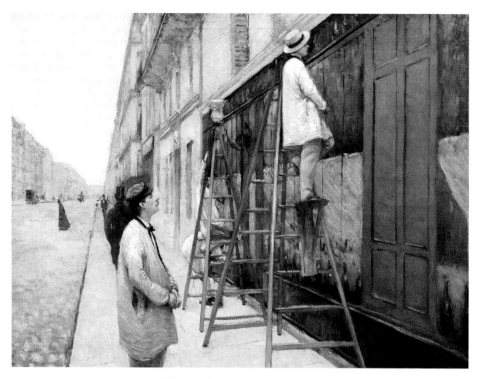

174 Gustave Caillebotte *The House-painters* 1877

handled picture, however, is anything but a celebration of peace and
progress. Yes, there are the obligatory flags, gas lamps and hackney cabs;
but at the near left, his back to us, is a one-legged man on crutches. Is this
figure, identifiable as a worker by his blue smock and beret, a survivor of
the recent Franco-Prussian War? Or the Commune? Or simply one of
the many poor and disadvantaged?

Altogether Manet painted three views of the rue Mosnier (now the
rue de Berne) at this time. In the foreground of *The Rue Mosnier with
Pavers* (1878), one of his very few depictions of manual labour, we see a
group of pavers hard at work, perhaps repairing the street for the forth-
coming *fête*. Manet contrasts their activity with a vignette of urban life:
the ridiculously small bourgeois couple, dressed in black, conversing on
the pavement. Tucked into the top left corner of the picture, in the iden-
tical position to its equivalent in *The Rue Mosnier Decked with Flags*, is a

188

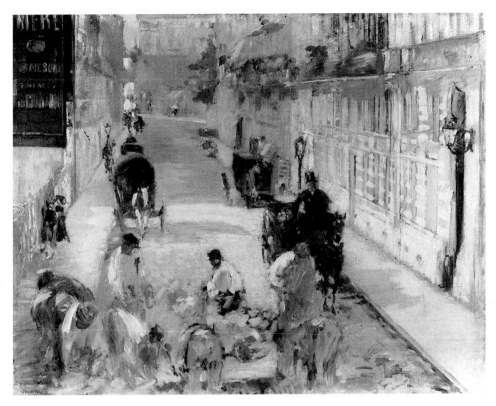

175 Manet *The Rue Mosnier with Pavers* 1878

signboard. Its slogan, 'children outfitted to measure in the latest fashion', introduces a whimsical note to this scene of toil.

The Rue Mosnier with Pavers invites comparison with Caillebotte's *The House-painters*, which Manet would probably have seen in the 1877 Impressionist exhibition. Both address the theme of manual labour in an urban context, but literally from different perspectives. Whereas Manet looks down on the street, a prospect presented to him from his second floor studio on the rue de Saint-Pétersbourg, Caillebotte's point of view is at ground level. He shares the space occupied by the painter in the foreground who looks up to inspect his colleague's work; the latter, wearing a boater, cuts a rather nonchalant figure as he leans back on his stepladder. Typical of Caillebotte, he emphasizes the plunging perspective of the street, and, unlike Manet, he makes the sky, in this case a cold cream-coloured one, an important feature of the picture.

176 Manet *Portrait of M. Pertuiset, the Lion Hunter* 1880–81

177 Manet
A Bar at the Folies-Bergère 1881–82

178 Manet study for
A Bar at the Folies-Bergère 1881

190

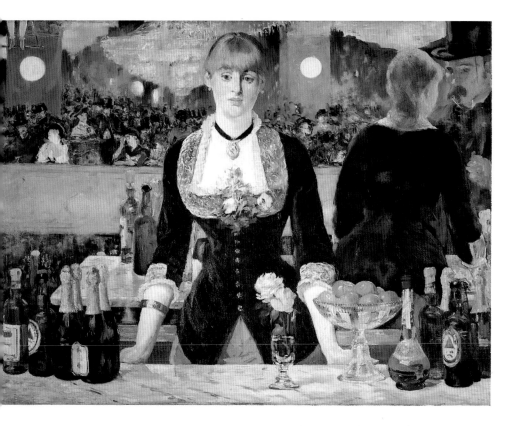

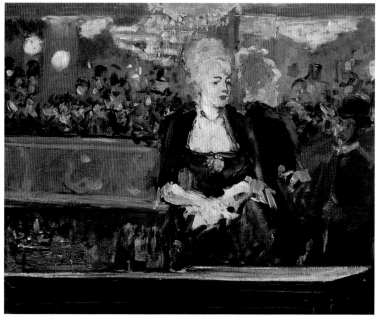

On 14 July 1880, some two years after the Fête de la Paix, the French government announced an amnesty allowing all those who had supported the Commune to return to France. This news was welcomed by Manet, who immediately penned a note to his friend, the fashionable Mlle Isabelle Lemonnier: 'Long live the amnesty', he exclaimed enthusiastically. One of those to benefit from the amnesty was Henri Rochefort (1830–1903), whom the authorities had sentenced to life imprisonment on New Caledonia for his part in the Commune. In 1874 he made a dramatic escape from the islands, and settled finally in Geneva. Soon after his return to Paris on 21 July 1880 he set up the socialist journal *L'Intransigeant*.

Rochefort's reputation as a vocal critic of Napoleon III and his radical republican views would have appealed to Manet, so it is not surprising that he decided to paint his portrait. In addition, he saw in Rochefort's escape from New Caledonia the makings of a major new history

179 Manet *Portrait of Mlle Isabelle Lemonnier c.* 1878–80

180 Manet *Escape of Rochefort* 1881 (small version)

painting along the lines of his earlier *Battle of the Kearsage and Alabama*. The idea was conveyed to Rochefort by Manet's friend Marcellin Desboutin (the model for *The Artist* of 1875), a relative of Rochefort's: 'The proposal was received *with enthusiasm*', Desboutin wrote to Manet. 'The idea of an *Alabama* sea carried the day!! … All doors are opened to your name and to your talent.' Rochefort provided details of his escape, apparently not all that accurate, and Manet began work sometime in late December 1880 or early January 1881.

He did two versions: the larger of the two, but unsigned, shows the moustachioed Rochefort at the tiller of a small boat whose only other identifiable passenger is the bearded Olivier Pain on the left, a journalist who had also been deported for his role in the Commune. These figures are still recognizable in the smaller version, but in that work the boat is set much further back and the sea is calmer. In the larger it swirls around the vessel and rises upwards to the high horizon line where the ship

awaiting the escapees is anchored. The vigorously painted foreground is perhaps the only concession Manet makes to drama, otherwise there is little heroics or bombast. Like his two earlier modern-life history paintings, the *Battle of the Kearsage and Alabama* and *The Execution of Maximilian*, his aim is not to glorify; if anything, he draws our attention to the vulnerability of the fugitives in their battle against the elements. At the time of painting *Escape of Rochefort* Manet was already suffering from the effects of syphilis which would eventually prove fatal; it may not be too fanciful to see in the picture, then, an autobiographical allusion to his own serious predicament.

Manet chose not to send the painting to the Salon, preferring instead his portrait of Rochefort and another of the lion-hunter, Eugène Pertuiset. Author of *Les Aventures d'un chasseur de lions* (1878), and a cele-brated figure in Paris, Pertuiset had apparently tried to present a lion skin to the Emperor Napoleon III. According to Antonin Proust, he was accompanied by both Manet and Proust himself: 'They came and told us we could not be received, we'd have to come back. How Pertuiset raged! It was a treat to see him rolling up the hide.' An apocryphal story perhaps, but Pertuiset's prized item did end up on display in the Algerian Palace during the Paris Exposition Universelle of 1878.

176 The *Portrait of M. Pertuiset, the Lion Hunter* is truly a weird and wonder-ful work. The kneeling, deadpan hunter with his walrus moustache and side-whiskers; the 'yellowish dummy lion at his feet' (the critic Huysmans' apt description) whose gaping mouth contrasts with Pertuiset's clenched teeth; and all this in a watery, violet-grey landscape, dramatically introduced by the cropped tree trunk on which Manet has written his signature.

Derived from various motifs studied out of doors and then executed in his new studio on the rue d'Amsterdam, the portrait of Pertuiset was Manet's largest canvas since *The Execution of Maximilian*. Containing all the hallmarks of his more challenging images of contemporary life – formal innovation, irony, humour and psychological intrigue – it is surprising that the Salon jury accepted it. The smaller, more convention-al portrait of Rochefort was also hung, but even that work by dint of its subject would have been controversial. As it turned out there was some heated discussion, but those friends of Manet who sat on the jury, and they included Alphonse de Neuville, Henri Gervex and Antoine Guillemet, played a decisive role. The two paintings, in fact, went on to win Manet a second-class medal, his first official recognition since 1861 when he had received an 'honourable mention' for *The Spanish Singer*. Armand Silvestre, a critic who had on more recent occasions written

favourably about Manet, now expressed his opinion on the award in the journal *La Vie moderne*: 'Frankly, Manet is above these qualified distinctions. Either you like his painting or you don't. For my part, I like it. Its audacious mastery should preserve it from such humiliating encouragement. ... A second-class medal for having had a great influence on our times! Don't you think that's a bit small?'

A few weeks after this tribute appeared Manet's deteriorating condition forced him to leave Paris for Versailles to recuperate. A letter he wrote to Mallarmé at the end of July was not encouraging: 'I haven't been too happy about my health since I came to Versailles. I don't know if it's the change of air or fluctuations in the temperature but I seem to be worse than I was in Paris – I may get over it.'

While at Versailles, staying in a rented house at 20, avenue de Villeneuve-l'Etang, poor weather 'reduced' him to 'painting my own garden which is quite the most hideous of gardens, and a few still lifes.' Although this may help explain the abandoned scene in *My Garden at Versailles*, the image still remains a moving evocation of transitoriness: the empty bench, the unkempt garden, the discarded yellow bonnet behind the bench.

182 Manet *White Lilacs and Roses* 1882–83

183 Manet
The Hare 1881

Manet returned to Paris in October 1881 and, despite failing health, set to work on what was to be his last major Salon painting, *A Bar at the Folies-Bergère*. His efforts were temporarily interrupted by the news that he was to be made a Chevalier of the Legion of Honour. This prestigious award, facilitated by Proust, recently appointed Minister of Fine Arts under the brief prime ministership of Gambetta, delighted him. One of the letters of congratulation he received was from Count Alfred de Nieuwerkerke, the former Superintendent-General of the Beaux-Arts. Manet acknowledged this in his reply to another well-wisher, the critic Ernest Chesneau, but let it be known that the award was somewhat late in coming: 'When you write to Nieuwerkerque [*sic*], tell him I appreciate his good wishes but that he could have been the one to decorate me. He would have made my fortune and now it's too late to compensate me for twenty lost years. But what about you, my dear Chesneau, how are you? I sympathize all the more with the state of your health since I'm not too well myself.'

Some fifteen months after Manet wrote this letter he died, on 30 April 1883, but not before he had completed *A Bar at the Folies Bergère*, his last

177

great image of modern Paris, which, together with *Jeanne* (1882), a portrait of the young actress Jeanne de Marsy, he sent to the Salon of 1882.

In *A Bar at the Folies-Bergère* Manet returns to the world of the café-concert, one which he had first painted in the late 1870s. But while *A Bar at the Folies-Bergère* relates to these earlier images it also parts company with them in significant ways. As we have previously seen, works like *Corner in a Café-Concert* and *Café-Concert* direct our attention to the men and women who frequented these establishments and the waitresses moving among them. In *A Bar at the Folies-Bergère*, however, we become effectively part of the clientele, looking at the woman behind the bar.

Since its reorganization in 1871, the Folies-Bergère had consisted of two areas: one, the winter garden, a large hall with balconies; and the other, where Manet sets his picture, a theatre with balconies and seats above, and below, a space to saunter, to drink and to exchange pleasantries. For those interested in watching the events on stage, there were, among other things, acrobats, circuses and operettas. Manet visited the Folies-Bergère and made sketches on the spot, but the work was executed in his studio. According to friends who visited him there, he had posed his model, a young woman called Suzon who worked at the Folies-Bergère, behind 'a table laden with bottles and comestibles'. A preliminary study shows her placed off to the right, whereas in the finished canvas she is very much the centre of attraction. Described variously by contemporary critics as the woman with a 'cardboard head', 'truly modern', a 'salesgirl', 'the fine girl in the blue-black dress', she recalls all

184 Manet
Jeanne 1882

those other women in Manet's canvases who stare out into the spectator's space. Yet there are some considerable differences. Unlike Victorine Meurent in *Le Déjeuner sur l'herbe* and *Olympia*, self-confident in her nakedness, or the more maternal and distinctly bourgeois Victorine in *The Railroad*, all of whom make eye contact with the spectator, the barmaid looks down and slightly to her right, withdrawn and cheerless. Comparisons may be made with the contemplative figure of Berthe Morisot in *The Balcony* and *Repose*, but introspection does not adequately describe the barmaid's expression. Nor, certainly, is there anything of Nana's coquettishness about her. If there is a precedent, it is perhaps the young woman in *Argenteuil*, world-weary and dispirited, who gazes off to her left.

Although the image of the barmaid invests the picture with an extraordinary poignancy, it also serves to contrast with the brilliance (on the surface, at any rate) of electric lights, chandeliers, crystal bowls, sparkling mandarins, vases, and assorted bottles of beverage. All this and more is reflected in the mirror behind the barmaid; its yellow frame, punctuated by the still lifes and the wrists of the woman, can be made out towards the bottom of the picture. Yet as puzzled critics pointed out at the time, and many scholars have commented upon since, the reflection of the barmaid and the customer at the far right simply cannot be reconciled with the mirror which runs parallel to the marble counter. A cartoon in the *Chronique parisienne* hinted at this ambiguity. Captioned 'The two-headed woman of the Folies-Bergère!', it does away with the reflected back of the woman and simply adds another head to the 'real' barmaid. The top-hatted man is still there on the right, but he is now more animated and points his cane at the 'other' woman.

In the top left corner of *A Bar at the Folies-Bergère* Manet shows the tiny legs of a trapeze artiste whose green shoes echo the lean-necked bottle of crème de menthe on the table at the bottom right. This touch of humour would seem out of place in a such a solemn image, but it is entirely characteristic of Manet to disturb the narratives he builds up. Below the acrobat, but ,oblivious to her presence, elegant spectators sit and converse. The two women with their arms on the rail of the balcony (the woman in white is taken from Manet's pastel study of Méry Laurent with whom he had become close friends during his last years) look to their right, while the woman dressed in black gazes through opera glasses.

There is a lot of 'looking' going on in this painting – we at the picture; the barmaid at us, but not quite; the reflected exchange between waitress and customer; the women on the balcony observing a performance we

cannot see. The activity of 'looking', then, brings us back to the mirror. We all make use of this item, everyday: it throws ourselves back at us. In this sense, it is tailor-made for the narcissist. Which of course is why Baudelaire required the dandy to 'live and sleep in front of a mirror'. Not so with Manet, however, in whom dandyism manifested itself more in terms of self-effacement, distancing, irony, and yes, ironically, engagement.

The problematic reflection in *A Bar at the Folies Bergère*, therefore, is a fitting metaphor for Manet's practice as a whole. His particular brand of Realism was never a simple reflection of the world around him. Whether it be a depiction of picnickers or a prostitute, the execution of a political figure or a group portrait of close friends, the subjects are both immediately familiar yet disturbingly distant: the perspective is wrong; faces are unsmiling when the opposite might be expected; celebration is turned into subtle criticism. The references to the world beyond are real enough – there are the cafés, the environs of Paris, the bourgeoisie and the beggars – but these for the most part are manipulated and reframed in his studio. In *A Bar at the Folies Bergère* he re-creates the setting by posing the 'real' waitress, Suzon, behind a mock-up bar. 'It seems that this painting represents a bar at the Folies-Bergère', wrote the critic Henry Houssaye, '[but] Is this painting true? No! Is it attractive? No! Well, then! What is it?' While today we would not ask such questions of Manet's picture, there is something about Houssaye's emphatic 'What is it?' that strikes a familiar note. In our postmodernist times we may happily accept the instability of meaning, but even so, when confronted by *A Bar at the Folies-Bergère* and other images by Manet, we often feel a need to ask, 'Well, then! What is it?' Realist art which fractures, distorts, and manipulates; one which appropriates from older art and the popular imagery of its own day, which makes visual puns and which destabilizes the act of looking. Manet's is an art which focuses on modern life, but nearly always in ironic and unsettling ways.

185 Anonymous caricature of Manet's *A Bar at the Folies-Bergère*, from *Chronique parisienne* 14 May 1882

Select Bibliography

Catalogues Raisonnés and Correspondence

Courthion, Pierre and Cailler, Pierre (eds), *Portrait of Manet by Himself and his Contemporaries*, trans. M. Ross, London, 1960. Harris, Jean Collins, *Edouard Manet: Graphic Works, a Definitive Catalogue Raisonné*, New York, 1970. Moreau-Nelaton, *Manet raconté par lui-même*, 2 vols, Paris, 1926. Rouart, L. et fils (eds), *Edouard Manet: Lettres de jeunesse*, Paris, 1928. Tabarant, Adolphe, *Histoire catalographique*, Paris, 1931. Wildenstein, Daniel, and Rouart, Denis, *Edouard Manet: Catalogue Raisonné*, 2 vols, Paris and Lausanne, 1975. Wilson-Bareau, Juliet (ed.), *Manet by Himself*, Boston, Toronto and London, 1991.

Manet and his Times

Adler, Kathleen, *Manet*, Oxford, 1986. Biez, Jacques de, *Manet*, Paris, 1884. Blanche, Jacques-Emile, *Manet*, Paris, 1924. Cachin, Françoise, et al., *Manet 1832–1883* (exh. cat.), Grand Palais, Paris and Metropolitan Museum of Art, New York, 1983. Clark, T.J., *The Painting of Modern Life: Paris in the Art of Manet and his Followers*, London, 1984. Darragon, E., *Manet*, Paris, 1989. Duret, Theodore, *Histoire d'Edouard Manet et de son oeuvre*, Paris, 1902. Farwell, Beatrice, *Manet and the Nude: A Study in Iconography in the Second Empire* (Ph.D diss. 1973), New York, 1981. Hamilton, George Heard, *Manet and his Critics* (New Haven, 1954), New York, 1969. Hanson, Anne Coffin, *Manet and the Modern Tradition*, New Haven and London, 1977. Herbert, Robert L., *Impressionism: Art, Leisure and Parisian Society*, New Haven and London, 1988. Perruchot, Henri, *Manet*, trans. H. Hare, London, 1962. Reff, Theodore, *Manet and Modern Paris* (exh. cat.), National Gallery of Art, Washington D.C., 1982. Rewald, John, *The History of Impressionism*, London and New York, 1946 (4th edn rev. 1973). Richardson, John, *Edouard Manet: Paintings and Drawings*, London and New York, 1958 (new edn annotated by K. Adler, Oxford, 1982). Rubin, James H., *Manet's Silence and the Poetics of Bouquets*, Cambridge, Mass., 1994. Sandblad, Nils Gösta, *Manet: Three Studies in Artistic Conception*, trans. W. Nash, Lund, 1954. Wilson-Bareau, Juliet, intro. John House, *The Hidden Face of Manet* (exh. cat.), Courtauld Institute Galleries, London, 1986; reprinted in *The Burlington Magazine*, April 1986.

CHAPTER ONE
Boime, Albert, *The Academy and French Painting in the Nineteenth Century*, London, 1971; *Thomas Couture and the Eclectic Vision*, New Haven and London, 1980. Druick, Douglas, and Hoog, Michel, *Fantin-Latour* (exh. cat.), Grand Palais, Paris, 1982. Faunce, Sarah, and Nochlin, Linda, *Courbet Reconsidered*, Brooklyn, 1988. Locke, Nancy, 'New documentary information on Manet's "Portrait of the artist's parents"', *The Burlington Magazine*, April 1991. Nochlin, Linda, *Realism and Tradition in Art: 1848–1900*, New Jersey, 1966. Peat, Anthony B. North, *Gossip from Paris during the Second Empire. Correspondence (1864–1869) of Anthony N. North Peat*, selected and arranged by A.R. Waller, London, 1903. Proust, Antonin, 'Edouard Manet: Souvenirs', *La Revue blanche*, February–April 1897. Tabarant, Adolphe, 'Un Manet Inedit', *La Renaissance*, May 1930. Vollard, Ambroise, *La Vie & l'oeuvre de Pierre-Auguste Renoir*, Paris, 1919.

CHAPTER TWO
Baudelaire: *Selected Writings on Art and Artists*, trans. and intro. P. E. Charvet, Harmondsworth, 1972. De Goncourt, Edmond and Jules, *Manette Salomon*, Paris, 1929. Fried, Michael, 'Manet's Sources. Aspects of his Art, 1859–1865', *Artforum*, March 1969. Krauss, Rosalind, 'Manet's "Nymphe Surprised"', *The Burlington Magazine*, November 1967. Krell, Alan, 'Manet's *Déjeuner sur l'herbe* in the *Salon des Refusés*: A Re-Appraisal', *The Art Bulletin*, June 1983. Mauner, George, *Manet: Peintre-philosophe. A Study of the Painter's Themes*, University Park and London, 1975. Nochlin, Linda, 'The Invention of the Avant-Garde: France, 1830–80', *Avant-Garde Art*, Hess, T.B. and Ashbery, J. (eds), London, 1967/68. Pointon, Marcia R., *Naked Authority: The Body in Western Painting, 1830–1908*, Cambridge, 1990. Reff, Theodore, 'Manet's Sources: a Critical Evaluation', *Artforum*, September 1969. Truqui, Alfred, *Zoologie parisienne*, Paris, 1869. Uzzane, Octave, *Fashion in Paris: the Various Phases of Feminine Taste and Aesthetics from 1797–1897*, trans. Lady Mary Loyd, London, 1898. Wright, Charles H.C., *The Background of Modern French Literature*, Boston, 1926.

CHAPTER THREE
Baudelaire, Charles, *Les Fleurs du mal*, trans. Richard Howard, London, 1982. Bernheimer, Charles, *Figures of Ill Repute: Representing Prostitution in Nineteenth-Century France*, Cambridge, Mass., 1989. Corbin, Alain, *Women for Hire: Prostitution and Sexuality in France after 1850*, trans. Alan Sheridan, Cambridge, Mass., 1990. Flescher, Sharon, *Zacharie Astruc: Critic, Artist, and Japoniste* (Ph.D diss. 1977), New York and London, 1978. Kete, Kathleen, *The Beast in the Boudoir: Petkeeping in Nineteenth-Century Paris*, Berkeley, Los Angeles and London, 1994. Krell, Alan, 'The Fantasy of Olympia', *The Connoisseur*, August 1977. Lipton, Eunice, *Alias Olympia*, London, 1992. McPherson, Heather, 'Manet: Reclining Women of Virtue and Vice', *Gazette des Beaux-Arts*, January 1990. Reff, Theodore, *Manet: Olympia*, London, 1976. Virmaitre, Charles, *Les Curiosités de Paris*, Paris, 1868.

CHAPTER FOUR
Ebin, Ima N., 'Manet and Zola', *Gazette des Beaux-Arts*, June 1945. Faison, S. Lane, Jr, 'Manet's Portrait of Zola', *Magazine of Art*, May 1949. Hadler, Mona, 'Manet's Woman with a Parrot of 1866', *Metropolitan Museum Journal*, VII, 1973. Krell, Alan, 'Manet, Zola and the "Motifs d'une exposition particulière"', *Gazette des Beaux-Arts*, March 1982. Reff, Theodore, 'Manet's Portrait of Zola', *The Burlington Magazine*, January 1975. Zola, Emile, *Salons*, F.W. Hemmings and R.J. Niess (eds), Geneva, 1959.

CHAPTER FIVE
Carey, John (ed.), *The Faber Book of Reportage*, London and Boston, 1987. Chapman, J.M., and Brian, *Baron Haussmann: Paris in the Second Empire*, London, 1957. Edelstein, T.J. (ed.), *Perspectives on Morisot*, New York, 1990. Garb, Tamar, *Women Impressionists*, Oxford, 1986. Pollock, Griselda, *Vision and Difference*, London and New York, 1988. Rouart, Denis (ed.),

Berthe Morisot, the Correspondence with her Family and Friends, trans. Betty W. Hubbard, intro. and notes Kathleen Adler and Tamar Garb, Mt Kisco, New York, 1987. Wilson-Bareau, Juliet, essays by John House and Douglas Johnson, Manet: The Execution of Maximilian: Painting, Politics and Censorship (exh. cat.), National Gallery of Art, London, 1992. Zeldin, Theodore, France, 2 vols, Oxford, 1972.

CHAPTER SIX

Hutton, John, 'The Clown at the Ball: Manet's Masked Ball of the Opera and the Collapse of Monarchism in the Early Third Republic', The Oxford Art Journal, 10:2, 1987. Kessler, Marni Reva, 'Reconstructing Relationships: Berthe Morisot's Edma Series', Woman's Art Journal, 12:1, Spring/Summer 1991. Loyrette, Henri, and Tinterow, Gary, Les Impressionnisme les origines 1859–1869 (exh. cat.), Grand Palais, Paris, and Metropolitan Museum of Art, New York, 1994/95. C.S. Moffett, et al., The New Painting: Impressionism 1874–1886 (exh. cat.), Fine Arts Museum of San Francisco and National Gallery of Art, Washington D.C., 1986. Nochlin, Linda, The Politics of Vision, London, 1991. Rand, Harry, Manet's Contemplation at the Gare Saint-Lazare, Berkeley and Los Angeles, London, 1987.

CHAPTER SEVEN

Benjamin, Walter, Charles Baudelaire: A Lyric Poet in the Era of High Capitalism, trans. Harry Zohn, London and New York, 1976. Broude, Norma, Impressionism: A Feminist Reading, New York, 1991. Distel, Anne et al., Gustave Caillebotte 1848–1894 (exh. cat.), Grand Palais, Paris, and The Art Institute, Chicago, 1994/95. Lipton, Eunice, 'Manet: A Radicalized Female Imagery', Artforum, March 1975; Looking into Degas: Uneasy Images of Women and Modern Life, Berkeley, 1986. Mainardi, Patricia, 'Edouard Manet's "View of the Universal Exposition of 1867"', Arts Magazine, January 1980. Spate, Virginia, The Colour of Time: Claude Monet, London, 1992. Tucker, Paul, Monet at Argenteuil, New Haven and London, 1982. Varnedoe, Kirk, Gustave Caillebotte, New Haven and London, 1987.

CHAPTER EIGHT

Charles Baudelaire: Intimate Journals, trans. Christopher Isherwood, intro. T.S. Eliot (1930), London, 1990. Clayson, Hollis, Painted Love: Prostitution in French Art of the Impressionist Era, New Haven, and London, 1991. Collins, Bradford R., 'Manet's "Rue Mosnier Decked with Flags" and the Flâneur Concept', The Burlington Magazine, November 1975. Druick, Douglas, and Zegers, Peter, 'Manet's "Baloon": French Diversion, The Fête de l'Empereur 1862', The Print Collector's Newsletter, May–June 1983. Eisenmann, Stephen F., 'Nonfiction Painting: Mimesis and Modernism in Manet's "Escape of Rochefort"', Art Journal, Winter 1987. Harrison, James A. (ed.), The Complete Works of Edgar Allan Poe, 17 vols, New York, 1979. Leiris, Alain de, The Drawings of Edouard Manet, Berkeley and Los Angeles, 1969. Roos, J.M., 'Within the "Zone of Silence": Manet and Monet in 1878,' Art History, September 1988. Ross, Novelene, Manet's Bar at the Folies-Bergère and the Myths of Popular Illustration, Ann Arbor, Michigan, 1982. Zola, Emile, The Kill (La Curée), trans. A. Teixeira De Mattos, London, 1957; Nana, trans. George Holden, Harmondsworth, 1972.

List of Illustrations

Measurements are given in centimetres, followed by inches, height before width before depth.

1 Nadar, photograph of Manet c. 1865. Bibliothèque Nationale, Paris.

2 Salon public from La Vie parisienne 21 May 1864. © Photo Bibliothèque Nationale, Paris.

3 Manet Spanish Singer 1860. Oil on canvas 147.3 x 114.3 (58 x 45). The Metropolitan Museum of Art, New York. Gift of William Church Osborn, 1949.

4 Manet Portrait of M. and Mme Auguste Manet 1860. Oil on canvas 111.5 x 91 (44 x 35¾). Musée d'Orsay, Paris. © Photo R.M.N.

5 Thomas Couture Romans of the Decadence 1847. Oil on canvas 473.7 x 787.4 (186½ x 310). Musée d'Orsay, Paris. © Photo R.M.N.

6 Manet Self-portrait 1850s. From A Tabarant 'Un Manet Inedit', La Renaissance, May 1930.

7 Manet Fishing 1861–63. Oil on canvas 76.8 x 123.2 (30¼ x 48½). The Metropolitan Museum of Art. Purchase, Mr and Mrs Richard Bernhard Fund, 1957.

8 Rubens The Castle Park. Oil on wood 52.7 x 97 (20¾ x 38¼). Kunsthistorisches Museum, Vienna.

9 Manet Music in the Tuileries 1862. Oil on canvas 76 x 118 (30 x 46½). Reproduced by courtesy of The Trustees of the National Gallery, London.

10 Manet after Velazquez The Little Cavaliers c. 1858–59. Oil on canvas 47 x 78 (18½ x 30¼). Chrysler Museum, Norfolk, Virginia.

11 Gustave Courbet The Painter's Studio: A Real Allegory Summing up Seven Years of My Artistic Life 1855. Oil on canvas 359 x 598 (141⅜ x 235½). Musée d'Orsay, Paris.

12 Henri Fantin-Latour Homage to Delacroix 1864. Oil on canvas 160 x 250 (63 x 98½). Musée d'Orsay, Paris.

13 Henri Fantin-Latour The Studio in the Batignolles Quarter 1870. Oil on canvas 203 x 270 (80¼ x 106). Musée d'Orsay, Paris.

14 Henri Fantin-Latour Portrait of Manet 1867. Oil on canvas 116.8 x 88.9 (46 x 35½). Courtesy of The Art Institute of Chicago. The Stickney Fund.

15 Manet Reclining Nude c. 1858–60. Red chalk 24.5 x 45.7 (9⅝ x 18). Musée du Louvre, Paris. © Photo R.M.N.

16 François Boucher Diana at the Bath 1742. Oil on canvas 56 x 73 (22 x 28½). Musée du Louvre, Paris.

17 Manet The Surprised Nymph 1859–61. Oil on canvas 146 x 114 (57½ x 45). Museo Nacional de Bellas Artes, Buenos Aires.

18 Manet Baudelaire in Profile Wearing a Hat c. 1862–65. Etching 13 x 7.5 (5⅛ x 3). Bibliothèque Nationale, Paris.

19 Manet Le Déjeuner sur l'herbe 1863. Oil on canvas 208 x 264 (82 x 104). Musée d'Orsay, Paris. © Photo R.M.N.

20 Marcantonio Raimondi after Raphael Judgment of Paris c. 1520. 29.8 x 44.2 (11¾ x 17½). Copyright British Museum.

21 Titian *Concert champêtre c.* 1508. Oil on canvas. 105 x 137 (41¼ x 54). Musée du Louvre, Paris.

22 Gilbert Shelton *Déjeuner sur l'herbe* 1994. Copyright Gilbert Shelton. Reproduced by permission of Knockabout Comics.

23 Cover of Bow Wow Wow's album *Go Wild in the Country* 1981. Sleeve © 1981 RCA Ltd. Design Nick Egan. Photography Andy Earl.

24 Cover of *The Australian Magazine* 17–18 December 1994. Republished with permission of Bill Leak/*The Australian Magazine*.

25 Grandville *Nouvelle jugement de Paris*, from his *Galerie mythologique* 1830. 20 x 26 (7⅞ x 10¼). © Photo Bibliothèque Nationale, Paris.

26 James Tissot *Partie carrée* 1870. Oil on canvas 147.3 x 119.4 (58 x 47). Private collection. Photo Copyright British Museum.

27 *Carte à rire, La Partie carrée au clair de la lune c.* 1815–30. 6.2 x 8.9 (2½ x 3½). © Photo Bibliothèque Nationale, Paris.

28 *Carte à rire, Promenade de Longchamp c.* 1815–30. 6.2 x 8.9 (2½ x 3½). © Photo Bibliothèque Nationale, Paris.

29 *Battle of Waterloo* 1835. Coloured woodcut 41.7 x 63.8 (16½ x 25⅛).

30 Gillot 'Les Tableaux plastiques dans le monde', from *La Vie parisienne* 1 May 1863. © Photo Bibliothèque Nationale, Paris.

31 Manet *Young Woman Reclining in Spanish Costume* 1862. Oil on canvas 94.7 x 113.7 (37¼ x 44¼). Yale University Art Gallery. Bequest of Stephen Carlton Clark, B.A. 1903.

32 Manet *Lola de Valence* 1862. Oil on canvas 123 x 92 (48½ x 36½). Musée d'Orsay, Paris.

33 Francisco de Goya *Naked Maja c.* 1798–1805. Oil on canvas 94.9 x 189.9 (37⅛ x 74¾). Museo del Prado, Madrid.

34 Francisco de Goya *Dressed Maja c.* 1798–1805. Oil on canvas 94.9 x 189.9 (37⅛ x 74¾). Museo del Prado, Madrid.

35 Manet *Mlle V. in the Costume of an Espada* 1862. Oil on canvas 165.1 x 127.6 (65 x 50¼). The Metropolitan Museum of Art. Bequest of Mrs H O Havemeyer, 1929. The H O Havemeyer Collection.

36 Manet *Young Man in the Costume of a Majo* 1862. Oil on canvas 188 x 124.8 (74 x 49⅛). The Metropolitan Museum of Art. Bequest of Mrs H O Havemeyer, 1929. The H O Havemeyer Collection.

37 Caricature by Gillot of 'Salon de 1863: Les Refusés', from *La Vie parisienne* 11 July 1863. © Photo Bibliothèque Nationale, Paris.

38 James McNeill Whistler *Symphony in White No. 1, The White Girl* 1862. Oil on canvas 214.6 x 107.5 (84½ x 42⅜). National Gallery of Art, Washington D.C. Harris Whittemore Collection.

39 Paul Baudry *The Pearl and the Wave* 1862. Oil on canvas 83 x 175 (32⅝ x 68⅞). Museo del Prado, Madrid. Photo Mas, Barcelona.

40 Alexandre Cabanel *Birth of Venus* 1863. Oil on canvas 130 x 225 (51⅛ x 88½). Musée d'Orsay, Paris.

41 Félix-Henri Giacomotti *The Abduction of Amymone* 1865. Oil on canvas 46 x 36 (18⅛ x 14⅛). Musée Raimon-Lafage, Lisle-sur-Tarn. © Photo R.M.N., Paris.

42 Manet *The Street Singer* 1862. Oil on canvas 175.2 x 108.6

(69 x 42¾). Courtesy, Museum of Fine Arts, Boston. Bequest of Sarah Choate Sears.

43–46 Manet *Olympia* 1863. Oil on canvas 130.5 x 190 (51¼ x 74¾). Musée d'Orsay, Paris. © Photo R.M.N.

47 Caroline Coon *Mr Olympia* 1983. Oil on canvas 91.4 x 121.9 (36 x 48). Caroline Coon/Photo Women's Art Library.

48 Annette Bezor *Odelympia* 1988. Oil on linen 162 x 240 (63¾ x 94½). Queensland Art Gallery, Brisbane.

49 John O'Reilly *Preparing to Photograph Olympia* 1984. Photographic collage 9.5 x 12.4 (3¾ x 4⅞). © Copyright John O'Reilly, 1984. Collection of Joshua Smith, Washington D.C.

50 Manet *Portrait of Jeanne Duval* 1862. Oil on canvas 90 x 113 (35½ x 44½). Szépmüvészeti Museum, Budapest.

51 Diego Velazquez *Portrait of Queen Mariana of Spain c.* 1635. Oil on canvas 208.9 x 125.1 (82¼ x 49¼). Musée du Louvre, Paris.

52 Titian *Venus of Urbino* 1538. Oil on canvas 118 x 167 (47 x 65). Uffizi, Florence.

53 Caricature by Bertall of Manet's *Olympia*, from *Le Journal amusant* 27 May 1865. © Photo Bibliothèque Nationale, Paris.

54 Caricature by G. Randon of Manet's *Olympia*, from *Le Journal amusant* 29 June 1867. © Photo Bibliothèque Nationale, Paris.

55–57 Caricatures of Manet's black cat, 1865. © Photo Société Amis Bibliothèque d'Art et d'Archaeologie, Paris.

58 Illustration by Cook: Courbet as 'Le Realiste', from Louis Leroy *Artistes et rapins* 1868. © Photo Bibliothèque Nationale, Paris.

59 Jean-Auguste-Dominique Ingres *Odalisque with Slave* 1842. Oil on canvas 71.1 x 100 (28 x 39⅜). Walters Art Gallery, Baltimore.

60 Manet *Portrait of Zacharie Astruc* 1866. Oil on canvas 90 x 116 (35½ x 45¾). Kunsthalle, Bremen.

61 Manet *Jesus Mocked by the Soldiers* 1865. Oil on canvas 190.8 x 148.3 (75⅛ x 58⅜). Courtesy of The Art Institute of Chicago. Gift of James Deering.

62 Caricature by Bertall of Manet's *Jesus Mocked by the Soldiers*, from *Le Journal amusant* 27 May 1865. © Photo Bibliothèque Nationale, Paris.

63 Caricature by Gill of Champfleury, cover of *L'Eclipse* 29 March 1868. © Photo Bibliothèque Nationale, Paris.

64 Manet *Portrait of George Moore* 1879. Pastel on canvas 55.3 x 35.3 (21¾ x 14). The Metropolitan Museum of Art, New York. Bequest of H O Havemeyer, 1929. The H O Havemeyer Collection.

65 Diego Velazquez *Pablillos de Valladolid* 1632–34. Oil on canvas 209 x 123 (82¼ x 48⅜). Museo del Prado, Madrid.

66 Manet *The Fifer* 1866. Oil on canvas 160 x 98 (63 x 38½). Musée d'Orsay, Paris. © Photo R.M.N.

67 Manet *The Tragic Actor* 1865. Oil on canvas 187.2 x 108.1 (73¾ x 42½). National Gallery of Art, Washington D.C. Gift of Edith Stuyvesant Gerry.

68 Manet's signed application to place an advert in the 1867 Exposition Universelle catalogue. The Pierpont Morgan Library, New York.

69 Manet *Portrait of Emile Zola* 1868. Oil on canvas 146 x 114 (57½ x 45). Musée d'Orsay, Paris. © Photo R.M.N.

70 Caricature by Bertall of Manet's *Young Lady in 1866*, from *Le Journal amusant* 19 May 1867.

71, 72 Manet *Young Lady in 1866* 1866. Oil on canvas 185.1 x 128.6 (72⅛ x 50⅝). The Metropolitan Museum of Art, New York. Gift of Erwin Davis, 1889.

73 Detail of Gustave Courbet *Woman with a Parrot* 1866. Oil on canvas 129.5 x 195.6 (51 x 77). The Metropolitan Museum of Art, New York. Bequest of Mrs H O Havemeyer, 1929. The H O Havemeyer Collection.

74 Manet *The Angels at the Tomb of Christ* 1864. Oil on canvas 179.4 x 149.9 (70⅝ x 59). The Metropolitan Museum of Art. Bequest of Mrs H O Havemeyer, 1929. The H O Havemeyer Collection.

75 Manet *Battle of the Kearsage and Alabama* 1864. Oil on canvas 138.8 x 129.9 (54⅝ x 51⅛). Philadelphia Museum of Art. The John G Johnson Collection.

76 Caricature by Stop of Manet's *Battle of the Kearsage and Alabama*, from *Le Journal amusant* 25 May 1872. © Photo Bibliothèque Nationale, Paris.

77 Adolphe Yvon *Capture of the Malakoff Tower, 8 September 1855 (Crimea)* 1857. Oil on canvas 600 x 900 (236¼ x 354⅜). Musée National du Château de Versailles. © Photo R.M.N.

78 Manet *Execution of Maximilian* 1867. Oil on canvas 196 x 259.8 (77¼ x 102¼). Courtesy, Museum of Fine Arts, Boston. Gift of Mr and Mrs Frank Gair Macomber.

79 Manet *Execution of Maximilian* 1867. Oil on canvas, four fragments on a single support 193 x 284 (76 x 111⅞). Reproduced by courtesy of The Trustees of the National Gallery, London.

80 Francisco de Goya *Executions of the Third of May, 1808* 1815. Oil on canvas 266 x 344.8 (104¼ x 135¼). Museo del Prado, Madrid.

81 Manet *Execution of Maximilian* 1868–69. Oil on canvas 252 x 305 (99¼ x 120⅛). Städtische Kunsthalle, Mannheim.

82 Jean-Léon Gérôme *Death of Caesar* 1859. Oil on canvas 85.3 x 145.4 (33⅝ x 57¼). Walters Art Gallery, Baltimore.

83 Caricature by Pons of *The Balcony*, from *La Parodie* No. 1 1869. © Photo Bibliothèque Nationale, Paris.

84 Manet *The Balcony* 1868–69. Oil on canvas 169 x 125 (66½ x 49¼). Musée d'Orsay, Paris. © Photo R.M.N.

85 Manet *The Luncheon* 1868–69. Oil on canvas 118.3 x 153.9 (46½ x 60⅝). Bayerische Staatsgemäldesammlungen, Neue Pinakothek, Munich.

86 Manet *Reading, Mme Manet and Léon* 1865–73? Oil on canvas 61 x 74 (24 x 29¼). Musée d'Orsay, Paris. © Photo R.M.N.

87 Eva Gonzalès *The Little Soldier* 1870. Oil on canvas 130 x 98 (51 x 38½). Hôtel de Ville, Villeneuve-sur-Lot.

88 Manet *Portrait of Eva Gonzalès* 1870. Oil on canvas 191 x 133 (75¼ x 52⅜). Reproduced by courtesy of The Trustees of the National Gallery, London.

89 Manet *Repose* 1869–70. Oil on canvas 148 x 113 (58¼ x 44½). Museum of Art, Rhode Island School of Design, Providence.

90 Mary Cassatt *Woman in Black at the Opera* 1880. Oil on canvas 80 x 64.8 (31½ x 25½). Courtesy, Museum of Fine Arts, Boston. The Hayden Collection.

91 Eva Gonzalès *A Loge at the Théâtres des Italiens* 1874. Oil on canvas 98 x 130 (38½ x 51). Musée d'Orsay, Paris. © Photo R.M.N.

92 Manet *The Barricade* 1871. Pencil, ink wash, watercolour and gouache 46.2 x 32.5 (18¼ x 12¾). Szépmüvészeti Museum, Budapest.

93 Manet *Civil War* 1871–73. Lithograph 39.9 x 50.8 (15¾ x 20).

94 Manet *The Dead Toreador* 1863–65. Oil on canvas 76 x 153.3 (29⅞ x 60⅜). National Gallery of Art, Washington D.C. Widener Collection, 1942.

95 Manet *Boy with a Sword* 1861. Oil on canvas 131.1 x 93.3 (51⅜ x 36¾). The Metropolitan Museum of Art, New York. Gift of Erwin Davis, 1889.

96 Manet *Matador Saluting* 1866. Oil on canvas 171.1 x 113 (67¾ x 44½). The Metropolitan Museum of Art, New York. Bequest of Mrs H O Havemeyer, 1929. The H O Havemeyer Collection.

97 Manet *Portrait of Théodore Duret* 1868. Oil on canvas 43 x 35 (17 x 13¾). Musée du Petit Palais, Paris.

98 Frans Hals *Jolly Trooper* 1629. Oil on canvas 81.5 x 66.5 (32 x 26⅛). Rijksmuseum, Amsterdam.

99 Manet *Le Bon Bock* 1873. Oil on canvas 94.6 x 83 (37¼ x 32⅛). The Philadelphia Museum of Art. Mr and Mrs Carroll S Tyson Collection, Philadelphia.

100 Caricature by Cham of Manet's *Le Bon Bock*, from *Le Charivari* 8 June 1873. © Photo Bibliothèque Nationale, Paris.

101 Manet *Berthe Morisot with a Bunch of Violets* 1872. Oil on canvas 22 x 27 (8¾ x 10¾). Private collection.

102 Auguste Renoir *Portrait of Bazille* 1867. Oil on canvas 105 x 73 (41½ x 28½). Musée d'Orsay, Paris. © Photo R.M.N.

103 Manet *Portrait of Jules de la Rochenoire* 1882. Pastel on linen canvas 55 x 34.5 (21⅝ x 13½). Josefowitz Collection.

104 Nadar's studio at 35 boulevard des Capucines, c. 1860. Bibliothèque Nationale, Paris.

105 Stanilas Lépine *Banks of the Seine* 1869. Oil on canvas 30 x 50 (11¾ x 19⅝). Musée d'Orsay, Paris. © Photo R.M.N.

106 Paul Cézanne *A Modern Olympia* 1872–73. Oil on canvas 46 x 55.5 (18⅛ x 21⅞). Musée d'Orsay, Paris. © Photo R.M.N.

107 Claude Monet *Boulevard des Capucines* 1873–74. Oil on canvas 79.4 x 59 (31¼ x 23¼). The Nelson-Atkins Museum of Art, Kansas City.

108 Berthe Morisot *The Cradle* 1873. Oil on canvas 56 x 46 (22 x 18⅛). Musée d'Orsay, Paris.

109 Berthe Morisot *The Lesson* 1869–70. Oil on canvas 101 x 81.8 (39½ x 32¼). National Gallery of Art, Washington D.C. Chester Dale Collection.

110 Manet *Swallows* 1873. Oil on canvas 65 x 81 (25⅝ x 31⅞). Stiftung Sammlung E G Bührle, Zurich.

111 Manet *The Masked Ball at the Opera* 1873–74. Oil on canvas 60 x 73 (23½ x 28¾). National Gallery of Art, Washington D.C. Gift of Mrs Horace Havemeyer in memory of her mother-in-law, Louisine W Havemeyer.

112 Auguste Renoir *The Opera Box* 1874. Oil on canvas 80 x 63 (31½ x 25). Courtauld Institute Galleries, London.

113 Auguste Renoir *The Dancer* 1874. Oil on canvas 142.5 x 94.5 (56⅛ x 37¼). National Gallery of Art, Washington D.C. Widener Collection.

114 Gustave Caillebotte *Self-portrait at the Easel* c. 1879–80. Oil on canvas 88.9 x 116.2 (35 x 45¾). Private collection, Paris.

115 Manet *The Railroad* 1872–73. Oil on canvas 93 x 114 (36½ x 45). National Gallery of Art, Washington D.C. Gift of Horace Havemeyer in memory of his mother, Louisine W Havemeyer.

116 Manet *Polichinelle* 1874. Lithograph 47.1 x 33.7 (18½ x 13¼). Bibliothèque Nationale, Paris.

117 Auguste Renoir *La Grenouillère* 1869. Oil on canvas 66 x 86 (26 x 34). Nationalmuseum, Stockholm.

118 Claude Monet *La Grenouillère* 1869. Oil on canvas 75 x 100 (29 x 39). The Metropolitan Museum of Art, New York. Bequest of H O Havemeyer, 1929. The H O Havemeyer Collection.

119 Manet *The Seine at Argenteuil* 1874. Oil on canvas 61 x 101 (24 x 39¾). Private collection.

120 Manet *The Monet Family in the Garden* 1874. Oil on canvas 61 x 99.7 (24 x 39¼). The Metropolitan Museum of Art, New York. Bequest of Joan Whitney Payson, 1975.

121 Berthe Morisot *Hide and Seek* 1873. Oil on canvas 45.1 x 54.9 (17¾ x 21⅝). From the collection of Mrs John Hay Whitney.

122 Manet *Boating* 1874. Oil on canvas 97.2 x 130.2 (38¼ x 51¼). The Metropolitan Museum of Art, New York. Bequest of Mrs H O Havemeyer, 1929. The H O Havemeyer Collection.

123 Manet *Argenteuil* 1874. Oil on canvas 151.8 x 114.9 (59¾ x 45¼). Musée des Beaux-Arts, Tournai.

124 Manet *Café-Concert* 1878. Oil on canvas 47.5 x 32 (18⅝ x 12⅝). The Walters Art Gallery, Baltimore.

125 Manet *Corner in a Café-Concert* 1878 or 1879. Oil on canvas 98 x 79 (38½ x 31⅛). Reproduced by courtesy of The Trustees of the National Gallery, London.

126 Manet *At the Café* 1878. Oil on canvas 77 x 83 (30¼ x 32⅝). Sammlung Oskar Reinhart 'Am Römerholz', Winterthur.

127 Edgar Degas *Aux Ambassadeurs* 1876–77. Pastel over monotype in black ink on heavy white laid paper 36 x 28 (14⅛ x 11). Musée des Beaux-Arts, Lyon.

128 Edgar Degas *Café-Concert* 1876–77. Pastel over monotype in black ink on white laid paper 24.2 x 44.5 (9½ x 17½). Corcoran Gallery of Art, Washington D.C. William A Clark Collection.

129 Edgar Degas *Women in Front of a Café, Evening* 1877. Pastel over monotype on white wove paper 41 x 60 (16⅛ x 23⅝). Musée d'Orsay, Paris.

130 Manet *The Absinthe Drinker* 1858–59. Oil on canvas 81 x 106 (31⅞ x 41¼). Ny Carlsberg Glyptothek, Copenhagen.

131 Edgar Degas *L'Absinthe* 1875–76. Oil on canvas 92 x 68 (36¼ x 26¾). Musée d'Orsay, Paris.

132 Manet *La Prune* 1878? Oil on canvas 73.6 x 50.2 (29 x 19¾). National Gallery of Art, Washington D.C. Collection of Mr and Mrs Paul Mellon.

133 Manet *Old Musician* 1862. Oil on canvas 187.4 x 248.3 (73¾ x 97¾). The National Gallery of Art, Washington D.C. Chester Dale Collection, 1962.

134 Diego Velazquez *Menippus* 1639–40. Oil on canvas 179 x 94 (70½ x 37). Museo del Prado, Madrid.

135 Manet *Philosopher* 1865–67. Oil on canvas 187.3 x 108 (73¾ x 42½). Courtesy of The Art Institute of Chicago. A A Munger Collection.

136 Claude Monet *Tuileries c.* 1876. Oil on canvas 53 x 73 (20⅞ x 28¾). Musée Marmottan, Paris.

137 Claude Monet *Le Parc Monceau* 1876. Oil on canvas 59.7 x 82.6 (23½ x 32½). The Metropolitan Museum of Art, New York. Bequest of Loula D Lasker, New York City, 1961.

138 Gustave Caillebotte *Paris Street: A Rainy Day* 1877. Oil on canvas 212 x 276 (83½ x 108¾). Courtesy of The Art Institute of Chicago. Charles H and Mary F S Worcester Fund Income.

139 Gustave Caillebotte *Le Pont de l'Europe* 1876. Oil on canvas 124.7 x 180.6 (49⅛ x 71⅛). Musée du Petit Palais, Geneva.

140 Claude Monet *Le Pont de l'Europe* 1877. Oil on canvas 64 x 81 (25 x 31½). Musée Marmottan, Paris.

141 Claude Monet *Gare Saint-Lazare* 1877. Oil on canvas 75.5 x 104 (29¼ x 41). Musée d'Orsay, Paris. © Photo R.M.N.

142 Manet *View of the 1867 Exposition Universelle* 1867. Oil on canvas 108 x 196.5 (42½ x 77⅜). Nasjonalgalleriet, Oslo.

143 Edgar Degas *Beach Scene* 1876–77. Three pieces of paper mounted on canvas 47 x 82.6 (18½ x 32½). Reproduced by courtesy of The Trustees of the National Gallery, London.

144 Manet *On the Beach at Boulogne* 1868 or 1869. Oil on canvas 32 x 65 (12⅝ x 25⅝). Virginia Museum of Art, Virginia. Collection of Mr and Mrs Paul Mellon.

145 Manet *Beach at Berck-sur-Mer* 1873. Oil on canvas 59.6 x 73.2 (23½ x 28⅞). Musée d'Orsay, Paris.

146 Manet *Portrait of Stéphane Mallarmé* 1876. Oil on canvas 27 x 36 (10⅝ x 14⅛). Musée d'Orsay, Paris.

147 Manet *Portrait of Edgar Allan Poe* 1860–62? Brush and India ink 30.5 x 22.7 (12 x 8⅞). Bibliothèque Nationale, Paris.

148 Manet, poster for 'The Raven' 1875. Transfer lithograph 16.2 x 15.8 (6⅜ x 6¼).

149 Manet *At the Window*, illustration for 'The Raven' 1875. Brush and ink transfer lithograph 38.5 x 30 (15⅛ x 11⅞).

150 Manet *The Raven on the Bust*, illustration for 'The Raven', 1875. Brush and ink transfer lithograph 47.5 x 31.6 (18¾ x 12½).

151 Manet's poster, *Cats' Rendezvous* 1868. Lithograph 122.5 x 84.5 (48¼ x 33¼).

152 Gustave Courbet *The Stonebreakers* 1849. Oil on canvas 160 x 259 (63 x 102). Formerly Gemäldegalerie, Dresden (destroyed in World War II).

153 Gustave Courbet *The Burial at Ornans* 1849–50. Oil on canvas 315 x 663 (124 x 261). Musée d'Orsay, Paris.

154 Caricature of Manet on the cover of *L'Eclipse* 11 May 1876. © Photo Société Amis Bibliothèque d'Art et d'Archaeologie, Paris.

155 Manet *The Artist* 1875. Oil on canvas 192 x 128 (75⅝ x 50⅜). Museu de Arte, Sao Paulo.

156 Manet *The Laundry* 1875. Oil on canvas 145 x 115 (57 x 45¼). The Barnes Foundation Museum of Art, Merion.

157 Edgar Degas *Women Ironing* 1884–86. Oil on unprimed canvas 76 x 81 (30 x 31⅞). Musée d'Orsay, Paris.

158 Edgar Degas *A Woman Ironing* 1874. Oil on canvas 54.2 x 39.4 (21⅜ x 15½). The Metropolitan Museum of Art, New York. Bequest of Mrs H O Havemeyer, 1929. The H O Havemeyer Collection.

159 Berthe Morisot *Laundresses Hanging Out the Wash* 1875. Oil on canvas 33 x 40.6 (13 x 16). National Gallery of Art, Washington D.C. Collection of Mr and Mrs Paul Mellon.

160 Manet *Nana* 1877. Oil on canvas 154 x 115 (60¼ x 45¼). Kunsthalle, Hamburg.

161 Edgar Degas *L'Etoile* 1876–77. Pastel over monotype 58 x 42 (22⅞ x 16½). Musée d'Orsay, Paris. © Photo R.M.N.

162 Edgar Degas *The Rehearsal on Stage* 1874. Pastel over brush and ink drawing on paper, laid on Bristol board mounted canvas 53.3 x 72.3 (21 x 28½). The Metropolitan Museum of Art. Bequest of Mrs H O Havemeyer, 1929. The H O Havemeyer Collection.

163 Edgar Degas *Before the Entrance on Stage* c. 1880. Pastel on paper 58 x 44 (22⅞ x 17⅜). Private collection.

164 Manet *Portrait of Proust* 1880. Oil on canvas 129.9 x 95.9 (51⅛ x 37¾). The Toledo Museum of Art, Toledo, Ohio. Gift of Edward Drummond Libbey.

165 Manet *In the Conservatory* 1879. Oil on canvas 115 x 150 (45¼ x 59). Staatliche Museen Preussischer Kulturbesitz, Nationalgalerie, Berlin.

166 Caricature by Stop of Manet's *In the Conservatory*, from *Le Journal amusant* 24 May 1879. © Photo Bibliothèque Nationale, Paris.

167 Marie Bracquemond *On the Terrace at Sèvres* 1880. 88 x 115 (34½ x 45¼). Fondation Oscar Ghez. Musée du Petit Palais, Paris.

168 Auguste Renoir *The Canoeist's Luncheon* 1879–80. Oil on canvas 55 x 66 (21⅝ x 26). Courtesy of The Art Institute of Chicago.

169 Manet *Chez le Père Lathuille* 1879. Oil on canvas 92 x 112 (36¼ x 44⅛). Musée des Beaux-Arts, Tournai.

170 Manet *The Balloon* 1862. Lithograph 40.3 x 51.5 (15⅞ x 20¼).

171 Manet *The Rue Mosnier Decked with Flags* 1878. Oil on canvas 65.5 x 81 (25¼ x 31⅞). Collection of J Paul Getty Museum, Malibu, CA.

172 Manet *The Escape of Rochefort* 1880–81. Oil on canvas 143 x 114 (56¼ x 44⅞). Kunsthaus, Zurich.

173 Manet *Portrait of M. Henri Rochefort* 1881. Oil on canvas 80 x 73 (31½ x 28¾). Hamburger Kunsthalle, Hamburg.

174 Gustave Caillebotte *The House-painters* 1877. Oil on canvas 89.2 x 116.2 (35⅛ x 45¼). Private collection.

175 Manet *The Rue Mosnier with Pavers* 1878. Oil on canvas 64 x 80 (25¼ x 31½). Private collection.

176 Manet *Portrait of M. Pertuiset, the Lion Hunter* 1880–81. Oil on canvas 150 x 170 (59 x 67). Museu de Arte Moderna, São Paolo.

177 Manet *A Bar at the Folies-Bergère* 1881–82. Oil on canvas 96 x 130 (37¾ x 51⅛). Courtauld Institute Galleries, London.

178 Manet study for *A Bar at the Folies-Bergère* 1881. Oil on canvas 47 x 56 (18½ x 22). Stedelijk Museum, Amsterdam.

179 Manet *Portrait of Mlle Isabelle Lemonnier* c. 1878–80. Pastel on canvas 55 x 46 (21⅝ x 18⅛). The Metropolitan Museum of Art, New York. Bequest of Mrs H O Havemeyer, 1929. The H O Havemeyer Collection.

180 Manet *Escape of Rochefort* 1881. Oil on canvas 80 x 73 (31½ x 28¼). Musée d'Orsay, Paris.

181 Manet *My Garden at Versailles* 1881. Oil on canvas 65 x 81 (25⅝ x 31⅞). Private collection.

182 Manet *White Lilacs and Roses* 1882–83. Oil on canvas 54 x 41 (21¼ x 16⅛). Paul Rosenberg Gallery, New York.

183 Manet *The Hare* 1881. Oil on canvas 97 x 60 (38⅛ x 23⅝). National Museum of Wales, Cardiff.

184 Manet *Jeanne* 1882. India ink and pencil 31.3 x 21.2 (12⅜ x 8⅜). Fogg Art Museum, Harvard University, Cambridge. Bequest Grenville L. Winthrop.

185 Anonymous caricature of Manet's *A Bar at the Folies-Bergère*, from *Chronique parisienne* 14 May 1882. © Photo Bibliothèque Nationale, Paris.

Index

Numbers in italic refer to illustrations

Académie Suisse 92
Adler, Kathleen 7
Alexander II, Tsar of Russia 83
Alexis, Paul 113–15
Ancourt, Edward 80
Argenteuil 27, 129, 132, 138, 182; *119, 123*
L'Artiste 56
Astruc, Zacharie 15, 20, 28, 61–62; *60*
Aubert, Francis 65, 72–73, 167
L'Avenir nationale 115

Balleroy, Albert de 17
Banville, Théodore de 112
Barthélemy, A. 14
Baudelaire, Charles 15, 18, 20, 26–27, 42, 50, 53, 67, 112, 159, 200; *12, 18*
Baudry, Paul 47; *39*
Bazille, Frédéric 15, 20, 113; *13, 103*
La Belle Polonaise 138; *124*
Bellot, Emile 112
Berck-sur-Mer 123, 158; *145*
Bernadotte, Charles, Crown Prince of Sweden 10, 11

Bertall 56, 58, 60, 65, 112, 153, 173; *53, 62, 70*
Bezor, Annette *48*
Le Bien public 166
Biez, Jacques de 14
Blanc, Charles 113
Blanche, Jacques-Emile 14, 54
Boubée, Simon 173
Boucher, François 24; *16*
Le Bouffon 80
Bougureau, Adolphe 47
Boulogne 85, 94, 95; *144*
Bow Wow Wow 7; *23*
Bracquemond, Félix 20, 103, 181; *12*
Bracquemond, Marie 181–82; *167*
Bracquemond, Pierre 181
Brazil 12–13
Burty, Philippe 85, 112

Cabanel, Alexandre 47, 82, 113, 116; *40*
Cachin, Françoise 7, 61, 181
Cadart, Alfred 77, 84
café-concerts 138, 139, 198; *124–29, 177, 178*
Caillebotte, Gustave 121, 129, 148, 151–53, 155, 173, 189; *114, 138, 139, 174*
Cantaloube, Amedée 56
Cardon, Emile 56
'cartes à rire' 34–37; *27, 28*
Cassatt, Mary 100; *90*

Castagnary, Jules-Antoine 20, 100, 168
Cavaignac, General Louis Eugène 12
Cézanne, Paul 76, 113, 119; *106*
Cham *100*
Champfleury, Jules Husson 18, 20, 66, 100, 162, 163, 164–65; *12, 63*
Chaplin, Charles 96
Le Charivari 119
Chaumelin, Maurice 82, 95
Chesneau, Ernest 28, 45, 197
Chronique parisienne 199
Claretie, Jules 46, 47, 56, 77, 86
Clark, T.J. 7, 56, 65
Claus, Fanny 92; *84*
Colardet (model) 146; *130, 133*
Collège Rolin 11, 12
Commune 103, 104, 192, 193
Le Constitutionnel 45
Cook (illustrator) *58*
Coon, Caroline 47
Corot, Jean-Baptiste Camille 94, 113
Courbet, Gustave 18, 20, 45, 58, 65, 76, 81, 82, 113, 165; *11, 58, 73, 152, 153*
Le Courrier de France 173
Couture, Thomas 13–14, 23, 94; *5*

D'Arpentigny 45
Debras, Louis 119

Degas, Edgar 68, 102, 113, 116, 117, 119, 129,
 139–42, 158, 171, 174–77; *127–29, 131, 143,
 157, 158, 161–63*
Delacroix, Eugène 20, 162; *12*
Desboutin, Marcellin 168, 193; *155*
Diderot, Denis 12
Duchamp, Marcel 45
Durand-Ruel, Paul 91, 107, 173
Duranty, Edmond 20; *12*
Duret, Théodore 14, 107, 116, 126, 133, 179;
 97
Duval, Jeanne 53–55; *50*

L'*Eclipse* 66, 164
Ecole des Beaux-Arts 14
Epinal 36; *29*
L'*Evénement* 72, 76
Expositions Universelles (1867) 73, 76, 83,
 155, 166; *68, 142*; (1878) 185, 194

Faison, Lane 80
Fantin-Latour, Henri 15, 18–20, 94, 113, 147,
 164, 167, 181; *12, 13, 14*
Le *Figaro* 47, 166
Le *Figaro-Programme* 56
Forbes, Archibald 103
Fourment, Héléne 14, 39
Fournel, Victor 56, 62
Fournier, Colonel Edmond 12
Fournier, Eugénie-Désirée 10, 11, 100, 122,
 123, 158; *4, 110, 145*
Fournier, Jean-Antoine 10, 11
Le *Français* 173
Franco-Prussian war 100–103

Gambetta, Léon Michel 197
Garb, Tamar 7, 100
Le *Gaulois* 168
Gautier *père* 63
Gautier, Théophile 9, 63, 67, 77, 83, 95, 96
La *Gazette de France* 56, 173
Gazette des beaux-arts 9, 94, 165
Gérôme, Jean-Léon 113; *82*
Gervex, Henri 194
Giacomotti, Félix-Henri 47; *41*
Gill, André 66; *63, 154*
Gillot (illustrator) 30, 37
Giorgione 27, 28
Gleyre, Charles 94, 113, 116
Goncourt, Jules and Edmond de 37
Gonzalès, Eva 96–100, 102; *87, 88, 91*
Gorce, Pierre de la 83
Goya y Lucientes, Francisco de 40–42, 45, 55,
 89, 91–92, 104; *33, 34, 80*
Le *Grand journal* 56
Grandville 32; *25*
La Grenouillère 129; *117, 118*
Gros, Baron Antoine Jean 13
Guéroult (model) 146; *133*
Guichard, Joseph-Benoit 94
Guillaumin, Armand 115, 116
Guillemet, Antoine 69, 92, 194; *84*
Guillemet, Mme 179–80

Hals, Frans 109; *98*
Hamilton, George Heard 106
Hauranne, Duvergier de 127

Hauser, Henriette 174, 177; *160*
Haussmann, Baron 146, 148, 151, 152
Herbert, Robert L. 7, 156
Hirsch, Alphonse 127
Holland 23, 109
Hoschédé, Ernest 116
Houssaye, Henri 200
Huysmans, Joris-Karl 17, 194

L'*Illustration* 65
Impressionism 112, 121, 129, 173
Impressionists 97, 113–16, 119–21, 173
Impressionist exhibitions 1st 94, 113, 116–121,
 129; 2nd 173; 3rd 121, 142, 189
L'*Indépendance Belge* 77
Ingres, Jean-Auguste-Dominique 181; *59*
L'*Intransigeant* 192

Jacques (pseud.) 153
Jankowitz, Victor de 62
Jean de Paris (pseud.) 166
Jongkind, Johan Barthold 115
Journal amusant 56, 77, 86
Junius (pseud.) 168, 174

Kete, Kathleen 59
Kitte, Lord 172
Kuniaki II 80
Kuniyoshi 112

Lagrange, Léon 9
Lagrene, Jean 146; *133*
Laroche, Paul 13
Laurent, Méry 199
Leenhoff, Ferdinand 28; *19*
Leenhoff, Léon (Koëlla-Leenhoff) 94, 100,
 155; *85, 86, 142*
Leenhoff, Rodolphe 133, 134; *122, 123*
Leenhoff, Suzanne 14, 23, 39, 49, 100, 102,
 122, 158; *7, 17, 110, 145*
Lefebvre, Hippolyte 37–38
Legros, Alphonse 20; *12*
Lejosne, Commandant and Mme 15
Lemonnier, Isabelle 192; *179*
Le Nain, Louis 146
Lepelletier, E. 152
Lepic, Vicomte Ludovic-Napoléon 116, 119
Lépine, Stanislas 119; *105*
Leroy, Louis 58, 119
Lesclide, Richard 193
Levert, Jean-Baptiste Léopold 116
Lipton, Eunice 7, 133
Loudun, Eugène 83

MacMahon, Marshal 127
Maître, Edmond 20; *13*
Mallarmé, Stéphane 121–23, 158, 159, 160,
 174, 195; *146*
Manet, Auguste 10, 12; *4*
Manet, Edouard
 The *Absinthe Drinker* 9, 77, 142–46; *130*
 The *Angels at the Tomb of Christ* 77, 83, 107,
 109; *14*
 Argenteuil 132–33, 134, 199; *123*
 The *Artist* 168–70; *164*
 At the Café 138–39; *126*
 The *Balcony* 69, 91–94, 95, 133, 199; *83, 84*

The *Balloon* 184–85; *170*
A *Bar at the Folies-Bergère* 126, 197,
 198–200; *177, 178, 185*
The *Barricade* 103–104; *92*
Battle of the Kearsage and Alabama 77, 84–87,
 89, 106–109, 193, 194; *75, 76*
Baudelaire in Profile, Wearing a Hat 18
Berthe Morisot with a Bunch of Violets 112; *101*
Boating 134–38, 179; *122*
Le *Bon Bock* 109, 112, 113, 117, 122, 128;
 99, 100
Boy with a Sword 107; *95*
Café-Concert 138, 198; *124*
Cats' Rendezvous 162–64; *151*
Chez le père Lathuille 183; *169*
Civil War 104; *93*
Corner in a Café-Concert 138, 198; *125*
The *Dead Toreador* 104–106; *94*
Le *Déjeuner sur l'herbe* 7, 24, 27–39, 43–46,
 49, 61, 77, 133, 174, 177, 199; *19, 22–24*
Episode from a Bullfight 109
Escape of Rochefort 86, 192–94; *172, 180*
The *Execution of Maximilian* 84, 87–91, 103,
 104, 194; *78, 79, 81*
The *Fifer* 69, 77, 97, 107; *66*
Fishing 14, 15, 17, 18, 39; *7*
The *Hare* 183
In the *Conservatory* 179; *165*
Jeanne 198; *184*
Jesus Mocked by the Soldiers 62–63, 65, 67,
 83, 109; *61, 62*
The *Laundry* 166, 168, 170–71, 172–73; *156*
Little Cavaliers 17; *10*
Lola de Valence 32
The *Luncheon* 91, 94–95, 133; *85*
Mlle V. in the Costume of an Espada 42–43,
 49, 107; *35*
The *Masked Ball at the Opera* 122, 123–27;
 111
Matador Saluting 107; *96*
The *Monet Family in the Garden* 129–31, 158;
 120
Music in the Tuileries 15–17, 18, 34, 37, 77,
 126, 147, 151, 164; *9*
My Garden at Versailles 195; *181*
Nana 34, 126, 174, 177, 179, 199; *160*
The *Old Musician* 77, 80, 146, 147; *133*
Olympia 20, 22, 26, 34, 47–49, 50–53,
 55–62, 63–65, 67, 77, 80–81, 82, 95, 100,
 109, 126, 164, 165, 174, 177, 199; *43, 44–49,
 53–57*
On the *Beach at Berck-sur-Mer* 158; *145*
On the *Beach at Boulogne* 156–58; *144*
The *Philosopher* 147; *135*
Polichinelle 122, 126–27; *116*
Portrait of Edgar Allan Poe 147
Portrait of Emile Zola 80–81; *69*
Portrait of Eva Gonzalès 96, 97; *88*
Portrait of George Moore 64
Portrait of Jeanne Duval 53–55; *50*
Portrait of Jules de la Rochenoire 103
Portrait of Mlle Isabelle Lemonnier 179
Portrait of M. and Mme Auguste Manet 9; *4*
Portrait of M. Henri Rochefort 194; *173*
Portrait of M. Pertuiset, the Lion Hunter 194;
 176
Portrait of Proust 179, 183; *164*

Portrait of Stéphane Mallarmé *146*
Portrait of Théodore Duret *97*
Portrait of Zacharie Astruc *62; 60*
La Prune *142; 132*
The Railroad *49, 127–28, 152, 153, 199; 115*
'The Raven' *159, 161–62; 148–50*
Reading, Mme Manet and Léon *86*
Reclining Nude *15*
Repose *109, 111–12, 199; 89*
The Rue Mosnier Decked with Flags *185–88; 171*
The Rue Mosnier with Pavers *188–89; 175*
The Seine at Argenteuil *131–32; 119*
Self-portrait *14; 6*
The Spanish Singer *9, 20, 77, 194; 3*
The Street Singer *49, 107; 42*
The Surprised Nymph *23–26; 17*
Swallows *122–23, 158; 110*
The Tragic Actor *69, 77, 107; 67*
View of the 1867 Exposition Universelle *94, 155–56; 142*
White Lilacs and Roses *182*
Woman with a Guitar *94*
Young Lady in 1866 (A Young Woman) *34, 49, 77, 81–82, 174; 70–72*
Young Man in the Costume of a Majo *42–43; 36*
Young Woman Reclining in Spanish Costume *39–40, 42; 31*
Manet, Eugène *10, 28, 32, 34, 37, 94, 111, 123, 158; 19, 145*
Manet, Gustave *10, 28*
Mantz, Paul *94, 165*
Marsy, Jeanne de *198*
Maximilian, Ferdinand-Joseph, Emperor of Mexico *83; 78, 79, 81*
Meissonier, Jean Louis *113*
Mejia, General Tomas *89, 104*
Meurent, Victorine *28, 32, 34, 37, 43, 49, 127, 128, 177, 199; 19, 35, 42, 43, 71, 115*
Meyer, Alfred *116*
Miramon, General Miguel *89*
Moffett, Charles S. *7*
Le Monde illustré *63, 67*
Monet, Camille *129, 131; 120*
Monet, Claude *20, 113, 115, 116, 119–21, 129, 148–51, 152, 153; 107, 118, 136, 137, 140, 141*
Monet, Jean *131*
Le Moniteur universel *9, 45, 63*
Moore, George *68; 64*
Morisot, Berthe *68–69, 92, 94, 96, 103, 109, 111–12, 116, 119, 121, 131, 129, 172, 199; 84, 89, 101, 108, 109, 121, 159*
Morisot, Edma *94, 111, 131*
Morisot, Marie Cornélie *68, 100, 111*
Morisot, Tiburce *111*
Motifs d'une exposition particulière *77–80, 122*
Murillo, Bartolomé Esteban *17*

Nadar *40, 42, 117, 155; 1, 104*
Nanteuil, Célestin *80*

Napoleon III, Emperor *9, 12, 39, 45, 83, 100, 146, 192, 194*
Neuville, Alphonse de *194*
Nieuwerkerke, Count Alfred de *76, 197*
Nochlin, Linda *7, 37, 45*
Offenbach, Jacques *15, 37*
Old Masters, influence of *12, 17, 23–24, 27, 28, 39, 76, 174*
L'Opinion nationale *45*
O'Reilly, John *49*
Ottin, Auguste *116*
Oudinet, Achille *94*

Paris
 boulevard des Capucines *117, 174; 104, 107*
 Brasserie de Reichshoffen *138; 124, 125*
 Café Guerbois *14, 112*
 Folies-Bergère *198, 200; 177, 178, 185*
 Gare Saint-Lazare *127–28, 129, 152–53; 141*
 Hôtel de Ville *184*
 Hôtel Drouot *116*
 Louvre *9, 12, 17, 23, 24, 55, 146*
 Martinet gallery *15, 77*
 L'Opéra *126, 174; 111*
 Palais de l'Industrie *9, 113, 116*
 Parc Monceau *148; 137*
 Père Lathuille café *183; 169*
 Place de l'Alma *76, 155*
 Pont de l'Europe *152–53; 139, 140*
 rue d'Amsterdam *194*
 rue Guyot *53, 69, 146*
 rue Le Peletier *126, 152*
 rue Mosnier *185, 188; 171, 175*
 rue de Saint-Pétersbourg *109, 128, 189*
 Tuileries gardens *148; 136*
Paris-Journal *173*
La Parodie *94*
Le Pays *72, 167*
Pertuiset, Eugène *194; 176*
La Petite république française *142*
Le Petit journal *45*
Pissarro, Lucien *113, 115, 116, 117, 119*
Poe, Edgar Allan *34, 159–62; 147*
Polichinelle *126–27; 116*
Pompilius, Capitaine *45*
Pons (cartoonist) *94, 95; 83*
Postwer (critic) *62*
Pothey, Alex *173*
La Presse *82, 173*
Prisse d'Avennes *162*
Proudhon, Pierre Joseph *18*
Proust, Antonin *12, 14, 27, 28, 179, 194, 197; 164*

Quiveron, Louise *181; 167*

Raimondi, Marcantonio *24, 28, 32, 37; 20*
Randon, G. *56, 58, 60, 77; 54*
Realism *9, 20, 22, 66, 165, 166, 173, 174, 200*
Reff, Theodore *7, 81*
Renoir, Jean *14, 20, 113, 116, 119, 121, 129, 131, 181, 182–83; 13, 102, 112, 113, 117, 168*

La République des lettres *179*
La Revue blanche *14*
La Revue des deux mondes *45*
Revue du XIXe siècle *72, 73, 80*
Ribot, Théodule *162*
Rochefort, Henri *192–93; 172, 173, 180*
Rochenoire, Jules de la *113; 103*
Rouart, Stanislas-Henri *116*
Rousseau, Jean *20*
Rousselin, Auguste *94; 85*
Rubens, Peter Paul *14, 17, 24, 39*

Salon *9, 61, 62, 68, 73–76, 113, 117, 122, 132, 194; 2; (1847) 13; (1857) 87; (1859) 9, 146; (1861) 9; (1863) 39; (1865) 46, 47, 67, 77, 109; (1866) 81; (1867) 20; (1869) 91, 94; (1870) 33, 97, 100; (1872) 85, 106, 109; (1873) 109; (1874) 126, 127, 158; (1876) 49, 166; (1877) 174; (1879) 49, 100, 134, 179; (1880) 183; (1882) 198*
Le Salon *28*
Salon des Refusés *7, 76, 113; (1863) 39, 43, 45; 37*
Scholderer, Otto *20; 13*
Second Empire *12, 38, 100, 138, 151*
Shelton, Gilbert *7; 22*
Silvestre, Armand *14, 112, 194–95*
Sisley, Alfred *115, 116, 119*
'Société anonyme co-operative des artistes, peintres, sculpteurs, graveurs etc.' *115, 116*
Spain *55, 61, 72, 89, 147, 164*
Stop (pseud.) *86, 179–81; 76, 166*
Suzon (model) *198–99, 200; 177*

Le Temps *45, 126–27*
Thiers, Adolphe *103*
Tissot, James *33–34, 117; 26*
Titian *23, 28, 55–56, 59, 62; 21, 52*
Toussenel, Alphonse *60, 62*
Truqui, Alfred *34*

Uzanne, Octave *38*

Valéry, Paul *112*
Velazquez, Diego *17, 54–55, 69–72, 80, 146, 147; 51, 65, 134*
Versailles *195; 181*
La Vie moderne *138, 195*
La Vie parisienne *2, 30, 37*
Virmaître, Charles *56*
Vosterman (engraver) *24*

Watteau, Jean Antoine *146*
Whistler, James McNeill *45; 38*
Wilson-Bareau, Juliet *7, 87, 108*

Yriarte, Charles *92*
Yvon, Adolphe *87; 77*

Zeldin, Théodore *103*
Zola, Emile *20, 69, 72, 73, 76, 80, 81, 179, 181; 13, 69*